Dedalus Original Fictic

WHEN THE WHIS'

Jack Allen is a Bristol based playwright who combines writ-
ing with looking after his two year old daughter. His work
includes the youth drama series *Jangles* for ITV which was
nominated for the Prix Jeunesse.

Jack Allen grew up in Bristol and was educated at Sefton Park
Secondary Modern. After training to be a teacher he
embarked on a career as a professional Rugby League Player
with Barrow-in-Furness. Injury led to a brief career as a
stand-up comedian and clown before he became a teacher.

He taught teenagers with learning difficulties English, in a
Secure Unit, before becoming a Head of a Special Unit for
disaffected pupils in Bristol. The success of his writing led to
his retirement from teaching.

When the Whistle Blows is Jack Allen's first novel. He is cur-
rently at work on further adventures of Caleb Duck.

Jack Allen

When the Whistle Blows

Dedalus

To Alison, Caitlin, Paul and Ben

Thanks to Richard Campbell for the typing,
Mike Mitchell for his reactions,
Paddy Benefield for laughing
and Eric Lane for all his help and advice

Published in the UK by Dedalus Ltd, Langford Lodge, St Judith's Lane, Sawtry,
Cambs, PE17 5XE

ISBN 1 873982 79 8

Dedalus is distributed in Australia & New Zealand by Peribo Pty Ltd, 58 Beaumont
Road, Mount Kuring-gai, N.S.W. 2080

Dedalus is distributed in Canada by Marginal Distribution, Unit 102, 277 George
Street North, Peterborough, Ontario, KJ9 3G9

First published by Dedalus in 2000

When the Whistle Blows copyright © Jack Allen 2000

Typeset by RefineCatch Limited, Bungay, Suffolk
Printed in Finland by WS Bookwell

A C.I.P. listing for this book is available on request.

Eastern Arts Board Funded

When the Whistle Blows – Jack Allen £8.99
The Experience of the Night – Marcel Béalu £8.99
Music, in a Foreign Language – Andrew Crumey £7.99
D'Alembert's Principle – Andrew Crumey £7.99
Pfitz – Andrew Crumey £7.99
The Acts of the Apostates – Geoffrey Farrington £6.99
The Revenants – Geoffrey Farrington £3.95
The Man in Flames – Serge Filippini £10.99
The Book of Nights – Sylvie Germain £8.99
The Book of Tobias – Sylvie Germain £7.99
Days of Anger – Sylvie Germain £8.99
Infinite Possibilities – Sylvie Germain £8.99
The Medusa Child – Sylvie Germain £8.99
Night of Amber – Sylvie Germain £8.99
The Weeping Woman – Sylvie Germain £6.99
The Cat – Pat Gray £6.99
Theodore – Christopher Harris £8.99
The Black Cauldron – William Heinesen £8.99
The Arabian Nightmare – Robert Irwin £6.99
Exquisite Corpse – Robert Irwin £14.99
The Limits of Vision – Robert Irwin £5.99
The Mysteries of Algiers – Robert Irwin £6.99
Prayer-Cushions of the Flesh – Robert Irwin £6.99
Satan Wants Me – Robert Irwin £14.99
The Great Bagarozy – Helmut Krausser £7.99
Primordial Soup – Christine Leunens £7.99
Confessions of a Flesh-Eater – David Madsen £7.99
Memoirs of a Gnostic Dwarf – David Madsen £8.99
Portrait of an Englishman in his Chateau – Mandiargues £7.99
Enigma – Rezvani £8.99
The Architect of Ruins – Herbert Rosendorfer £8.99
Letters Back to Ancient China – Herbert Rosendorfer £9.99

Stefanie – Herbert Rosendorfer £7.99
Zaire – Harry Smart £8.99
Bad to the Bone – James Waddington £7.99
Eroticon – Yoryis Yatromanolakis £8.99
The History of a Vendetta – Yoryis Yatromanolakis £6.99
A Report of a Murder – Yoryis Yatromanolakis £8.99
The Spiritual Meadow – Yoryis Yatromanolakis £8.99

URGENT

From: G. Rees B.Sc To: C. Duck
 Deputy Headmaster Acting Head of Integrated
 Studies

Date: 7.4.98
Time: 9.15 a.m.

Please submit to me by 16:00 hours, 14.4.98, copies of the
Maths, English, Humanities, Design and Technology Syllabi
as used in the Integrated Studies Department. Particular
attention must be paid to relevant National Curriculum
Attainment Targets at Key Stage Four.
This information is urgently required by the Headmaster for
the next Board of Governors Meeting.

Thank you.

G. Rees, Deputy Headmaster.

CHAPTER 1

Bollocks! Caleb screws the memo up and tosses it baseball style out of the window. Rage sears through his system. Rees can go and fuck himself the diminutive Welsh twat! If that slimy fat-arsed creep hasn't the guts to come over and ask him himself it can't be all that important. Back to the task in hand.

He positions himself more comfortably behind his desk. Steers the finger towards his left nostril. Probing, pushing, searching gently until he finds an edge to hook upon. Got one! Now comes the tricky part. Needs a steady hand. He turns his wrist and using his neck as a fulcrum leans slowly backwards in his chair. Pulls the winkle from its shell. Carefully. Very carefully. All the stresses and strains of his shitty job drift away at this magic moment. A wonderful calm seeps through his system. He rolls the bogey between his thumb and fingers. Allowing the chalk on his skin to absorb the vital body fluids. Reducing the monster to a tiny ball.

Caleb is very proud of his morning's work. High in job satisfaction. Strolls cowboy style across the classroom towards the cast iron heating pipe that surrounds the room and feeds the solitary radiator beneath the window. He bends down to peer behind. His spirits raised by what he sees. There they are. One for every day he's been working here as acting unpaid Head of Department. Five bogies to the working week. One inch per day. A three inch gap for a weekend or holiday. This is the dream target he's set himself. He must get out before they circumnavigate the room and return to their starting place by the door. With only another three walls to go time is running out. June 13th is E.D.E. – Estimated Date of Escape. After that he knows he's fucked. Reflexes will slow and speech become slurred. He'll become a husk. A hollow shell.

Caleb is fully aware of the danger he's in so puts great emphasis on vigorous exercise and regular bowel movements. The job demands he's in peak condition mentally and physically. Always ready for the next attack. Be it from a crazy pupil,

an angry parent or another typed instruction from that bastard Rees. The Deputy Head has a fierce ambition. Will allow nothing to stand in his way to the top. Loves to put the pressure on.

Caleb carefully touches yesterday's bogey. Just to check on progress. A look of alarm sweeps over his face when he discovers it's still tacky. Not welded to the pipe like all the others. Jesus fucking Christ! He needs to get to the bottom of this. Quick! Carefully measures where today's date should go and gently presses it into position. Scrambles further down the pipe to test the heat with his fingers. Already he can feel his heart rate rising. Adrenalin surging through. To his utter dismay the pipe is only lukewarm! No wonder it's still soft! He gets to his feet and leans against the wall. Frantically searches his jacket pockets for the tablets prescribed for emergencies like this. Beta-blockers and Lorazepam. Brain reeling from the shock. He beats wildly on the walls with both fists clenched. Yelling in rage at the man who must have ordered all this. Issuing instructions that effect him personally but not having the manners to inform him first. Caleb rushes to the window and hauls it open. Shouts in the direction of the Main School Block.

"I'll have you Rees you bastard! When I get out of here you'll be the first on my list!"

Caleb spins around angrily to face his class. Fully occupied playing cards or ping-pong. Ignoring Caleb and his personal feud. They've seen it too many times before for them to get excited. Shouting and screaming in general delight. Highly motivated by the tasks they've been set all within the scope of National Curriculum targets.* Caleb follows the golden rule of teaching that education must be an enjoyable experience.

* It says in the Design & Technology National Curriculum document Key Stage 2, pupils:

> "should be given the opportunity to work with a range of materials and gadgets including stiff and flexible sheet materials (playing cards), mouldable materials (plastic table tennis balls) and electrical devices (ghetto blasters and/or headsets)."

12

"Errol mount guard! If I let that little shit get away with this there's no telling where it will end."

Errol Perkins, a huge, princely looking Afro-Caribbean lad. Chronological Age 15.8. Reading Age 8.2. Already earning more money than Caleb with all his business interests. Wears a spotlessly white Yves Saint Laurent suit. Black shirt offset with flash silk tie. Looks like something out of Guys and Dolls. Beams a magnificent smile.

"Yes sir Mr Duck. There'll be no trouble when the King is in command."

"There better not be Errol or else you'll find somewhere else to live. Why didn't you tell me it was cold in here?"

Errol rubs his chin ruefully. A little embarrassed.

"Well you see Mr Duck man. I slept in your office last night and I have something nice and warm lying next to me for my personal pleasure like. You know what I mean?"

Caleb nods his head. He knows what he means.

"As long as Dave doesn't catch you Errol. That's all that matters. Make sure no one fools around when I'm gone."

Ever since his mother kicked him out of the house Errol's lived in the I.S. Department as unofficial night watchman. Caleb hasn't the heart to see him out on the streets. Told him he could stay. As long as he doesn't take advantage and isn't late with the rent. And Dave the caretaker doesn't find out.

Caleb curses himself for not spotting the drop in temperature sooner. It's obvious what Rees is up to. Reduce the temperature in the building to weaken his body resistance. Knock all the fight out of this troublesome bastard. Get him to resign or take early retirement. Replace him with some Welsh crony of his. Caleb's convinced he's already got someone lined up. The scheming little cunt!

He leaves the classroom and walks through the Main Hall of the Integrated Studies Department. Distressed state. Eyes search around for any signs of trouble coming from the kids who are already in. None. And he knows it will stay that way. As soon as he's gone Errol will remove the knife from his Calvin Klein socks and go around and collect his insurance money. Then when he's finished doing that he'll sit on a table

at one end of the hall with his hand up some skirt feeling pleased with himself. Making sure everyone behaves themselves. And they will.

He'll get no trouble from the loony John Irving, the self-styled great musician/conductor. (C.A. 16.1 R.A. 6.7). He's already set his equipment up and is totally absorbed in conducting the classical music of the world. Puccini's Madame Butterfly. Blaring out in hideous distortment from the remains of the battered tape recorder he rescued from a tip. John flails away in front of an invisible orchestra with the leg of a chair that was smashed during the last Indo-Jamaican War.

The serious table tennis has already started. Tense excitement. The history books being used as bats make it impossible for the top ranked players to produce good stroke play. As Caleb passes he makes a mental note that some lighter, smaller books must be ordered. Something in the Ladybird range that have the correct feel and balance. If he's to produce the Champions of Tomorrow then nothing but the best equipment will do. A decent net too. The row of Bibles stretched across the middle of the table are not regulation height.

Dashing down the concrete steps that lead from the hall to his office. Must answer the phone before it stops ringing unless Lynda Coles is already there. She is. He walks into the room and she hands him the receiver. Fag dangling from the corner of her mouth. (C.A. 16.0. R.A. 12.4. By far the brightest in the department).

"It's for you luv. That Mr Powell again."

Caleb knows already what he's going to say.

"I won't be in this morning Caleb. I've got this bit of a chill. The doctor told me to take it easy for a couple of days."

"That's okay Andy. It should be nice down in Weston today."

Idle fucker! Wanker! Since being appointed last December to cover for the former Head of Integrated Studies he hasn't completed a single week's work. A pathetic excuse every time.

"Bloody marvellous isn't it Lynda. He's having another day off!"

Lynda takes the phone from Caleb and puts it back in its place.

"What's he look like luv this Mr Powell? I can't remember being taught by he."

"You won't. You've probably been out on work experience the two days he's been in."

Lynda's very neat and tidy. Good with her hands. Works part-time as a sex care provider in a seedy local parlour. Already building up a strong client base. The rest of the week she acts as Caleb's secretary. Answering the phone and typing a few letters. Everyone's happy. Especially the beautiful Angela White, the school's Education Welfare Officer. She checks the register on a weekly basis and sees Lynda marked present everyday. No problem. A lovely girl Angela. Dedicated and concerned with nice big tits. A combination Caleb finds rare and attractive. Irresistible.

"Alright if I takes a break luv? I needs a pee."

"Yeah. Go ahead Lynda. Ten minutes yeah?"

Lynda walks out of the room fag in hand. Wiggles her arse as she leaves. Caleb smiles to himself and closes the door. Sits down and dials the number. It's picked up almost immediately.

"Rees speaking."

Caleb's heart starts pounding. Breathing becomes more difficult and tight. An anger stirring up deep within him at this contact with the enemy.

"Listen Rees you big fat turd! Turn the fucking heating back on or I'll cut your bollocks off!"

"You need help Duck, you're sick."

"Not as sick as you're going to be if the heating's not put on. You're not getting my job Rees! You wanker! You can tell all your oppo's butty I'm made of stronger stuff. I'm a fucking Plantagenet!"

"Why don't you let me arrange for you to see someone Duck? You don't want to end up like Jeremy Philes!"

Alarm bells sound in Caleb's head. The bastard's keeping him talking whilst they trace the call.

"Fuck off Rees! You patronising git! Don't say you haven't been warned!"

Caleb slams the phone down hard. Experiencing a deep inner glow of self-satisfaction and a mild trembling of the hands. Makes his way across to the sink and fills the kettle for a cup of tea. Although it's only 10 a.m. he's already done a full day's work. He can feel the adrenalin surging deep inside. Causing his heart to beat at an almost suicidal rate. This job has already taken its toll on three teachers this year and he has no intention of making it four.

As Caleb washes out a cup he vows he'll never allow the job to affect him like that. Never let the system grind him down into a gibbering idiot. Slobbering at the mouth and pissing his pants whilst he marks the register with a stick of chalk. As soon as he discovers he's going off his rocker of course he will resign. Revert to his real passion of D.I.Y. or climbing the Cumberland fells. Failing that of course he could always escape. Dig a tunnel like the late Jeremy Philes. Said with a silent 'H'. The former Head of the I.S. Department had the perfect plan. Get back to civilisation to be retrained as a School Librarian or office boy. Then go for the breakdown package. They wouldn't put him on active service again and send him back to the Front. Not after twenty years experience in the trenches. Shells crashing down every few seconds. Explosions inside his head. They wouldn't dare. Forty-eight year old men don't react as fast. They're slower and more set in their ways. Find it difficult to adapt to the ever changing patterns of educational thought. The National Curriculum and all that bollocks. A younger man can see the sense in Records of Achievement, Key Stage 4, Attainment Target 8. Learning by exploration. No such thing as a naughty child. Caleb is fucked if he can. He belongs to the old school where there were set standards of uniform and behaviour. Where good manners cost nothing and were insisted upon. In those days everything was done on military lines. The school was divided into colours or houses. Red, green, blue, yellow. Classes were A, B, C and D. The computer brains were always in A and B and the psycho's and headbangers in C and D.

Desks were positioned in rows. Not in a fucking circle! The most able pupil sat nearest the teacher and had to put up their hands to answer a question. Multiplication tables were learned by rote. The teacher patrolling between the rows with his cane at the ready and longing to strike. Trying to catch someone only mouthing the words. And when playtime finally came to an end a whistle was blown by the teacher on duty. The first blast meant everyone stood still. STILL! No one daring to take another step. A beating in front of the school if they did. The second blast and they ran to their lines. At the double as fast as they could! Stand up straight with shoulders back! Eyes glued to the head in front of them. God help anyone who said a word as they marched in line by line.*

Of the four teachers currently working in I.S. Caleb is the only one with experience of the ways of the Elders and he feels it's his responsibility as Acting Head to pass his knowledge on. However, he has great difficulty in getting his message across. Every day without fail Andy Powell phones in sick. Lyn Jones, the cropped haired Bloke/Girl of the group is busy trying to recapture her darling budgies and Jan Scott is having an affair with Baldev Singh. A belligerent Indian in Year 11 with a serious attitude problem.

The phone rings again in Caleb's office breaking up his thoughts. He picks it up prepared for anything. Barks like a dog before he replies. Just to cause confusion.

"Woof! Woof! Bristol Dogs Home!"

"Morning Caleb. Glad to find you haven't lost your sense of humour!"

He recognises the voice immediately. It's Williams the Nice W.C. Once again his pulse rate rises.

"Good morning Headmaster. How are you?"

"Listen Caleb, got a moment to spare? I want a quiet chat."

Caleb takes his time. Knows Rees must be behind all this. Doesn't want to appear too keen.

"Next Monday morning's the best I can do."

* Dr Benefield told the Enquiry that Caleb Duck's obsession with old-fashioned and discredited teaching methods was the root cause of his illness.

"Nine thirty alright with you?"

"Okay by me. Woof! Woof!"

Caleb puts the phone down slowly and listens for the second click. It didn't come. He has this uneasy feeling in his gut he's being secretly checked out. That Rees and Williams are having him bugged. Collecting their evidence for his dismissal. Caleb knows they've been watching too much telly. Like to play the double act. The good cop bad cop routine. But in their case it's Mr Nice Welsh Cunt and Mr Nasty Welsh Cunt. That's how they keep control. Williams is at his most dangerous when he's being polite and smarmy. Then when he thinks he's softened the suspect up he'll ask Rees to wield the knife. Which he does with enormous relish. Caleb knows he's dealing with a crafty Welsh bastard. He'll have to watch him like a hawk. The First Level of Awareness!*

* Stockhausen said the First Level of Awareness was know thine own enemy.

CHAPTER 2

Caleb doesn't like talking about home. Refuses to allow the mind-blowing squalor of the workplace to enter the sanctity and loving calm of perfect domestic bliss. He likes to keep the two things separate.

But. Leaving school the previous day Caleb makes his usual pilgrimage into the surrounding countryside. Time for his daily workout. Rid the body of the pent-up poisons that accumulate at an alarming rate when working at the chalk face. Pulls the Capri into the lay-by, gets out and takes in huge gulps of God's fresh air. Wallowing in the glorious solitude. He looks around the field for his training companion. Other cows are in there chewing the cud and some even give him the big come on. Flashing their beautiful eyes. He refuses to be tempted. There's only one cow in his life and that's Rosie. Others will get their turn when he's stronger.

Caleb spies the chosen one in the corner tugging away at her mother's teats. He approaches quiet and slow. Offering a handful of grass on the flat of his hand. Strokes her back and allows the long pink tongue to lick the grass off his hand. Makes no sudden movements. Crouches down low to get a balanced grip and fights the struggling legs. Then runs like fuck for all he's worth. Rosie gradually becoming more still and quiet as the rhythm of his running lulls her into feeling secure. Breathing coming in a controlled regular pattern and knees being lifted up high off the ground. Toes pointing ballerina style. Up! Two! Three! Four! This is how Milo the Greek trained Hercules. Every single day for a year and by the end of it the Strong One was lifting a fully grown bull on his shoulders and running with it to Athens and back. Caleb reckoned that if it was good enough for Hercules it was good enough for him. Been at it now for over a month. Ever since the Headmaster asked him to take over as Acting unpaid Head of Department. So look out anyone who dares rile him up. Let them have a go if they think they're hard enough!

After one lap of the field he places his burden down. Certainly feels much better for it and sucks in more lungfulls of the countryside pong. Gets his breath back slowly. Only now can he relax and let the tension ooze. Calmer and ready for home.

Caleb skids the car to a halt outside his house with the skill of a drug crazed joyrider. Feeling young and virile once again. Casts admiring glances at the Victorian sash windows he so lovingly restored three years ago. Hours and hours spent on the job but well worth all the effort. Original features greatly enhance the value.

Sounds of loud music rush to greet him as he approaches his front door. Blur, Oasis or Radiohead. They're all the fucking same. James his oldest must be home already. Doing a three year course in Economics at Manchester University. Jayne the youngest away at college too. Training to be a teacher. Caleb did everything in his power to put her off the idea. Even took her into his place of work. The scrag-end of education. Not even the appalling spectacle of Shitty Shearn (C.A. 15.7. R.A. 6.5) dumping a load in his pants during a ping-pong match could get her to change her mind. Nor Errol sidling up to her and offering protection from his sexual advances. At a price of course. A very nasty moment until the penny dropped and Caleb put him straight. Nothing could put Jayne off. Determined to make a career of it. Just like her old man.

Through the front door. Music even louder. He steps into the stripped pine hallway. Another seven days out of his life to do that. Forty-three if you count the doors and the skirting. Caleb recommended to all who listened not to get them dipped. The joints break loose and there's always a bit of paint left in the corners. Use a heat stripper instead and keep the end moving. No burnt patches that way. Into a smoke-filled front room. A hundred years of distemper picked out with a pin from the beautiful ornate cornice. One foot a night for a full three months. A Victorian marble fireplace with a cast iron surround. A thousand pounds well spent. Now stacked with empty beer cans and cigarette ends. James and his mates

have been having a mid-day party. The sort only middle class white kids can have. He yells out above the noise.

"Come on Caleb! Where's our tea?"

"Isn't your mother in?"

"No."

"Where the fuck is she then?"

All the good of his workout immediately lost as his temper flares up again. As if he didn't know. Nearly half past six and still at work as an overworked and underpaid secretary. Treated like shit by all her Primary School masters. At their beck and call. Caleb knows a single day at an inner city multi-racial school would sort the lot of them out.

"You could get your own tea couldn't you? Plenty of food in the freezer."

"Okay. So where's the freezer?"

"In the utility room!"

"So how would I know that?"

"Use your fucking common sense!"

Caleb had to put it there whilst he lays a quarry tiled floor in the kitchen. Extending it to princely proportions with the help of his builder mate Stockhausen. A man with strong opinions on everything. Particularly education.*

Caleb and Kaye are working to an agreed master plan. Restore the house to its Victorian glory and sell when the kids leave home. Then go and live in a smaller abode and spend the profit on trips round the world. All being well and with a fair breeze behind them they should be able to accomplish this by the time Caleb retires. In just two year's time at the big Five-0! They've spent the last ten years submerged in the project. No breaks, no holidays, no socialising. At it all the time. Caleb's quite prepared to make the short-term sacrifice in exchange for the long-term gain. Happy in the knowledge that Kaye is with him. That together they make the perfect team.

Caleb's pleased that James feels secure enough to invite his

* Lenny Stockhausen: The builder/philosopher who argued strongly for an amphetamine based system of education which he claimed would speed up the learning process. A founder member of the group known as The Bristol Poets.

friends back to his house for tea. Entertain them with his drinks. Fill his rooms with thick tobacco smoke, get pissed and play the music they like to hear. Fucking loud. No pressure. It must say something for the way he's been brought up. This slacker generation. Pampered and spoiled by over-protective parents. Killing them softly with their love. He wouldn't have it any other way. Smiles to himself and starts peeling potatoes. Makes a start on tea. Thinks to himself where the fuck is Kaye. She should be doing all this! As if on cue the noise in the other room subsides. A female voice alarmed and concerned. Enquires what the hell is going on. Kaye steps through into the kitchen. A look of thunder on her face.

"Have you seen the state that room is in?"

"You should have been here to stop them then!"

"I had to get a letter out. It put me behind!"

"They don't pay you overtime! You finish at four!"

"I'll finish when I want to! You don't dictate what hours I work!"

The argument continues back and forth. All about pay and working conditions. Snide remarks to twist the knife. Shouting in each other's faces.

"You let them walk all over you Kaye! Fucking stand up to them for once!"

"It was my choice all right!"

James meekly pokes his head round the door. Tells them he and his mates are going out. Don't bother to cook them any tea.

Caleb yells at him angrily.

"What do you mean? You're going out! I've done all this now!"

"Well you eat it then! I don't want to sit down with my friends listening to you two slagging each other off. It's embarrassing."

James slams the door shut. Caleb is rocked back on his heels.

"Fucking brilliant Kaye! Thanks a lot! James only comes home twice a year! Couldn't you make an effort for once to be here when he arrives!"

"How many times have I got to tell you! I had to get a letter out! How dare you speak to me like this! Who the hell d'you think you are?"

Caleb ups the stakes. Starts hurling pots and pans around. Lets her know just how he feels. On the edge. Quick to snap. A volcano about to erupt. Kaye no slouch herself when it comes to aggro. Well able to defend herself. Attacks him with a sweeping brush. Beats him about the head. Caleb needs to do something really dramatic to bring the conflict to a head. Picks up a twelve inch pizza newly defrosted and slaps it straight in her face. Suits her down to the ground.

"Clean that lot up you servile bitch! Pretend you're still at work!"

Two hours later. Caleb is pissed. Stretched out in an armchair. Listening to Mahler's First played loud on his headphones. An empty bottle of wine on the floor. All manner of thoughts buzzing around his head. Is it the job that makes him feel angry or is it the tablets Errol provides? He'd read how steroids can make their users aggressive. Bouncers that beat the punters up and body builders who go home and eat their wives. Maybe that's the reason. Perhaps he should only take one a day as recommended on the bottle and not the three he's been swallowing recently. He warns himself to be on the look out for any signs of violent behaviour coming from within. So far he's seen nothing to arouse suspicion.

The door opens quietly and in walks Kaye. She turns the stereo off to get his attention. He opens his eyes and studies her. All dolled up to the nines. Eyes a little red where she's been crying. But in a much more placatory mood.

"I'm going out."

Caleb much happier and quieter now. The inner rage subsided and the comfort of another bottle of wine in the kitchen helps him see things with a rosy glow.

"Where you going?"

"You know where I'm going. It's the Local Elections. I said I'd help them out."

"Self-seeking bunch of wankers Kaye! Don't waste your time or energy."

Her voice rises again but with a harder edge he hadn't noticed before. A smattering of real hate.

"Just make sure you vote then Caleb. People gave their lives for your right to do that. Don't insult their memory by staying home getting pissed!"

She leaves by slamming the door. Caleb finds her zeal all highly amusing. Starts breaking into song:

> "I want a girl,
> just like the girl
> who married dear old Dad."

Surprised by the power in his voice and the quality of delivery he gets to his feet to pursue the performance. Serenades Kaye down the garden path. She spins around in temper.

"Grow up Caleb will you!"

He refuses to be put off by her heckling. Follows her neighbourly down the road. His singing getting more dramatic and attracting some attention. But Kaye doesn't appreciate the gesture.

"Fuck off Caleb will you?! You're making a fool of yourself!"

Caleb decides to take her advice. Retreats to the house to savour the moment. Laughing to himself at the humour in it and swigging back the booze. His rejoicing comes to a sudden end as a gurgling inhabits his bowels. There's a sudden rush to go to the toilet. A worried look on his face. It's ten long days since he's been. He gets all the usual rumbles and feelings. Up to the point of the bombs away then absolutely nothing. Resisting all the built-up pressure. Impossible to shift. He makes a mental note to see a doctor. Make an urgent appointment.

URGENT

From: G. Rees B.Sc
 Deputy Headmaster

To: C. Duck
 Acting Head of Integrated
 Studies

Date: 14.4.98
Time: 11.25 a.m

Please find enclosed copy of Stress Situations at School that will be used for discussion purposes in the Stress Management course being run this Saturday at Clevedon House for all Heads of Department of Children with Educational and Behavioural Difficulties.

You are expected to be there at 8.30 a.m. ready for a 9.00 a.m. start. It is essential you attend! Any problems please see me!

G. Rees, Deputy Headmaster.

STRESS SITUATIONS AT SCHOOL

Please tick the ones that apply to you at school. All completed forms will be treated in strictest confidence.

1. You are repeatedly asked to do things you basically disagree with.
2. You have too much work to do any one thing properly.
3. You're not really sure of the extent of your authority within the School/Department and consequently feel inadequate at times.
4. You have so many forms to fill in that your teaching preparation time suffers as a result.
5. You're not really sure of your worth to the Faculty/School because no one ever bothers to tell you.
6. Your loyalties as a teacher are often torn between pupils, parents and colleagues.
7. You find it difficult to obtain all the information needed to carry out your job properly.
8. You find that your Head/Head of Faculty/Dept/House/Year is not prepared to listen to your ideas as readily as he/she is to some of your colleagues.
9. The higher up the ladder your Head of Dept climbs the more unsavoury parts of his/her anatomy are displayed to you below. Not a pretty sight.
10. Despite the number of mints you've sucked pupils in your Tutor Group still complain about your beer smelling breath.
11. You have extreme difficulty in getting out of the car park at the end of the day because more experienced teachers have wired the school bell to the ignition of their cars and consequently got to the main gate before you.
12. At a parent evening the mother/father of a pupil in your Tutor Group turns out to be the person you screwed after a recent Singles Night Disco.

RESPONSES TO STRESS AT SCHOOL

People indicate their stress by emotional, body or behavioural signs. If you recognise any of the following symptoms in your present behaviour please tick them:

1. General irritability and bad temper
2. The loss of a sense of humour
3. Excessive aggressiveness
4. Moodiness
5. The inability to make decisions
6. Accident prone
7. Feverish activity with little purpose
8. Inability to concentrate
9. Frequent use of tranquillisers
10. Absenteeism
11. Insomnia and/or apathy
12. Marital or family conflict
13. Heavy drinking
14. Ulcers and/or skin rash
15. Depression
16. Frequent forgetfulness
17. Tension headaches
18. Incontinence
19. Inability to eat
20. Hyper-sensitivity to criticism
21. Excessive smoking
22. Back pain
23. Migraine
24. Inability to obtain or maintain an erection
25. Constipation

Type of school _____

Position in school _____

CHAPTER 3

Caleb is in a much more confident mood this morning. He'd felt the pipes and they were piping hot. Rees must have got the message. A quick read through his latest missive. 'Stress Situations at School'. Decides none of it applies to him. All a load of bollocks! He's in total control of mind and body. Chucks it in the bin.

The morning's bogey was an immature youngster. Wet all over. Caleb had to roll him around for over an hour before the little devil began to firm up. No matter they all count. A three inch space and start a new week. In relentless pursuit of his dream escape. The only thing that keeps him going. Away from here by June 13th. It's been like this for the last fifteen years. Always a date, a target. And when June 13th is reached and he's still here he'll set another target. Something to keep him hammering away. Beating his head against the wall. But one of these days he'll do it *4 real* as Ritchie Manic would say.

Caleb always feels very vulnerable when he leaves the comfort of the Integrated Studies Block. The three foot thick walls of the former secondary modern give a wonderful feeling of basic security. In his present stressed out state he knows exactly what his actions would be if the Authorities ever decided to cancel his contract. He'd barricade himself inside the building and hold the fort for days. Let everyone know the pressure he's under. The stresses and strains of the job.

The playground resembles a marketplace with the West Indians as always dominating the scene. Noisy and uninhibited. Smiling black faces in abundance with large flashing eyes and sight-screen teeth. Brilliantly coloured clothes made to dazzle that even on this dull grey April morning necessitates designer shades. Mouse the ganja man skulks in the background. Keeping an eye out for rival dealers who'd beat the shit out of him if they discovered he was trading on their patch. Caleb sees Errol going across to meet him. Collecting his insurance money and checking Mouse isn't selling any

heavier gear. That's one of Errol's perks. Well, his apart from Yellowhead. The new arrival from Jamaica. Nobody fucks with Yellowhead. Not even Errol for some strange reason. Caleb's never found out why.

Maria Stewart arrives at his side and pushes her arm through his. (C.A. 15.9. R.A. 10.2). They enter into jolly banter. Years of trust built up over the years.

"Maria, when are you going to marry me? You know I love you dearly."

She laughs outrageously. Almost a cackle. Maria is crazy. Beautiful to look at but wild in her ways. Caleb once had occasion to go to her home because the word on the street said she'd been murdered. Sacrificed by her father who dabbled in ju-ju. A council flat halfway up a high-rise block. Caleb shudders as he remembers it. Totem poles and voodoo dolls. An altar place splattered in blood. Everything painted black. In fact Maria was extremely alive and well. Just knocking off school to marinade fish. In a quite revolting way. Juices ebbing and flowing. Caleb parted on the best of terms. Shook her father's hand and wished him well. He in return cast a good spell for Caleb and gave him a bottle of Irresistible Drops. Told him to use them if he wanted power over women. Caleb laughed and nodded his thanks.

Maria looks at him out of the corners of almond-shaped eyes. Not knowing for sure if he meant it.

"I ain't going out with no married man Mr Duck!"

Her words send Caleb reeling. He has to hold on tight for extra support. Doesn't want reminding about his wife. The other night after the local election results. Kaye didn't get in until three in the morning and there was a bit of a domestic dispute. Culminating in sleeping in separate rooms. James a confused witness. All Caleb wanted was to kiss and make up. Not much to ask of a wife. But Kaye was having none of it. Froze him out completely. Caleb can't face the thought of rejection again. Begs and pleads with Maria.

"Come on Maria! Let's run away. We'll go to London and spend the night together. Breakfast in bed if you like? How d'you like your eggs?"

This girl he'd sacrifice his brilliant career for tears herself free and covers her face with her hands. Runs through the playground screaming high-pitched laughter. Causing the others to stop and stare then turn their puzzled gaze at him.

The crack in Caleb's brain is getting wider and wider. Caused by the stress and strain of domestic life. Brain cells haemorrhaging in their millions looking for somewhere else to live and Caleb can't say that he blames them. Nevertheless he keeps on walking and eventually arrives at the Headmaster's room. Knocks on the door and waits. A gentle Welsh voice cuts through.

"Come in!"

He enters firmly into the room. Ordering his thoughts into line. As the highest ranking officer in Integrated Studies Caleb knows it's his duty to act the part. Slams the door behind him with a bang and then springs to attention with a brisk salute. Barking out his presence.

"Acting unpaid Commander Duck at your service sir!"

Caleb notices that the normally placid nice Welsh cunt is taken aback by his ramrod approach. Didn't expect him to look as sharp as this. Certainly not after Rees the Nasty had ordered a reduction in classroom temperature. Williams blinks hard. Deep shock-lines appear across his forehead and continue over the roof of his shiny bald head as he takes in Caleb's appearance. Resplendent in his commando-style jacket. Newly washed and ironed for this important occasion.

"Sit down Caleb would you?"

Caleb on red alert. He's already seen this one at the movies. Where the arms of the chair swing round and grab him. Hold him rigid whilst Williams pulls his teeth out one by one. Spotlights flashing in his face. Blinding him with terror.

"No thank you sir. I'd rather stand if you don't mind."

"As you wish Caleb. Cigarette?"

"No thank you sir. I don't smoke. Bad example for the men eh? Rations are jolly short you know."

Williams gives Caleb a long quizzical look. Maybe Rees is right. He is going crazy.

"You don't mind if I do, do you Caleb?"

"No certainly sir. You carry on."

A short squat man immaculately dressed. Everything about him is neat and well-ordered. No loose papers lying around. He controls the vast Walliscote Road Comprehensive School from this very office. Charts and timetables pinned on the wall tell him precisely who should be teaching what and where. One of the old school. B.C. Before computers.

Caleb watches as Williams lights up a cigarette. Eyeing him strangely through the first puff of smoke. Eyes squinting together with deep suspicion. Can't quite make him out. Decides to test his reactions.

"Look Caleb, I'll get right to the point. Since poor Jeremy's tragic demise you've run the Integrated Studies Department on your own. And you haven't had a lot of help."

Caleb is just about to agree with him when he starts to speak again.

"Without naming any names Caleb I think it's fair to say you're carrying one or two teachers over there. Right?"

Caleb shrugs his shoulders. Non-committal. He would have said all three.

"Not many teachers out can handle the bottom stream leavers. I've got staff who have trouble with the so-called academic types, but you've got some right bastards over there. Correct?"

Caleb is puzzled. Can't work out what Williams is trying to get him to say. If he admits to him he has any problems it looks as if he can't do his job.

"Well I've got one or two who can be awkward."

Williams laughs. Suggesting there was nothing he could do about the information he gives.

"Well, I've got some bad news for you boy. You're getting another on Monday. A Gary Greenwood. Just been expelled from Greenhill Comprehensive for dangling a teacher out of a window. He's also in trouble with the police. Robbed a post office with a shotgun. Only out on bail at the moment but as the law says he's got to go to school he's come to us or rather to you boyo. Well done Caleb! You've hit the jackpot!"

Williams pretends to find it funny. To see if Caleb laughs as

well. He doesn't. Smells a rat instead. Never before had Senior Management sent a firearms expert into I.S. They'd had thieves, arsonists, prostitutes and rapists but no hard core criminal types. There had to be a catch. Mr Nice W.C. becomes suddenly serious again.

"Listen Caleb. How many years have you got to go now?"

Caleb tells him two. Finish at fifty. Take the retirement package and run like fuck. His way of celebrating the Millennium.

"Well maybe I can do you a favour Caleb by increasing the size of your lump sum."

Caleb allows himself the luxury of a tiny smile. At last. The real reason why he called him over.

"How can you do that?"

Williams blows out a perfectly formed smoke ring. Watches it slowly rise. Quickly followed by another. Gets four in the air at once. He wants Caleb to be impressed by his smoke blowing prowess but Caleb refuses to comment. Why the fuck should he be impressed by that? He has all day to practice. Keeps his eyes firmly fixed on Williams. Waiting for the catch.

"How would you like the job on a permanent basis Caleb? Take over the running of the whole shebang on Senior Master money?"

Caleb laughs aloud. Now he can see what Williams is up to. Hiring him as a quisling to spy on his men. Get him to betray the confidences he'd built up over the years. No way. The kids in I.S. trusted Caleb. Knew he wouldn't grass. Told him things that could put them in prison if the authorities ever found out. Mr Nice W.C.'s voice becomes increasingly concerned.

"I want stability over there see Caleb with this Ofsted coming up. The kids respect you. You speak their language and the retirement package won't be on offer forever. As soon as the Local Authority has reduced the number of teachers to an economical level they'll stop it. Mark my words!"

He snaps his fingers. Studies Caleb's face. Continues sounding grave.

"I don't want to pressurise you into taking something on that's going to damage your health boy. I don't want you ending up like Jeremy Philes."

A pause. Another smoke ring. Then more guarded through half-closed eyes.

"You see Caleb I'll be honest with you. Rees seems to think the pressure might prove too much. He thinks you've got enough on your plate already. What with your home improvements and all."

A flash of anger across Caleb's face. So Rees has already been in to snitch! Living up to his reputation as a sneaky W.C.

"The trouble with that man Mr Nice he hasn't got a sense of humour."

Williams manages to strain a tiny snigger. Doesn't appreciate his staff being over familiar.

"That's what I told him. You've got to have a sense of fun to work in I.S. D'you want some time to think it over? Discuss it with Kaye first?"

"No. No. No. I'll give you my answer now."

"So what's it to be?"

Caleb sees no point in refusing a pay rise. No matter who gets the job it'll be him in charge. He speaks from the hymn book. Strong and true. Just like Jonathan Aitken.

"Armed with my Sword of Knowledge and Arrows of Desire I shall ride forth and conquer all ignorance Sire."

A puzzled smile breaks out on Williams' face. Doesn't understand. Has never fathomed what planet Caleb inhabits.

"Does that mean you accept it Caleb?"

"Too fucking right it does W.C.!"

Williams gets to his feet and reaches across the table. Shakes him warmly by the hand.

"Good lad Caleb! I knew you would make the right decision. Well done boy! Welcome aboard!"

His grip becomes more earnest. There's a look of concern in his eyes when he speaks.

"Don't end up like the others boyo. Any problems come to me first. I want you to enjoy a long and happy retirement."

Caleb's eyes mist over at the memory of former colleagues.

Men like Silent 'H'. The sort of chap you could take into the jungle with you. Had a visit from the Ofsted team. Fucking Gestapo bastards! They carried out a surprise raid on the Department and didn't like what they found. Demanded to see the syllabus. When Silent 'H' produced one on a piece of scrap paper they said it wasn't linked to the National Curriculum. Ordered another full inspection within three months and put the school at risk of closure. Called it Special Measures. Threatened Jeremy with the sack. Told him he would be stripped of his rank and pension if things didn't improve at once. Cunts left no stone unturned.

Silent 'H' could take no more. As they wouldn't grant him early retirement he went to the Camp Escape Committee with the plan of a tunnel out of the building. The Committee which consisted of 'H' and Caleb approved of his daring idea and wished him all the best. Working four hour shifts on hands and knees he managed thirty bucketfuls of earth each time he went down. Disposed of it in the school library. Letting it spill down the inside of his trouser leg. Washed down with minor incontinence. But all this proved too much for a sixty-three year old veteran. He dropped dead one morning at Assembly. Halfway through Jerusalem. A stroke brought on by the stress of the job.

Silent 'H' 's death had made Caleb more determined than ever. The fact that Williams has just appointed him to take 'H' 's place in no way detracted from his desire to escape. There are eighty-one pupil/prisoners in the I.S. Department and in Caleb they have a man of spirit like Henry V. A long and distant ancestor of his whose blood courses through his veins. He won't betray their trust.

Mr Nice W.C. accompanies Caleb to the door of his office. Manners and charm gushing full flow.

"Don't be afraid to ask for anything you want boy. Yours is a difficult job I know, and I want to give you all the help I can."

He puts a fatherly arm around Caleb's shoulder. Takes his hand and grips it tightly once more.

"The best of luck then Caleb. And congratulations boyo!"

35

But then the pretence comes to a sudden end. There's a certain menace in his voice as he remembers something Rees must have told him.

"Just one thing before you go Caleb. I forgot to mention it before. Could you let me have a copy of your syllabus as soon as possible? I need it for the Governors' meeting. Of course it needs to be related to the National Curriculum."

Caleb snaps to attention and gives a smart salute.

"No problem at all sir! Consider it already done!"

Spins on his heels and marches away. Highly polished riding boots stamping order and efficiency on the lino floor. Confident he's left a fine impression in Mr Nice's mind.

In fact it was just the opposite. Mr Williams the nice W.C. feels suddenly quite ill. It was the boots and jacket that did it. Maybe Rees was right. Duck isn't the man to run the I.S. Department with the forthcoming Ofsted inspection. He's certainly acting very strange. Too late now to make another appointment. Besides he's given his word and as he's such an honourable man he can't go back on that.

The day ends with Caleb running round in the field with Rosie on his back. Feeling extremely good. The steroids are having a marvellous effect. Arms and shoulders like hardened steel. Well able to handle Rosie's increased weight. Bounding around with high knee lift and toes pointed sharply to the ground he reflects on the achievements of the day. In deep philosophical mood. He's come a long way since being a muscle bound P.E. teacher teaching teenage boys to hop, skip and jump. An event that's got as much technical skill as putting the washing out. Less if it's pissing down with rain. Years later he retrained as a woodwork master. A great opportunity to do up his house. Using all the facilities the school provides. Plane face side and then face edge. But in came R.O.S.L.A. like a screaming monster. The raising of the school leaving age. From fifteen years to sixteen and nobody knew what to do with the crazies. The nutters, slow learners, school phobics, headbangers, disaffected youth, fuck-offs, lowlife scumbags. Call them what you want. Very few teachers could handle them. And Caleb was one of the few. So when the job came

up at Walliscote Road School he applied for it and got it. The path made easy by Jeremy Philes. A longtime friend from his sporting days. And now he's capped a brilliant career by being appointed the Head of Department. Fantastic! The Second Level of Awareness! Satisfaction in the workplace just like Stockhausen said.*

Caleb vows to leave his mark. Complete the work of Silent 'H'. Of love and understanding. Provide cups of tea for all his pupils. The benevolent dictator. All that and much, much more. Things will never be the same again. Wait till Kaye learns of his promotion!

* Stockhausen claimed that Physiology should play a major role in determining when pupils can leave school. Girls when they first begin to menstruate and boys when their bollocks drop. He claimed the way things are going it won't be long before every single pupil goes on to Higher Education and gains a Mickey Mouse degree. Nobody will leave at sixteen to become the craftsmen and women the country will need. A crisis waiting to happen. Who will do the painting and decorating, service the car, install the central heating, rewire the house, put the gas fire in, bake the bread and mend the washing machine? No one! That's who! All still at college doing fucking Media Studies or some other wet fart subject!

CHAPTER 4

Caleb sensed that something was wrong. Ever since the night of the local elections when she had come home late and acted very strange. Had never turned down a quickie before. After previous rows going back over the years it had acted like a magic wand. Casting a spell of genuine calm over domestic strife. Even adding a dash of spice. But not this time. Not even when Caleb tied a tissue on the end and tapped her on the nose with it as a token sign of peaceful surrender for the way he had behaved. She didn't want to know. In fact Kaye got extremely irate.

Caleb watches as she dances in the crowded Sunday lunch-time pub. A place they always go. Flirting and hugging with the blokes at the bar. Pretending he didn't exist. Why is she behaving like this? Ignoring him and James completely. That morning when he was straining at stool, fighting the evil constipation, his mind had turned to more pleasant things. The perfect way to celebrate his promotion and get back into their good books. Or so it seemed at the time. Now she's intent upon ruining it by humiliating him in public. Fucking bitch! Dark furrows of rage stretch across Caleb's brow. He mutters the word cunt from under his breath. Just loud enough for James to hear. He responds by downing his pint in one.

"Right I'm off. I'll see you."

Caleb surprised and a little hurt.

"Already? Why?"

"There's going to be a bloody great row. I don't want to be around."

He leaves somewhat dejectedly. Not even saying goodbye to his mother. Slinking through the crowd.

And he was right. Five pints of cider later the battling Ducks spill onto the pavement going at it hammer and tongs. Rolling over and over in the filth and squalor. Into the remains of Saturday night. Two sets of arms and legs whirling

like windmills. Each one trying to land the killer blow. Biting, scratching, kicking, spitting. Plenty of blood and snot.

A fair crowd gather to watch the sport. Kaye looks around and sees them laughing. Storms off down the street. Upset. Caleb left sitting in the gutter. Head down and heaving up. Gallons of stinking cider vomit splashing all over his Sunday shoes. He watches a worm being washed away. Surfing a wave of sick.

Hours spent wandering around the streets of Bristol. Trying to gather his wits about him and wondering how it began. A pounding drum inside his head. A birdcage mouth and red-rimmed eyes. Huge and staring out of his head. No recollection whatsoever of the day's events. Can vaguely recall that something happened. Don't ask him why he's been asleep in the park. Eventually staggering up the garden path. Four feet wide and thirty-six feet long. An Easter holiday job. One cement, one sand and three chippings to dust. Easy when you know how.

He fumbles with the key and enters. Seeks out Kaye to make a peace. Screw like they always did. But not this time. James in the front room all alone. Watching the football on the telly with a hangdog look about him.

"Where's your mother?"

"Out. She's left a note on the table."

James looks worried. The stresses and strains of being caught in the middle are proving a heavy burden to bear. Caleb shuffles through to the kitchen. Fills the kettle for a cup of coffee. Switches it on then picks up the note. His eyes fall immediately on the word sorry. He smiles to himself and assumes an apology. Soon to be proved horrendously wrong. His face first registers disbelief, then hurt, then pain in ascending order. Finally amusement to disguise all three.

"Listen to this James! You won't believe it."

"Is it my business?"

"'Course it's your business! She's your fucking mother!"

Caleb reads the letter out aloud. "I've gone to stay with my Mum for a few days. I'm confused. I want some time to sort things out. I'm sorry."

Caleb angry and unbelievably stressed. Face screwed up in anguish.

"She's confused! I'm fucking confused! What the hell's she playing at?"

Immediately on the phone to his mother-in-law's house. Granny Green Teeth as Jayne and James call her. Smells of lavender and talcum powder. Nagged her own husband into an early grave.

"Tell her I want to speak to her!"

"What about?"

"None of your goddam business! Just put her on!"

"No I won't and d'you know why?

"Why?"

"She's not here. She's gone out with a fella. And I can't say I blame her. She deserves better than you. He treats her properly. There. I wasn't supposed to tell you that."

Mini explosions go off in Caleb's brain. Out with another man! Collapses into a chair. Not even being hit over the head with a five pound Speer and Jackson could have caused more pain or grief. Another man! He can't believe it! After all he's done for her! The bitch! The treacherous fucking whore! How does Granny Green-Teeth know how he treats her? They've been discussing him behind his back! In open conversation. Caleb feels as if he's been disembowelled. Guts ripped out and on open display. Suddenly realises he's still holding the phone.

"You still there?"

"'Course I am. I've been enjoying the silence. Made you think hasn't it?"

"Listen you old hag! You tell her I'm coming over tonight! Tell her she'd better have some answers ready."

"You'll be wasting your time."

"Why?"

"Something else you didn't know. They've got a flat together. And don't ask me where 'cause I won't tell you. If you ask me she deserves a little happiness in her life."

Caleb swoons out of the chair and onto the floor. A total eclipse of his brain. Groaning. Devastated. In total shock. Kaye.

His Kaye! Has betrayed him! The one person in the world he would have trusted with his life. The rock he could depend on. Has gone and stabbed him in the back. His house. His whole future. Their whole future together. She's thrown it all away. The master plan of early retirement. Of trips around the world. The fucking bitch hasn't thought it through. Caleb concludes it's the H. R. T.! She doesn't know what she's gone and done! Wait till he gets hold of her! Him as well for that matter!

From: G. Rees B.Sc To: C. Duck
 Deputy Headmaster Head of Integrated Studies

Date: 21.4.98
Time: 8.30 a.m.

1. Please explain to the Headmaster, as soon as possible, why you failed to attend the weekend course on Stress Management.
2. Please make sure that the enclosed form is completed by you for all the children in your Department by this Friday.
3. The Headmaster has informed me he has still not received a syllabus of work for the Integrated Studies Department. Subjects covered are Maths, English, History, Design and Technology. It needs to be detailed and related to Attainment Targets and where necessary Programmes of Study in the appropriate National Curriculum documents.
4. Please give these matters your urgent attention. As you are well aware, your new position of responsibility demands the highest standards of efficiency if we are to survive the forthcoming Ofsted inspection. We cannot afford to fail it again!

G. Rees, Deputy Headmaster.

WALLISCOTE ROAD SCHOOL

PERSONAL RECORD CARD	**YEAR**		**LOWER SCHOOL**
	NAME		**TUTOR**
	TUTOR GROUP		**TEACHING GROUP**

		Mark X	COMMENT IF NECESSARY
Relationships	Manner is a distinct asset		
	General bearing good		
	Is fairly self assured		
	Manner often needs improving		
Dependability	Exceptionally reliable		
	Very dependable and helpful		
	Reasonably reliable		
	Doubts about reliability		
	Unreliable – can be a source of friction		
Initiative	Quick to seize opportunities		
	Can make own decisions		
	Quite resourceful – but prefers guidance		
	Inclined to play safe		
	Shows little initiative		
Application	Exceptionally industrious		
	A good keen worker		
	Moderately hard working		
	Not always conscientious		
	Easily distracted – lazy		
Leadership	Very capable leader		
	Good at handling others		
	Some success at getting the best out of people		
	Only slight success as a leader		
	Has not shown leadership qualities		
Appearance	Extremely neat and tidy		
	Takes good care of appearance		
	Average – usually neat and tidy		
	Fair – only usually needs improving		
	Slovenly in appearance		

	1	2	3	4	5	6	7	8
Academic								
G.C.S.E. Subject								
Anticipated Grade								

Relationships		good	average	poor		ABS/LATE	MAX.
	a) with peers				Attendance		
	b) with staff				Punctuality		
Attendance	a) School						
	b) Outside						

ANY OTHER INFORMATION

CHAPTER 5

Caleb passes Rees the Nasty Welsh Cunt's memo on to his secretary for her to deal with in her own efficient manner. In the bin. Lynda works hard. Deserves all the success in the world. Saving her money to buy her own massage parlour for an A list clientele. Caleb encourages her in her life's ambition. Gives her the opportunity to learn administrative skills, a good telephone manner and supreme self-confidence by allowing her to handle his personal business. She's been on the phone this morning to Kaye's place of work. He told her all about his domestic situation and entrusted her to discover what's going on.

"She ain't there luv. Reported in sick early this morning. If you ask me the old slag's at it again."

Lynda wise beyond her years with an inner vision that sees things clearly.

"What d'you mean, at it again?"

"Well blow job or wank this time of the morning innit!"

Caleb's heart gives a massive thump. The thought of his wife in bed with another man fiddling about with his genitalia sends shock waves trembling through his system. Good job he's got the pills to soften the blow.

He had cause last night to call out the doctor. Heart going a million miles per hour. Breath coming in short sharp pants. He thought he was going to die. A heart attack or something. The good doctor didn't ask him too many questions. Prescribed more Beta-blockers and Lorazepam. Slow-me-downs and antidepressants. Lactulose too to get things moving. Still hasn't been. The tops of his thighs and around the back are beginning to swell and harden. Over two weeks now and rather worrying. The doctor said it was all stress related. Told him to try and relax.

Considering all the confusion in his life Caleb is amazed how well he feels. Apart from the constipation. Strong as an ox. Sound of body and mind. Errol's muscle building tablets are working wonders and when swigged down with a

morning coffee he's ready to meet the challenge of the day ahead. A brandy slipped in helps generate more pace.

His forehand's working well this morning. Blinding flashes of near perfection dazzle his opponent Hubcap Kelly. (C.A. 15.9. R.A. 8.4). The bat he's using is a brand new Ladybird book with the back cover ripped off to give the correct balance. The first thing he did after the Nice Welsh Cunt made him Head of Department was to go out and buy a new set. All about Sir Francis Drake. They were desperately needed. Most of the boys have followed his example although some find it easier with the cover left on. It gives added weight to their stroke play. Backhand top spin, forehand loops, defensive chops. They're all there this morning and not many can beat him when he's in this mood. He spies the new boy Gary Greenwood lurking in the background. On his own and acting hard. Waiting for his moment. Caleb will wait until he makes a slip of the tongue and says something out of place. Then he'll show him who's the boss. Discover the real reason why he's here.

Anyone entering the I.S. Department now would be shocked at what they see. Apparent chaos and total disorder. No resemblance at all to a place of learning. Only one adult in the building and judging by his bizarre dress and outrageous behaviour he obviously doesn't belong. Uses obscene language and spits on the floor. Wears highly polished boots and riding breeches with the red stripe down the side like the Mounted Police. The scarlet topcoat of a Grenadier Guard with brass buttons and medals all bright and shiny. Now Caleb's been made Commander-In-Chief he's decided to lead by example. Ask nothing of his men he wouldn't be prepared to do himself. The Third Level of Awareness.*

* Stockhausen claimed that there were seven Levels of Awareness to achieve before one reached Enlightenment. He said as Man grew wiser he ascended onto higher spiritual planes. Each plane or level becoming increasingly more difficult to reach. Each had its own absolute truth and beauty which Man had to fully digest and understand before he could progress to a higher level. Stockhausen said Man rarely progressed beyond Level 3 because Gluttony, Ambition, Slothfulness and Family Commitments were major obstacles to overcome. He also stated that the secret of spiritual elevation lay in the use of steam. Caleb never understood what he meant by that.

The other teachers haven't arrived. Andy rang up and told him he still felt poorly and would probably go to Weston for a breath of fresh air. But he did say he was sorry. No sign yet of Jan Scott or Lyn Jones the self-styled Bloke/Girl of the school. She's probably still working out on the weights. Developing her triceps and latissimus dorsi. As well as a neat moustache. Far too early for either of them. It's still only 10.00 a.m.

A few of the pupils are missing as well. A group of smokers in the toilets but that doesn't bother Caleb. Coppernob will be in there having his morning wank and Backwheel's up in court this morning charged with stealing bikes. Or more to the point just their rear wheels. Gears included of course. More money in that and far less risk. Caleb gave him an excellent reference in return for a twenty speed job. No flash rubbish. That was the deal.

But for the children who have marked themselves present in the register there's a whole raft of subjects on offer today. All related to the National Curriculum with it's Programmes of Study and Attainment Targets. Besides all the table tennis that's going on Caleb has two rival Musical Societies on the go. Each trying to capture the pupils' sense of beat. John Irving has no support for his classical approach. It's strictly for the connoisseur. A pity. But Yellowhead has no such problem. Explores new depths of drum 'n bass. Massive. He's gathered a wicked posse around him man and secretly deals smack to feed his habit. Earn a bob or two. Caleb doesn't see it going on but knows the trade exists. Decides to let the young blade carry on. It would be more than his life's worth to interfere. Yellowhead is a heavy dude and as long as it keeps them happy.

Most of the other kids have become self-taught. A small group of Indian girls colour in the pages of the Yellow Pages. Using their own felt tip pens and biros. Some of the boys are finding it quite a challenge to complete a word search puzzle devised by Caleb. He's deliberately left out one of the words and offered a ten pound prize to the one who finds it. Try as they might they can't!

Caleb is proud to be in charge of all these children. He

knows they're looking to him to champion their cause. Show them the good things in life their stunted backgrounds prevent them from seeing. Break the cycle of deprivation and allow them to taste the riches of a more privileged world. And why the fuck shouldn't they? Why should the likes of James and his mates have it all on a silver plate! Bollocks!

When greatness comes to the chosen few it comes in a mini-second of the micro-moment. A spark to ignite a century. Like Jesus, Elvis or Mohammed Ali. John Selwyn Gummer if push comes to shove. And thus it was with Caleb. He looks at the clock. It shows 10.05 a.m. Nothing unusual in that, but the potent mix of drugs he's taken, illegal and prescribed, together with the prunes and all the stress causes a rare chemical reaction to take place in his brain. The lights in the hall begin to flicker and fade and a darkness begins to set in. An icy blast sweeps through the building and all activities come to a halt. Pupils frozen in time and space. In the distance thunder rolls and lightening cracks across the sky. Even the mighty Yellowhead is silenced. A miracle about to unfold. Caleb stands transfixed by the power of it all. Overwhelmed by the forces of good. An angelic chorus wells up from the Heavens. Softly at first but with gathering crescendo. A voice rich and deep with authority booms out.

"Caleb, you are the one I have chosen to lead my children! Take them out of this shit hole back to the Land of Plenty! Teach them the standards of the Elders! How to read and write and chant tables on a chair! Do this service for me Caleb and you will be well rewarded!"

Caleb is in a state of shock. Squeezes his head to ease the pain and try to restore his vision. Slowly, very slowly a warmth revives him. The hurt dissolves into a heavenly peace. His face shines bright in understanding. Glows in the joy of this precious knowledge. That the Almighty Himself has given his blessing. Chosen him above everyone else on Earth to enrich the lives of the children he teaches. Make them masters and mistresses of their own destiny! My how proud he feels!

And then it was over. Gone in a flash. As if by magic the lights in the Hall return and the children continue with what

they were doing. Blissfully unaware of the visitation and the fact they've been in the presence of the Lord. Such is the power of the Almighty He has erased the Event from their minds.

The experience has an alarming effect on Caleb's brain. Fantasy becomes reality. How selfish he was just to consider himself and plan a solitary escape by June 13th. Fuck the year 2000! Millennium retirement no longer viable now Kaye has joined the enemy camp. He makes a momentous decision. They'll all go now. The whole fucking Department! All eighty-one of them. Do it for real. Children of all races, creeds and colours led by Caleb the Good! The banner of manners and literacy will fly high again over every city in the land. Rallying supporters to the ranks of the Council Taxpayers Liberation Army.

Caleb abandons his game of table tennis and calls Errol over to his side. Now he knows it's going to be a mass escape he'll need financial support. Forged passports and uniforms will cost a fortune but are needed to get them past the station guards.

"Look Errol I want the truth. How much do you make on your insurance policies every week?"

Looks very handsome this morning in a red Armani jacket and matching hand-stitched trousers. A rose in his buttonhole and snakeskin shoes. Expensive aftershave.

"You want the true figure sir or the one I give the taxman?"

"The true figure Errol. You and me have got a big job coming up and we're going to need all the money we can get."

"Not my money?"

"Yeah. Yours as well. Come on, how much?"

Errol doesn't want to divulge his earnings. He sees a client coming into the hall and makes that his excuse to leave.

"I gotta go for a minute sir. That kid ain't paid me for last week yet. I gotta tell him I can't guarantee his safety in school no more!"

Errol makes to walk away ignoring Caleb's request. Hoping to escape. Caleb grabs him by the throat. Pushes him back against the wall. A stressful situation.

"Look Errol, I ain't kidding. I asked you a question and I want a fucking answer! Okay? How much do you get a week?"

Errol's more worried about his coat.

"Okay! Okay! Cool it man! Mind my fucking jacket! Let go and I'll tell you!"

Caleb loosens his grip but stands menacingly close. In case he decides to make a run for it.

"If no one bin away and they all pay up proper I get about fifty quid. Okay!"

Caleb laughs. Decides to give him the benefit of the doubt.

"Yeah okay Errol I believe you but from now on it's mine okay!"

Errol takes a headfit. Screams at the top of his voice.

"What the fuck you on about man? No way!"

"Listen Errol, this is the big one! We're all getting out of this dump once and for all and you're going to be my second in command!"

He shakes his head. Still in the dark.

"You've fucking lost me now man!"

Caleb triumphant. Speaks with tongues.

"We're going home lad! Back to Blighty!"

Caleb has no time to go into all the details. Speed is of the essence.

"From now on all money goes into the C.T.L.A. Escape Committee Fund. Mash up the keeners in the Main Block if you have to! All I want is their taxes!"

"You're a wicked man sir. Teaching us bad ways."

"I've had the word Errol. It's up to me to do something about it. The end justifies the means."

Caleb watches as Errol goes about his redefined duties. Allows his glazed eyes to wonder around the hall. Notices Yvonne Campbell sitting alone in the corner. (C.A. 16.1. R.A. 9.4). Very downcast and miserable. She ignores his friendly greeting.

"Come on Yvonne. Don't give me the brushoff. If you're going to be my wife you've got to learn to be civil. What happens if we're invited out to dinner? Is it boyfriend trouble?"

She takes that as her cue to flip completely. Leaps to her feet in a wild fit of rage and hurls a stream of vile abuse.

"Don't speak to me you fucking white cunt! What business it yours pork-man!"

Caleb breathes out a heavy sigh. A mist descends again. Not going to be spoken to like that. By her or anyone else. Rushes in to grab her by the hair and drags her screaming from the hall. Nobody takes any notice. It's normal behaviour from this ranting looney. Something deep inside is wrong with her head but previous Tory cutbacks prevent a residential cure. Only John Irving reacts. Turns his music up. Mars God of War blasts his trumpets conjuring up an atmosphere of violent intent. Yellowhead rises to the challenge. He gives John Irving the thousand yard stare. Lights up a spliff and flicks a switch and the bass bins boom into overdrive. Mars is nowhere to be seen or heard. Fucked off home and who can blame him. Caleb tugs this unhinged demon along. Past the choking atmosphere outside the boy's toilets and hurls her down the stairs. Her screams bring the smokers out of the toilet to complain about the noise.

"Sorry boys. Didn't mean to disturb you. I know how much you value your morning smoke."

Craig Vincent decides to give him the benefit of the doubt. (C.A. 15.9 R.A. 6.3).

"That's alright then mate! Don't let it happen again or else I'll have to do something about it."

He glares at Caleb menacingly. Banging his fist into the palm of his hand. Caleb knows he's only play-acting. It gives kids like Vincent an outlet. But not this morning. Not in the mood. He turns on the youth and gives him a slap. Watches as he crashes to the floor then wades in with boot and fist. In the distance a warning cry. Telling him to cool it. It penetrates the swirling red mists and manifests itself in a damp wet patch running down the inside leg. Caleb takes a backward step. Sees Vincent scramble towards the safety of the toilets. That's no man's land in there. A place he never ventures. It stinks too much and a message on the wall disturbs him deeply. Says "Caleb is a count!".

He contemplates his morning so far. Still only half past ten. What a way to earn a living! Fighting girls who spit in his face

and boys who give him cheek. Surrounded all the time by this continual din. The Mighty Yellowhead now reaching a climax. Keeping pace with his own thumping heart. Adrenalin surging through the body systems causing a deadly build up of lactic acid. The bringer of heart disease. No way can he stand two more years of this! Now he's had the call he's out of here. Sooner said than done.

Kowalski the skinhead comes running out of the dart room. A dart sticking out of his shaven head. (C.A. 16.0 R.A. 10.2). Bellows.

"Look what that cunt Shearn did to I!"

Points to the offending arrow. Caleb springs into action again. Pressure unrelenting. Pulls the dart out of Kowalski's head and tells him to put his finger on the hole to stop his brains from escaping. Charges into the dart room to give Shearn a good hiding. Jesus! What a stink! He feels like throwing up. Shitty Shearn he's always been because he fills his pants. Just like he has done now.

"Okay Shearn, why did you do it?"

But Kowalski has already taken revenge. Left Shitty lying in a pool of blood. Heaving his guts up on the floor. A pitiful sight in his ragged clothes. Trousers all torn and many sizes too big. A shirt that once must have been his Mother's blouse.

"Come on Dale, stop putting it on. Tell me where he hit you."

The hand on the shoulder sparks him off again. Starts vomiting green and yellow stuff. Caleb spins on Kowalski in a rage.

"You stupid bastard, you could have killed him!"

"Fucking deserves it! Mad fucking cunt!"

"You stay there! I'll deal with you later! Bogey, go and get the nurse!"

Bogey Greenham rushes off as fast as he can. The slimy evergreen that gives him his name in full bloom at the end of his nose. Kowalski begrudgingly fetches a bucket of sand and Roger Pater another gang member volunteers to collect a mop and shovel. (C.A. 16.2 R.A. 5.1). For some unknown flawed-gene reason Pater loves getting stuck into the really

dirty jobs. They attract him like a magnet. The in-house expert on bodily waste. Whether excreted, vomited, picked from nostril, ear or sphincter, blown, sucked, wiped, snorted then spat or simply self-produced by enthusiastic rubbing. Pater is your man. He rushes to collect the tools of his trade.

Caleb wants everyone out of the room but some seem reluctant to move. He picks up a chair and hurls it at them. Becoming emotionally involved again.

"Get out you sickos! When I say leave you fucking well leave!"

The dart players rush to escape the wrath of Caleb. They charge into John Irving's end of the hall to the magnificent strains of the 1812 Overture. Still in full flow but losing the battle. It's moments like this when he's at his best. Conducting like a man possessed. Russian cannons booming forth. Hurling their defiance at the approaching foe. Agonising screams from the wounded Shearn add genuine pathos to the scene. The stink of war drifting up from his trousers.

Caleb's head continues to spin. Like a wheel within a wheel. Never ending like a circle. Up and down and over. The events of the morning are taking their toll. The cocktail of pills and booze he's taken don't seem to be having the desired effect. Making matters worse or wearing off? He can't really tell. Whichever way he feels like shit. Everyone shouting and screaming at the top of their voices. Their normal means of communication.

Caleb drawn like a magnet towards the loudest sounds. The earsplitting, gut wrenching thump of bass. He's appointed Yellowhead Master in Charge of Music and he's doing a brilliant job. At least fifty in his movement group. All glassy-eyed and out of it. They twist and contort themselves in jerky fashion. Drowning in the sea of sound. Yellowhead himself the ultimate DJ. A Jamaican albino with long yellow locks. Two feet below his shoulders. With headset and shades he looks the part. Cool and threatening which he is. Nobody fucks with him. Caleb moves amongst the dancers. Medals dangling and clanging together. Arse sticking out and elbows flapping. Clucking noises at the back of his throat. He looks

for all the world like a giant chicken as he forces a way through to the speakers. Now his head is back and howling. A primitive noise from the dawn of Mankind. When fire kept dinosaurs from the cave.

The music has control of Caleb's body. Sending him into a trance-like state. In times of stress he gets like this so it's nothing new to the kids. They stop and enjoy the free entertainment. Mainlining on pure unadulterated sounds and other dubious substances. Yellowhead sends the decibels higher. The walls of the building begin to shake and a pane of glass comes tumbling out. The black girls begin to laugh at Caleb and mock him in a good-natured way.

"Mr Duck, you're gone in the head man! You're mad you know!"

Caleb stops dancing and pleads with them. At last someone has spotted what's wrong. He shouts in their ears to make himself heard.

"I know! I know! I want someone to help me! Why don't you write to your M.P. and complain? Can't you see I'm sick?"

Caleb starts spinning around on one leg. Rotational speed getting faster and faster. Now the other leg in the opposite direction. Faster still yet faster! He tries to tie himself into a knot using all his arms and legs. Fails in spectacular fashion. Stumbles and crashes in a heap to the floor. Lies there and watches the world go by. Garage acid trash booms out. Repetitive and soporific. Thumping in his ears. He closes his eyes and goes to sleep. Gentle as a lamb.

CHAPTER 6

It was the newly promoted Sergeant Perkins who came to Caleb's rescue. Picked him up and carried him off. Back to the safety of his office where he was resuscitated by Lynda and cups of coffee. Lynda has to leave and makes her apologies.

"I'm off now luv. Work experience. See you tomorrow."

Caleb thanks her for being so helpful. He and Errol left on their own. His Second-in-Command sounds all conspiratorial. Turns around and locks the door.

"Listen man no need to let tings get on top of you. I got the answer to all your problems."

Caleb is astounded by his specialist knowledge. Errol the expert when it comes to drugs. His personal physician.

"What's it this time then Errol?"

He produces a tobacco tin. Takes out a tiny diamond-shaped purple tablet. Offers it across.

"Roofies. One of these and you forget everything man. Total wipeout guaranteed."

Caleb with his judgement already irreparably damaged takes up the challenge with a grin. Wants to obliterate the horror of the morning. Swallows two down with a glass of water and waits to see what happens.

"They're ten times stronger than valium man. Fucking brilliant!"

Caleb has no option but to believe him. Then duty calls again. Upstairs once more to keep an eye on things. Just about to return to Yellowhead's music when he spots Margaret Baxter at the back of the hall. Not joining in with all the fun. Clutching the side of her face in obvious pain. He moves across to investigate.

"What's the matter then Margaret? Somebody hit you?"

Only too pleased to reveal what happened.

"My mammy burnt me sir. I got home late."

"Let me have a look."

He takes hold of her wrist and pulls it away from her cheek.

"Jesus! What time d'you get in for Christ's sake?"

"Half past four sir."

"No wonder she was angry then. Half past four is late!"

Margaret gives a little laugh. Eyelashes blink their protest.

"Not half past four in the morning sir. Half past four in the afternoon! She beat me with a brush and made me do all the cleaning and washing sir. Then she picks up the iron and puts it in my face."

A sickly feeling creeping into Caleb's stomach. The frustration of it all. Spends all his time teaching them respect for their elders, sociability, good manners and kindness to animals and then this happens to them! What chance have they got? How could any mother do that to a child? Especially one so pretty, loving and polite. Always willing to do anything for you. Caleb was going to ask her to marry him but he can't now she's been disfigured.

"Listen Margaret. The wedding's off. Don't worry my love. You'll find someone else. Not as good-looking I know, but younger."

She looks at Caleb with fear in her eyes. Tightly clutches hold of his arms at the elbow.

"Please don't tell my mammy I told you Mr Duck else she'll beat me again."

"I won't do that Margaret. I promise."

Caleb storms down to Office H.Q. Upset and angry. Brain filling up with cotton wool. A slight wobble of the legs. Fuzzy. Passes Bloke/Girl Jones and Jan Scott on their way up to the Hall. Just arrived sipping cups of coffee. Think they deserve it after the morning they've had! Idle fucks! He tries to ignore the pair of them but Bloke/Girl decides to be more sociable. A hail and hearty manly greeting. He spins on her angry and aggressive, fully prepared to give her a piece of his mind. Making him do all the fucking work! Halts when he beholds the size of her forearms. The bulging biceps in her Persil white shirt. Nicely set off by the black Moss Bros waistcoat buckled neatly behind her back. Decides discretion is the better part of valour. No point in tangling with the Bloke/Girl now. He rushes past them on a mission. Desperate to phone the E.W.O.

to tell her of the plight of Margaret and how Social Services ought to be involved. A girl's life is in danger for Christ's sake!

The sweet gentle voice of Angela White on the other end of the line. Soft and soothing and trying to calm him down.

"I'm sorry Caleb. There's nothing I can do about it today I'm afraid. Later on this week maybe?"

"Soon as you can then Angela. The media would have a field day if they ever found Margaret's charred remains."

Caleb's exaggerating the enormity of the crime. It wasn't a serious mark on Margaret's face but he had to show concern. Give her a little love and tenderness. Sadly lacking in her life. Make her feel important. No, the real reason he was on the phone to the E.W.O. was because he wanted to speak to Angela again. A woman on his wavelength. She shares an affinity with the kids in his care and like him she wants them to succeed. Those extremely rare qualities combined with film star looks make her someone he can turn to in troubled times. Give him a shoulder to cry on. Like she has before.

In his befuddled chemically bemused state it's easy for Caleb to imagine the affair. All the passion and daring of the French Resistance sends his brain reeling off course again. Craving for the love of a beautiful woman now that Kaye has left him. Enormous self-pity building up.

He sits down in H.Q. and takes things easy. Beginning to enjoy the benefits of Errol's tobacco tin. Away from the din upstairs. He decides to let Jan and Bloke/Girl do a bit. Take the pressure off. This is how it goes in the I.S. Department. A day of fits and starts. All action one minute and calm the next. Enough to send him round the twist!

A bell rings loud throughout the building. Signifying break. Not that that means anything in I.S. It's one long break in there. But it's time to sell the crisps. The profit from the tuck shop takes on a new meaning. No longer to be used to subsidise his income. The money can be put to a finer cause. Help him with the Great Escape. Buy vital classroom resources. Into the hall to set up shop. Beef, chicken and cheese and onion. An urgency about his movements. No time for any nonsense. Jan and the Bloke/Girl have already fled.

Over to the Main Block staffroom to tell of the terrible morning they've had!

"Greenwood, move that table away from the door!"

The boy from Greenhill Comprehensive glares at him with utter contempt. A definite leer on his lips.

"Fuck off! Do it yerself! Lazy cunt!"

Caleb doesn't take that from anyone. Gross insubordination. The bugle charge alert. He rushes headlong at the surly Greenwood whose aggressive stance shows he doesn't give a toss. He ain't scared of any fucking teacher. Especially one who's dressed like a prat. His mother's boyfriend is shit scared of him and down the Rovers he's feared and respected. Kicking the guts out of rival supporters with the big Doc Martens he's wearing now. Laughing whilst he does it. But not now. The bloodcurdling yell that Caleb gives has driven the colour from his cheeks. The first biff catches him on the side of the head and sends him spinning into the lockers. A great clatter of noise arises from his landing causing all activity in the hall to cease. It's always the same when a new boy arrives and wants to prove himself to the other bulls. He has this primitive instinct to mark out the boundaries. Establish his place in the pecking order. Greenwood bellows his protest and accepts the challenge. Testosterone rising fast.

"You cunt! I'll fuckin' kill you now!"

Caleb hoists a table tennis table above his head and hurls it across at Master Gary. Follows it up with a couple of chairs and the rallying cry of John of Gaunt.

"You mean you'll fucking try you wanker!"

Caleb goes berserk. Into his body with flailing fists. Left, right and right again. A knee in his groin for the pleasure it brings and a fist in his face that cracks his nose. The claret flows strongly from his sniffer. An arm locked tight around his neck he drags this arrogant youth through the hall. Downstairs to Butlinland. Caleb locks the door. Draws the curtains on the windows to leave the room in semidarkness. He grabs hold of Greenwood's long blond hair and twists his head back hard against the joint.

"Now listen Greenwood you lowlife scumbag! This is

58

Butlinland! What goes on in here is between you and me. No witnesses you understand!"

Vicious slaps across his face. Stinging the colour back into the cheeks and starting the blood to flow again. Greenwood cracks. Huge sobs gush up from deep within. Instinct tells Caleb the time is right to get down to serious business.

He goes across to his desk and takes out a hunting knife. Confiscated from one of the boys. Fondles the blade in front of Greenwood allowing the edge to pass close to his throat.

"Look Gary I want to be your friend. I want everyone in this building to be happy together. Happy, happy, happy. Bells ringing and dicky birds singing. Understand what I'm saying?"

His cracked bruised lips move slowly apart as he makes a brave effort to speak. The sound never comes out.

"I've got plans see Gary. I've been chosen for the football team. Captain. And I think you've been sent here by certain people shall we say, to find out what my plans are. Am I right?"

The point of the dagger is thrust nearer his windpipe. Greenwood tosses his head back to escape the danger. Arms dangling by his side in total submission and pleading cries of mercy find their strangled way out.

"Oh God, no! Please. Please, oh God. Please no. Help me please!"

Caleb with his eyes ablaze. The strength of the British Empire behind him. The justification of this brutal behaviour lies in the fact that it's a Christian cause.

"Tell me the truth Gary and I'll let you go. Have you been sent to spy on me?"

Greenwood's words are barely audible.

"No! No! On my mother's grave!"

Caleb takes the knife away. Decides to give him the benefit of the doubt.

"Okay. I'm not going to kill you. But you've got to prove you're loyal to the cause. You prepared to do that?"

Young Gary is only too pleased. Laughs joyously between the sobs. Pitiful looks of admiration at the man who gave him the chance to live.

"I'll do anything you say sir."

"That's better. That's the spirit. Cigarette?"

"Yes please sir."

Caleb tosses him the packet he keeps in his desk.

Greenwood accepts them gratefully. Searches his pockets for a match. Caleb throws him a box.

"Now I'm going to write out your I. E. P."

"What's that sir?"

"Individual Educational Plan. You know the boy's toilet upstairs Gary, don't you?"

"Yes sir."

"Well the bit you stand on when you have a piss and the bit you piss against are made of lead. Did you know that Gary?"

His trembling fingers try to light the fag.

"No sir. I didn't sir."

"But you know there's a war against ignorance going on. Modern teaching methods. We need money to buy resource materials. Overhead projectors, flip charts and magic markers."

Greenwood doesn't bat an eyelid. Suffering from severe concussion.

"I want you to rip that lead out and take it down the scrap yard then bring the money back to me. Do you think you could manage that? You have a time scale of twenty-four hours?"

"Yes sir. Of course sir. That's easy sir."

"Good. Well done lad. Here's the key to the toilet. Don't let anyone see you do it."

"Thank you sir. Shall I go now sir?"

"No. I want you to write out a Home-School contract for me first. Like a sort of confession."

Caleb moves across to his desk and collects some A4 paper. He tells Greenwood to sit down and copy what he says. Only too pleased to do it.

Walliscote Road School
21.4.98

Whoever finds this note must understand the reasons why I

topped myself. I can't take the pressure any more. Saddam Hussein is a fucking madman. He wants to kill us all with his germs. I haven't the courage to wait for that end. Please contact Mr Duck at school and tell him I am very sorry. He above everyone else tried to give me a reason to live. I am sorry I have failed him so miserably. He is a truly grate man and a wonderful human bean. Kind and generous to a turd.

Signed: Gary Greenwood.

Two hours later when Greenwood stops printing. Large capital letters that don't join up. Caleb pats him benevolently on the head then signs his part of the deal.

"You see Gary, one word to anyone about our little meeting here and I'm going to string you up from a branch of a tree. Understand what I'm saying?"

Caleb waves the blade of the dagger in front of Greenwood's face. He shuts his eyes in horror.

"Yes sir. Understand sir."

"Of course you do. Now fuck off and go about your business. And good luck Gary. All the best. Review date first thing tomorrow morning."

Greenwood rises slowly from the chair and staggers towards the door. Legs giving way from under him. Caleb supports him by the arm, turns the key in the lock and opens the door. Allows Greenwood to go through first.

"Thank you sir. Thank you very much."

Caleb sits at his desk for a well deserved break. Files the Home-School contract away. Probes his left nostril with his little finger searching enthusiastically for today's date. A bit of a fight going on in there. Grandfather Bogey wants to stay put. He laughs when he thinks about the anonymous phone calls he's just made to W.C. 's Williams and Rees. Called them both a couple of bent ignorant bastards who'd never get him to grass on his men. No way.

As his struggle with the gobby continues Caleb happens to glance onto the sportsfield below. Spies a fair-haired youth struggling with something very heavy tightly wrapped up in a

coat. Caleb gives a whoop of triumph. Causing his nail to bite deep into the soft nasal tissue and a drop of blood to trickle down. No worries. Greenwood's in his gang! Long live King George! And up the Gas! Already the memory is beginning to fade.

CHAPTER 7

Caleb is settling into a familiar routine. Spending his nights in Butlinland so no time is wasted in planning the big escape. No point in going home. It's empty. So after a hard day fighting his war on ignorance he settles for a gentle workout with Rosie. Then it's back to I.S. for beans on toast followed by pills of various shapes and sizes washed down with a couple of stiff ones. Anything to help him forget.

He's getting into the habit of eating lots of satsumas to try and get his bowels moving. Still no news in that direction. He hopes to Christ he doesn't end up like Elvis with half a ton of clay up his arse! Lactulose is a slow moving agent but guaranteed to work. So his doctor had told him.

Lynda hands him the phone.

"It's a Mrs Greenwood luv. Gary's mum."

Lynda pulls a worried face. They all saw him yesterday after Caleb had finished. Reckoned he was lucky to be alive. Caleb doesn't know what all the fuss is about. Can't remember a single thing. Not even the name of the tablets he took. A great cheerfulness about him.

"Good morning Mrs Greenwood! How are you today? Trust you're keeping fit and well!"

Far from having a go at him Mrs Greenwood starts singing Mr Duck's praises. Thanks him for saving her son Gary from being beaten up by a gang of City supporters. Brave of him to go in like that. Could easily have been killed. She'd never seen Gary quite so quiet. Best school he's ever been to he said.

"And he's been to a lot Mr Duck I can tell you. He even offered to help around the house and do my shopping for me. Spoke of saving up and buying a flat abroad. Wants to live in Spain for some strange reason."

"Maybe he likes the sun?"

"No it ain't that. He's got sensitive skin. Anyway. Thank you for making him feel so welcome. He thinks you're brilliant. I wish you'd been his teacher at the last school."

"Only doing my job Mrs Greenwood. It's a pleasure, believe you me."

Before putting the phone down Caleb makes a point of mentioning School Fund Contributions. Nothing's for free these days. New Labour – New rip-off. Just twenty pounds a term. Chicken feed when compared to the private sector.

"He'll bring it with him tomorrow morning Mr Duck. How d'you want it, cash or cheque?"

"Cash will do nicely and many thanks."

He puts the phone down and grins at Lynda. She's been listening in on the conversation. Looks of admiration in his direction.

"I thought you handled that brilliantly luv. Twenty quid! Blimey! I could give you one of my specials for that!"

There's a glint in her eye as she says it. Caleb spots it at once. Knows she's coming on to him. His heart rate begins to quicken. A stirring deep in his loins. Now that Kaye is out of the picture there's no reason why he shouldn't. Can't believe it's him that's speaking.

"What's a special?"

"I'll show you if you like."

"What here?"

"Why not? You're not the sort who comes to the parlour."

"Too true. I'm not."

"Well? D'you want me to or not?"

Caleb's heart leaps up into the back of his throat. The very thought of it makes him feel giddy. The room begins to spin around. Then comes to a sudden stop. Mouth goes dry. It's not him that answers.

"Go on then. Let's see you at work?"

He watches wide-eyed and innocent as Lynda walks across the room to lock the office door. Turns to face him with a sultry look. Pulls her jumper over her head with all the aplomb of a catwalk model. Caleb's eyes bulging out of his head. Alarm bells ringing in his ears as he wrestles with his conscience. She's over sixteen! She's a summer leaver! It's not against the law. Unhooks her bra and lets it drop to the floor.

Revealing the most beautiful breasts he's ever seen. Large, full-rounded and upturned.

"What d'you reckon then Mr Duck? D'you want to have a go on these?"

Caleb can't speak. The words won't come out. Just nods his head slowly up and down. She glides in warm and stealthily and eases them gently into his face. Uses her hands to move them around. Rubbing lips, nose, mouth and eyes with her beautiful satin skin. Nipples diamond hard. Caleb greedily tugs them into his mouth and sucks to make them riper. Gently bites for the pleasure it gives.

"Jesus Lynda! What are you doing to me?"

"Relax luv. You deserve it after what's happened to you."

Caleb can't believe that one so young can be so under-standing. How does she know what he really needs? It's uncanny. He feels his passion rising. Breathing coming in short quick gasps. She levers him onto his feet. Seeks out the buckle of the Mountain Police breeches and unhooks it with a flick. Pulls them down below the knees. Now her fingers feel out his groin. Slowly at first to gauge the length.

"Umm! Nice one luv. Ready for lift off?"

Mouth dry and unable to answer. She guides him back into the chair. Down on her knees between his legs and pops it into her mouth. Clouds of comfort swoon over his head. Reeling in the magic they bring. Eyes shut tight and hands grasping her hair. Guiding her head slowly up and down. To get the right speed. Slowly up and down. Up and down. Her hand on his balls for added effect. Now she's reaching for the baby oil. Lets it trickle before rubbing well in. Pours a little into her cleavage. She knows from experience it won't be long.

"Come on then luv. Let's see what you're made of."

Caleb knows the dream is nearing completion. Fights to hold it back. Staying in the Land of Milk and Honey for as long as he is able. Enfolds her head with both arms around it and gently rocks her back and forth. The rocket is about to take off. Slowly at first without any warning but then with a scream Caleb explodes. Boom! Boom! Into orbit. Out into

hyperspace. Caleb continues squealing like a wounded animal. Writhing and thrashing about. Frightening to the untutored ear. Holy Shit! He can't take much more! Too much to ask of any man. A blackness coming up over the horizon. The room begins turning upside down. Meeting stars and planets on the way then a total darkness. Oblivion.

"Are you alright luv?"

Caleb twitching on the floor puffing and panting. Sucking precious oxygen into his lungs. Slowly coming back down to earth. Lynda crouching low beside him with an extremely worried look on her face.

"Mr Duck are you okay?"

Somehow he manages to mutter yes and staggers to his feet. But his legs aren't strong enough to take the weight. Collapses again into the easy chair.

"Jesus Lynda! What d'you do to me?"

"A Frontline Special. That's twenty quid you owes me."

Caleb blinks hard to get his bearings. In a trance-like state. Watches as Lynda cleans herself up unable to say a word.

"You 'ad me worried back there for a moment luv. I thought you'd gone and snuffed it!"

Caleb smiles to himself a secret smile. Of utter peace and contentment. Now he knows for sure she'll be very successful. Go all the way to the top. Lynda makes her excuses and leaves in a hurry. Got to be at work by twelve o'clock. An important client coming in.★

Caleb left alone to ponder in silence. Quietly gather his senses together. Breathing and heart rate nearly back to normal. Able to plan the day ahead. It's been a long time since he felt so focussed. It was as if the Frontline Special had cleared his head of all the shit. Now crystal clear like a mountain pool.

★ When called to give evidence at the Public Enquiry into Walliscote School Lynda Coles denied she'd ever had a sexual encounter with Mr Duck on school premises. Asked what she'd done for a living since leaving school Ms Jones replied, 'I present myself as a commodity allotment within a business doctrine'. The Judge was suitably impressed. Told her well done and wished her all the best. Said he wished more young people of her generation displayed her kind of initiative and determination to succeed. Asked her for her card.

He reasons that if he is to be respected as a figure of authority he must have a Morning Assembly. A ritual unheard of in this comprehensive age. Mr Nice and Mr Nasty never had the bottle to come across and talk to the headbangers in I.S. The kids would have told them to go away. In no uncertain terms.

So Errol puts the word out to attend morning parade. It's vital they hear what sir's got to say. Top of the list Caleb puts respect for each other. Bullying and stealing are out. No more swearing. It's not clever and it's not very nice. Great importance will be paid to personal hygiene. Pupils must take pride in their appearance. Good manners too take a top priority. Good manners cost nothing so there's no excuse. And last but not least no more sexual harassment. Girls and boys treated with equal respect.

Every pupil arrives in the hall to listen. Excellent! More like it! Errol has got them into straight lines. Not side to side like normal schools but from the back of the hall to the front. He's even gone one step further than that. He's put them in order of size. Tallest at the back and shortest at the front. Delroy Wong the six-foot seven Chinese-Jamaican stands proudly at the rear. Little Alison Long is the other extreme. Only three-foot eleven and right at the front. Her special needs identified by Caleb. Concluded she needs a bigger chair.

The Head of I.S. asks for silence but nobody takes any notice. He looks to Errol for assistance who knows exactly what to do. Leaps onto one of the table tennis tables and yells above the noise.

"Fucking shut up the lot of you! Listen to what the man say!"

Errol flashes a fierce look around the hall. His right hand delves swiftly into the jacket pocket of the white silk coat he's wearing today. They all know what he keeps in there. The hall goes deathly quiet. Immediate respect.

"The boys and girls are ready to listen to you now Mr Duck."

"Thank you Errol. That was most impressive."

Caleb doesn't hang about. Goes straight into the story of the Sisal Plant. One he had prepared.

"So the missionaries in South America saw these Sisal plants growing in terrible conditions. On parched almost desert land. Hardly any water. But the amazing thing was the quality of hemp these plants produced. From the hemp the natives made the strongest rope the missionaries had ever seen. Not only strong but amazingly pliable. They couldn't fucking believe it! So what did they do? They took some of the plants back to Florida with them. They figured in ideal growing conditions, lots of water and good fertile soil the sisal plants would grow even bigger! So that's what they did. Grew the biggest fucking sisal plants the world had ever seen! But! And this is the point. No fucking use at all! The hemp was crap! Too soft and pulpy to make a bit of string let alone a long stout rope!"

Caleb looks at the pupils gathered before him. Never before in senior school had they been addressed like this. Sees they're hanging onto his every word. Listening spellbound to the story. It's reminding them all of Sunday school.

"So you're all wondering what the fuck I'm on about. Yes? What's that crazy old bastard trying to tell us this morning?"

Yellowhead heckles from the back of the hall. Angry he's been told to turn his speakers off.

"Yeah man. So what the fuck you on about? What's so fucking good about that?"

Caleb flashes a look towards Sergeant Perkins who sucks his teeth at this rude intervention. He hasn't yet explained to Yellowhead what rules apply over here.

"I'll tell you what the fucking point is Yellowhead! The point is you're like one of those sisal plants!"

This infuriates him even more. Insulted in front of his posse.

"Fuck off! I ain't no fucking sisal plant man!"

"Yes you are! And so am I! So is everyone else in this hall. We're all like the sisal plant and I'll tell you why!"

"Yeah! Fucking tell me man! I'm interested to know!"

"Because if we have to struggle for the good things in life we'll all be better off for it! Tough living conditions make us stronger characters! Right?"

Errol, God bless him sees the message clearly. Rejoices aloud at Caleb's words of wisdom.

"Right on Mr Duck! You tell 'em man!"

Unbelievably the rest join in. Loud choruses of 'Amen' and 'Praise the Lord!' echo around the hall. Caleb is moved to tears. He winds them up now he's got them going.

"It doesn't do us any good to get everything we want! Clothes, food, money! We become weak and spoilt individuals!"

"Amen! Praise the Lord!"

"We've got no backbone and drive! No will to succeed! We get far more satisfaction if we have to work hard for everything we achieve in life!"

"Amen! You're the man!"

"And I'm going to show you the way! I'm going to be your guiding star and lead you out of this place to a land fit for heroes!"

The crowd are raised to fever pitch. Roar their approval of Mr Duck. Some of the congregation start clapping their hands. Making music of a primitive kind. Caleb shouts above their praises.

"Follow me and I will make you Fishers of Men! Yellow-head play the tune!"

Yellowhead needs no second bidding. With the flick of a switch and a twirl of some knobs the Main Hall becomes a huge wall of primeval sound. Real heavy duty gangster rap. Yellowhead's dex creating that throbbing vibe which resonates through to the animal urges.

Morning Assembly degenerates into a giant rave. People letting themselves go like never before. And why not? Caleb has given them hope and encouragement. Shown them the light at the end of the tunnel. Caleb wearing his Trousers of Inspiration has just had a brilliant idea. TUNNEL! That's it! Why not a tunnel? Why not continue the work of Silent 'H' and use that as the method of escape?

Before he has a chance to develop the thought he's tapped on the shoulder by Boom-Boom Campbell. One of his finest. Boom-Boom's hobby is collecting car stereos. He's an expert

at his trade. Less than thirteen seconds to get one out. Caleb's seen him do it. Boom-Boom looks at him excitedly.

"It's there! I took it out just like you said boss!"

At last! The news Caleb's been waiting to hear. Boom-Boom's just reclaimed the stereo he put in Kaye's car. The Jezebel has finally returned to work. Time to pay a visit.

"Anything else worth having?"

"You won't believe it man! I got a Nackmichi C. D. 701. They cost over a grand brand new!"

Caleb grins to himself. That would be Roger Sweet's. The creepy Deputy Head. He's always bragging about his in-car hi-fi. Serves the boring bastard right.

"Well done Boom-Boom! I'll see you get a good report for this! Your mum will be proud of you!"

"You're the man Mr Duck!"

Caleb strides out of the department with a purpose about him. Leaves Bloke/Girl and Jan Scott in charge of proceedings. Tips Errol off to keep an eye on them. One or two things he needs to sort out.

CHAPTER 8

Caleb arriving at Kaye's place of work. Some low-key, all white, smug and cosy Laura Ashley Primary School situated in Bristol's sherry-belt. Top of the league tables and an excellent Ofsted report . . . Well done staff! A pat on the back! It just shows what can be done.

He approaches her office by the side entrance. Peers through the window to see her at work. Expecting to see a pale sad face. A shadow of her former self. But no! Nothing of the sort! In their stead all smiles and teeth. Laughter even with the one in the room. Caleb can't believe it. Not the normal reaction to a broken marriage. Peeps a little higher to see who's causing such mirth. Gives a gasp of astonishment. It's Roger Sweet! The flash bastard himself. The world's most boring man! What's he said she finds so funny?

A puzzled Caleb watches on in silence. Outside the window with mouth agape. They seem to have built up a great rapport. Each one laughing at the others jokes. Caleb about to dismiss the chemistry as a figment of his deranged imagination. Put it all down to those drugs he's been taking. No way could Sweet be the one. He's fifteen years younger and married with babies. Not even Kaye would stoop as low as that. But wait! What's this he sees before his eyes? Kaye gets up and approaches Roger. Arms outstretched she gives him a hug and he reciprocates in like manner. Jesus fucking Christ! Shock waves tremble through Caleb's system. Sharp black pains explode in his head. He can't believe he's seeing this! Suddenly feels quite sick. The sight of these two kissing and caressing causes him to throw up on the spot.

Another peep to double check. Confirmation that it's true. Now the grubby little fat boy's fingers are playing with her arse. Squeezes each cheek like he would a lemon. Fuck! Caleb's not standing for that! A waste bin handy in the playground. He runs across and picks it up. His head a maelstrom of anger and hate. Faster and faster he approaches the window.

Nostrils snorting steam. Two hands to hold it above his head then sends it crashing through the window. Kaye screams out loud in naked terror. Hasn't seen him yet. Probably thinks it's some extreme right-wing organisation that's targeted her as a threat. Treacherous egotistical whore! Caleb blunt and to the point shouts through the broken glass.

"Please don't tell me Kaye it's THAT boring cunt!"

Kaye is visibly shaken. White and hands to her face.

"Caleb! What are you doing here? This is where I work!"

"What am I doing! You fucking bitch! You're the one who's gone off her head! Are you screwing that heap of shit?"

The Mighty Roger caught in the act decides to speak at last.

"Listen Caleb. Grow up will you. She doesn't love you any more. She doesn't want to be with you. Can't you understand that?"

It's the way he talks that crawls under Caleb's skin. Smug, smarmy, superior tone. His Junior School chin jutting out towards him. His Junior School beard ticking him off. Cheeky bastard! As if Caleb were one of his seven year old pupils. The pompous little prick! Like a demon Caleb begins to climb through the window. Yelling the battle cry of the Plantagenets. The one that caused the French to buckle at Agincourt.

"I'll fucking have you! You CUNT!"

Mighty Roger puts up a surprisingly good defence. Keeps pushing Caleb back with a sweeping brush. The razor sharp glass prevents real progress and Sweet takes cowardly advantage of this. Yells at Kaye.

"Quick Kaye! Call the police! Tell them there's a madman on the premises!"

Caleb gutted. Watches in horror as his wife of twenty three years obeys the order. The mother of his children! Concludes it must be the H.G.V. tablets she's on. He grabs hold of Roger Sweet's arm. Pulls it through the window towards him. Bends his fingers against their joints and laughs when he screams in pain.

"Ow! Ow! That hurts you bloody idiot!"

"Good, 'cos this will hurt a fucking lot more!"

Caleb exerts a little downward pressure and listens to them crack. One, two and a wiggle for luck.

"Ahhh! Ahhh! Ahhhhh! You bastard!"

Lets go of his hold and shouts through the window.

"Now play with her arse with those!"

Caleb turns to Kaye and points a finger.

"Don't worry Kaye. I'm on my way."

He looks at her more calmly now. A pitying glance to let her know what she's done. Destroyed the dream they had together. Travel the world and see sights of wonder. Paintings in Spain and France. The Temples of the Orient. Why for Christ's sake has she done this to him? Chooses his words carefully for greatest effect.

"Whatever you may have thought Kaye I really loved you. I just want you to know."

Turns on his heels sadly and leaves this place. No further business now. Did he bollocks! Fucking bitch! He hopes she rots in Hell!

As Caleb runs around the field with Rosie on his back he notices steam rising from the backs of the other cows. The cool chill of the evening has caused this to happen. Forming clouds that hover just above the grass and drift around as if by magic. Something tells Caleb to head towards it. Drawn by its strange and mystic appeal. This is the land that time forgot. Of Arthur, Merlin and Camelot.

Caleb prances gaily into the mist. High knee raising and pointed toes. Rosie suddenly ceases to struggle. Calm and still upon his shoulders together as they enter this special place. Caleb can see himself running towards him. Admires in slow motion the beauty and grace. Accompanied by stirring organ music. It allows him to recap on the events of the day. To analyse and put in their proper perspective. Gone the dreams and ambitions he once had for himself. He knows they've vanished forever. But on a brighter side and much higher plane new layers of his destiny are revealed to him. New challenges to take him to a better place. . The Fourth Level of Awareness! A place in Education's Hall of Fame alongside

Kenny Baker. The trumpeter not the founder of Baker Days. Or even Baker's Dolphin.

Caleb gives a shout of sheer delight as the secret of Level 4 unfolds. So this is what Stockhausen★ meant by steam and the role it played in Enlightenment. He experiences a feeling of great inner glory at being a member of that privileged club who've advanced beyond Level 3. It marks him out as a special case. A rare and gifted man. He takes great care in putting Rosie down. Avoiding the worms that have gathered around preparing for their journey south. Heading for Cornwall and the sun.

★ In his book 'Interpretations of Life' Stockhausen stresses the importance of music and achievement. The two are inextricably linked he says. When something great has been accomplished it is always accompanied by stirring music to herald its completion. He offers as proof of his theory music from the following films: (a) The Great Escape. (b) Chariots of Fire. (c) The Dam Busters and (d) The Magnificent Seven.

Stockhausen says if you don't hear music after achieving something you consider to be brilliant you can take it as read it isn't. It's a load of fucking crap. Caleb definitely heard the music.

CHAPTER 9

Early one morning just as the sun was rising Caleb up with the lark and straining at stool. Elbows on his knees. Still nothing happens. Not even a fart. He conjures up the courage to go exploring. Gingerly puts his hand down below to feel around the back. Gently with the fingertips. Steels himself for the shock. Jesus Christ! What the fuck is that? A lump the size of a tennis ball growing out tight from his arse! He swoons and falls to the floor.

When he recovers he gets out of there fast. A very frightened man. His brain has come to a horrifying conclusion. The food he's been eating over the last few weeks is finally beginning to set! Caleb panics. Rushes down to raid the kitchen cupboards. Swallows anything he can to loosen things up. Orange juice, anchovies, ice cream and Guinness. Plus three tablespoons of lactulose and Caleb's eyes alight on the tiny black bottle at the back of the shelf. The Irresistible Drops! Given to him by Maria's Dad, the bloke who put the spell on him. An alarm bell goes off in his head. Maybe that's what it's all about? The spell and constipation. The two are inextricably linked. Won't be broken until Caleb samples a drop of ju-ju magic. In his desperate state he'll try anything. A couple of drops behind the ears and one on the tip of his tongue. Not quite sure how to take them.

Caleb peddling like fuck on his mountain bike. Testing the Shimano gears out to the full. A top of the range job donated by Backwheel for services rendered to the court. The fresh air helps take his mind off his bowels. Enables him to concentrate on other things. Sweet just can't do this to him and get away with it. He's a married man with three small kids. What sort of cunt does that?

Whilst puffing and panting his way up a hill. His brain in turmoil. Utmost despair. Pressure forty pounds per square inch. God tells him how he can solve the problem. A solution

so pure and touched by genius Caleb wondered why he hadn't thought of it himself.

Into Kaye's school up an invalid ramp. Whizzing along the corridor. Things couldn't be better for him. They're having an assembly. Heads bowed in silence they pray. Mrs Bowstead the fearsome headmistress leading square-jawed from the front. All eyes shut tight and hands together. The prayer of St. Ignatius Loyola. Caleb quietly pushes his bike up behind her. Prove to them he's not afraid. In full view of pupils and staff round the edges. He smiles triumphantly as he sees Sweet squirm. Hand in plaster. Arm in a sling.

> "To labour and not to ask for any reward.
> Save that of knowing that we do thy will.
> Amen."

The pupils open their eyes and begin to snigger at the dashing figure of the Mighty Caleb. Freshly ironed jodhpurs and guardsman jacket. A host of medals dangling down. Mrs Bowstead looks behind. A look of horror on her face. Roll-top chest expanded.

"Mr Duck? What on earth are you doing?"

Caleb the harbinger of bad tidings. Earnest and slightly out of breath. Points across the hall.

"I bring grave news ma'am! Yon bounder Sweet cowering over there is having it off with my wife! Unless you act with the utmost speed I fear the gravest consequence!"

Mrs Bowstead remains calm and bull dog collected. Unflustered even though her pupils have become suddenly restless. She turns at them and roars.

"QUIET!"

Absolute silence. You can hear a pin drop. Then back to Caleb in a deep rich stentorian voice.

"I won't tolerate this kind of behaviour in my school Mr Duck! Will you please leave at once!"

Caleb smiles. Only happy to oblige.

"Of course I will your majesty as long as you understand what a right LITTLE SHIT YOU'VE GOT AS A DEPUTY HEAD!"

Caleb content he's made his point. Everyone's got the message. Being escorted off the premises by other teachers who seem to fancy their chances. Don't push him he's close to the edge.

"I'm going! I'm going! Take your fucking hands off me!"

The commotion brings Kaye out of her office. Caleb delights in addressing her.

"It's alright Kaye. I've just put everyone in the picture. So there won't be any misunderstandings. No shocks to their systems when they hear the news!"

Kaye immediately begins to break down and cry.

"Caleb you sod! How could you do this?"

"It's easy Kaye. You taught me!"*

Cycling away from the scene of his triumph. A famous victory under his belt. Singing aloud his favourite song. 'Champion the Wonder Horse.' The Lorazepam has taught him not to give a fuck. Likewise the steroids and Roofies from Errol. Despite there being much evidence to the contrary Caleb has seen no signs of the personality disorders some would claim these drugs can cause. Just a pleasant full up feeling.

Sergeant 'Tosser' Torrington the School's Community Liaison Officer puts his hands up to protect his eyes from the glistening silver of Caleb's bike. He's just parked up in the Main School car park and is on his way to see him. As it 'appens. Tosser uses black street talk to give himself cred amongst his bigfoot colleagues. It's them who gave him his handle.

"Yo Caleb! A word in your shell like! I heard your missus and some other dude had their sounds nicked the other day. Some boy from the 'hood out to make a raise. What's going down? Any idea?"

"I haven't heard anything Tosser. I'll listen out for the drums."

* Mrs Bowstead told the Enquiry she'd previously got on very well with Mr Duck. He'd volunteered his services at the Junior School discos and School Fairs. On a personal level he'd been able to get her a good deal on an in-car hi-fi system and had obtained a twenty-one speed mountain bike for her nephew at a very reasonable price.

"Thanks B. Hey, what gives with you and the rumble this morning? I've just had that nice Mrs Bowstead on the dog to me."

Tosser gets a little confused. Mixes Cockney rhyming slang with the beat on the street. Caleb chuckles to himself. So this was the real purpose of his visit. To check him out!

"It's sorted Tosser. A bit of a domestic. Over now. It's cool."

"Two things aren't connected are they Caleb?"

"How d'you mean?"

"Car Hi-Fi's and this morning. I mean it was your wife's set of wheels and Mr Sweets? A bit of a coincidence eh?"

Caleb looks at him with a glint in his eye.

"Yeah. Funny that innit?"

Leaves Tosser stroking his chin policeman style. Wondering about him seriously. Feels the eyes burning into the back of his head as he returns left! right! into the I.S. Dept. Enters his office with a spring in the step. Engulfed by massive feelings of pride and accomplishment.

"Good morning Lynda. Any post this morning?"

"Two over there from that twat Rees. What d'you want me to do with them?"

"File them away with all the rest."

From: Deputy Headmaster To: Head of Integrated Studies

1. Please arrange for the enclosed form to be sent out to ALL pupils as soon as possible. I have not seen your registers for over a week and I can only assume that you are retaining them for some very important purpose. The Headmaster would like all registers to be returned to Main School Office immediately after registration at 8.50 a.m. and 1.30 p.m.
2. Copy of Integrated Studies syllabus still outstanding. Please have the courtesy to submit it as soon as possible or give a suitable explanation why you find it impossible to do so.
3. Explanation for not attending weekend course still outstanding.
4. Will you please make sure that the above are given your earnest attention.

G. Rees. B.Sc Deputy Headmaster

WALLISCOTE ROAD SCHOOL
WALLISCOTE ROAD,
Tel: Bristol (0272) 22221 BRISTOL BS5 8KG.

Dear Parent/Guardian,

Student ..

Tutor Group

 Your son/daughter has the following attendance record for the past six weeks.

Week ending:	M	T	W	T	F	Reasons given

You will obviously be as concerned about this as school is. If there are any problems which are causing this, please phone or write for an appointment convenient to you so that school and home can work together for the benefit of your child.

 Yours sincerely,

...

..

..

..

She needs no second bidding. Chucks them in the bin. A girl after his own heart.

"Any messages for me?"

"Mrs Greenwood came in and left the twenty quid for Gary's School Fund. I gave her a receipt."

"Thanks Lynda. Where d'you put it?"

"In me purse. Where d'you think? You owes me that for the treat you had."

Lynda sidles up to him. Puts two arms around for a loving hug. Takes Caleb by surprise. She's never come on as strong as this before. Strangely disconcerting.

"You don't mind me doing it that way sir do you?"

"No. No. It's yours. You earned it!"

"I missed you this morning luv. Where've you been?"

"Sorting out a few problems."

"D'you want to tell me about them? I'm a very good listener."

"No. No. It's boring."

"Anything I can get you then? Cup of coffee or summat?"

She gives him a look with her blow job eyes that makes his jodhpurs stir. Any other time he'd be in like a flash but not this morning he's work to do.

"Just the coffee Lynda. That'll be great."

She lets her fingers trickle down his chest.

"You're a good-looking geezer Mr Duck. D'you know that? Even though you're old."

Caleb can feel the pressure rising. He'd better get out of here fast. Before the temptation proves too much and he succumbs, if that's the right word, to his baser instincts.

"Keep an eye on the office Lynda I'll be back in a minute."

Caleb leaves walking slightly stooped. A hand in his jodhpurs to ease the situation. The battle of the bands is well underway. Yellowhead came in early this morning which took them all by surprise. He's winning the contest by a mile but John Irving refuses to give up without a fight. Added an extra speaker overnight.

Caleb ponders the Yellowhead problem. It's the classic group ego problem. No matter how strong a personality a

teacher has. How great a teacher thou art. How interesting he/she makes their lessons if three or more anti-Christs offer resistance the lesson is doomed to fail. And Yellowhead is beginning to cause that problem. Attracting the lowlife scumbags to him with the lure of smack. There's nothing in the National Curriculum that tells you how to cope with lads like that. There's something about him. A hidden menace. The kids know what it is but won't let on.

Watching Backwheel in the hall doing wheelies on his latest snatch gives Caleb a great idea. He promotes Backwheel to the rank of Corporal and appoints him Minister of Transport. His task is to build posh brand new bikes out of the spares he gathers every week. Left lying on the pavements. Corporal Backwheel signs a three year contract giving him two per cent of the weekly gross. A New Labour idea of a mixed economy. Absolutely brilliant! His probation officer will be delighted to hear he's at last found something that will keep him out of trouble.

Caleb leaves Backwheel to do the business and starts to root away inside his nostril. Searching out the lurking bogey to keep his calendar up to date. Finds a nice one. Hard and firmed up by the morning's bike ride. Just about to press it into position when Grabber Newell approaches with his hand-written confession. (C.A. 15.4 R.A. 4.9). Caleb takes it off him. As newly appointed Head of Department he's keen to improve academic standards. Had the brilliant idea of combining the confession to the appropriate National Curriculum document. English of course. Key Stage One. Attainment Target 3. Grabber had to produce a piece of writing that told a story involving more than one character. He had to show he had complete understanding of the use of capital letters, full stops, commas and question marks. They use the word demarcated. Posh.

This is what Grabber wrote.
I wus in the Botom coridore nexd too bultinlande Aving a drinke off watar Frome the Tap. edna Tomas cumes up too me hand Says cane I se Ure THING i a$ke Her wat. shees taking

Abowt hand she says you no. I say I Donte no. Hand she says i do No. I says poynt too it. Hand she poynts too My trowsers. she says CaN i pute my and in hand ave a FILL I says let me Finnish my crisps furst. SHE says she wants too doo it erseiv know, So she putes her and Frew my flys hand tuches My penuts. it goes all ard she startes Robin it up. Hand down. I finnish my crisps as fast as i cane hand pute my ands on her tites. i gete VERI exited. Hand the nexd fing i now is I am liying on Tope. off her. Hand tring too gete her nicers of. mister Luge the cartaker cums along hand watchs us four abit. he arSKS me Wate im tring too do. Hand i say hime only muking aboat so he Goes. Away. Then I PUTE my and on ednas thinge hand she SREEMS she getes up hand runs upstars two tele Mistar Duc. I go upstars two bye sum more crisps in the tucshop. mistar Duc cals me acrass hand Hits me acrass the fase as hard has he can. it neerly Broke my JAW, Hand then i cride alot. He caled me a DERTY BASTERD. Sined Henry NEWELL (15)

Caleb looks at Grabber in a stern schoolmasterly manner.

"Okay Grabber. That's all I wanted. I hope you're sorry for what you did?"

"Yes sir."

"On your way lad and don't let it happen again."

Caleb watches him go. It won't be long before he does it again. That's how he got his name. Undernourished and unloved. No dad at home and mother an alcoholic. Sooner or later he's got to make up his mind. Is it cunt he wants or crisps?

Lynda brings him up his coffee. Stays by his side and presses her tits against him.

"I love being with you y'know. It makes me feel good."

Caleb smiles. This is what the job is all about. Bringing stability to disjointed lives. Soon other girls begin to gather round. Looking at him moon-eyed. They see in him a father figure. One they never had. Kind but firm. Handsome and generous. Caleb promises them all he won't let them down. They sigh and stroke his arm.

CHAPTER 10

Sitting comfortably in an easy chair browsing through the pages of his mind. Eyes shut tight against the light and head resting in his hand. Butlinland is Freedomland. The only room in the I.S. Department where kids are not allowed. Unless they're dragged downstairs to be punished like Greenwood. It's a haven for calm and collecting his thoughts. A place to recharge the batteries. The peace in the room allows him to do it. Put order into a bewildered head. This is quality time he spends with himself. Thoroughly recommended.

Caleb's task this morning is to wrestle with his conscience. To determine what's right and what's wrong. So far he thinks he's winning the argument. Doing what he believes is best for his pupils. But still a small voice of reason chirps up. Has the gall to question his motivation. Tells him he ought to get out of teaching immediately before he does something really crazy that lands him in the shit. Caleb suddenly gets a violent mood swing. Leaps to his feet in a terrible rage. Scatters the contents of his desk all over the floor. Drawing pins, rulers and a supply of biros. Shouts at this smug and insolent bastard who's hiding somewhere in the room. Thinks he knows the fucking lot!

"Listen you stupid motherfucking moron! I want these pupils to leave with skills that will set them up for life! Standards of hygiene and literacy that will gain them employment in the real world! Is that too fucking much to ask?"

A fierce row brewing between Caleb and his conscience. Foul language coming thick and fast. One, the pillar of respectability but with stunted ambition and low self-esteem. The other a strong half crazy egotistical bastard who'll allow nothing and no one to stand in his way. The dominant personality. A knock on the door stops a fight developing. Just as well she came really.

"I hope I'm not interrupting anything?"

Caleb reels on his feet. Takes a backward step. Good God! It's the beautiful E.W.O. Angela White!

"Of course you're not. Come on in."

He'd forgotten all about her. A bit naughty of Lynda for not reminding him. He'll have to have a word.

Caleb has always fancied Angela White. Lusted after her in his dreams. Ever since that time she'd kept him talking on inner city deprivation. Coming in close and touching his knee. A tremble in her voice that showed true concern. Coming on strong. He being a happily married man on that occasion had rejected all her advances. Kept the conversation Bristol fashion. All above board and on the level. Not today if she gives him the chance.

She smiles. Young. Beautiful white teeth. Jet black hair worn long in the French Resistance style. Eyes that sparkle welcome. Bravery there. Lips wet, luscious. Asking him about Margaret Baxter. How is the girl? Where is she now? A pause.

"Caleb, can you hear me?"

Caleb shakes himself to his senses. Concentrates hard.

"I'm sorry. I wasn't listening. My mind was elsewhere."

"Have you been rehearsing for a play or something?"

"Sorry?"

She shakes her head in disbelief. At his vagueness as well as his clothes.

"I said have you been rehearsing for a play? You're all dressed up and I heard you talking to yourself earlier on?"

Caleb remembers with pride the uniform he's wearing. Straightens his tunic and adjusts the medals. Polishes his boots one behind the other on the back of his sturdy calves.

"I wear this when I'm on official business. It's in keeping with my new rank. Coffee?"

Angela laughs. Blinding light. Head tossed back gaily in uninhibited laughter. Appreciating the absurdity of the reply.

"Love one."

She shuts the door and makes herself at home. Takes off her jacket and puts it on the back of the chair. Sits down wearily and breathes a heavy sigh of relief. Glad of the first break she's

had since early this morning. Caleb gingerly grabs the steaming kettle and pours two cups of coffee.

"Black or white?"

"Black please. No sugar."

Secretly with his back towards her he pops in a couple of Roofies. Why not? He may as well give it a go. Can't remember much of the Greenwood business so there must be something in it. Hands the drink across.

"Thanks. D'you know I love this room. You're so lucky to have a room like this Caleb."

"It's got a lovely feel to it hasn't it?"

Caleb feasts his eyes on her dark red sweater. The gorgeous contours of her figure stir a hearty lusting in him. Snugly fitting round her waist. Neat. Trim. Tight. Like a rattlesnake he bets.

"What are we going to do about Margaret then Caleb?"

Caleb turns the gas down low. Leaves the kettle on for a second cup. Moves towards the sound of her voice. A peace about this woman he must absorb. A calm to bring relief. Shield him from his world of bedlam.

"We've got to be careful. If we overreact Margaret's mother will take it out on the girl."

"A delicate situation."

"Very true."

She looks at him over the top of her cup as she takes another sip. Caleb stares into those dark sparkling pools. Daring her to read his mind. To see what's going on. Her pupils dilate as she receives his message. Joy of joys! Success! A little smile. Giving him the big come on. Closer now and within touching distance. Sniff French perfume from the black market. Nylons. He risks a hand raised to her face to smooth the cheek and reach behind the neck. Feel a tremble there.

"D'you mind if I do that?"

Voice soft and soothing as she puts her cup down.

"Not at all. It's nice."

Again the thump inside his chest. The one that tells him he's in business. A desperate need to embrace and fondle. Stroke and feel with a loving touch.

"How should I deal with it then Caleb? Do you think I ought to contact Social Services and have the child removed from the home?"

Such devotion to duty does her credit. Caleb lets his hands fall into hers and pulls her to her feet. Arms wrapped around her for comfort and joy. She reciprocates in like manner and together they stand there all alone in silence. Giving each other the Social Worker Hug. Letting the strain and stress of their daily lives drift away in a warm embrace. Mutters softly in her ear.

"The trouble with Social Services Mrs White is they make a lot of enquiries before they act. In the meantime of course the mother knows her daughter's been talking and could get the iron out again. No one could stop her."

Another whisper. This time from her. Not educational welfare business but something more private and intimate. Hushed and breathless.

"I've always wanted this to happen Caleb. Just to have you in my arms. I thought you'd never respond."

"I've always felt this way about you too Angela."

"Honestly?"

"Honestly. On my heart I swear."

"Tell me something Caleb. D'you want me as much as I want you?"

Caleb holds her at arms length. Stares at her with gooey sincerity.

"More. I want you more than anything else in the world."

And with that she doesn't say another word. Starts taking her clothes off in a fevered excitement. The drum sounds loud in Caleb's chest. Pounding out a crazy rhythm as he watches her undress. He can't believe his luck. What is it about him this morning that makes the girls behave like this? First it was Lynda in the office then the girls up in the hall. It was as if he were a film star or a teenage idol they all found irresistible. Irresistible! No! Fuck off! Never! Caleb knows that was a load of mumbo jumbo. Ju-ju bollocks from Maria's dad!

Whatever it was it seems to be working. Clothes in a heap around her feet. Naked and waiting before him. Watching

him drool his eyes all over her body. Taking it in with open mouth relish. Feasting at the sight. Her shoulders, breasts and triangular patch. Not neat and tidy like they usually are but a veritable organic wilderness. Luscious pastures of environmentally friendly jungle growing thick and rich over her lower belly and thighs. Caleb can't wait to plough amongst the undergrowth. Reap and sow his seed. The kettle begins to boil again. Steam hissing out from the spout.

He stands precariously on one leg trying his best to heave his breeches off. Almost toppling in his lusty desire. Angela with her fine social conscience reaches forward to lend a hand. Tugs off his boots as he sits astride the desk. Grunting and pulling until both are off. Caleb transfixed by her pendulous breasts. Swaying gently from side to side. Mesmerised by her beauty.

"Here. Let me do that."

Lifts both hands away from his Underpants of Great Expectation and allows her the privilege of removing them. She goes down on her knees in front of him and tugs them to the floor. Emits a gasp of utter amazement.

"My God!"

His old boy is up there and ready to greet her.

"I always keep it fed and watered."

Not like the sisal plant he would have added but didn't get the chance. She already had it in her mouth. Amazingly the way he liked. Slowly with just her lips. Not too hard. No hands. All the time in the world. But even now the trumpet sounds. Calling her to duty. She breaks off to ask a question.

"Should I go round and see Mrs Baxter first then Caleb? Say we're a bit concerned about the marks on Margaret's face and think she ought to see her doctor. That's not saying we know how it happened but it's telling her we're aware of the marks."

Then back to what she was doing before but this time his bollocks tight in her hand. What a wonderful job this woman does. School Welfare Officers are the front line troops in this bitter war on ignorance. A tighter grip for extra pleasure. Jesus! Just what he needed! Pants out his words of advice.

"That's probably the best way to tackle it. Then if anything does happen to Margaret again we can step in and take immediate action. Oh, that's nice! Keep doing that! Oh God that's nice!"

"I want you Caleb. I want you inside me."

And Caleb wants it too. He watches the steam spurting out from the kettle and flares his nostrils to suck it in. Deeply into his lungs. It sharpens his senses and rouses his passion to even greater heights of craving. Never before had he felt this power. Enough to drive an engine. Imbued with a tremendous sense of urgency he spreads his Grenadier coat over the cold wooden blocks of the Butlinland floor. The next thing he knows she's on her knees with her arse high in the air awaiting the purple warrior. Caleb charges like a stallion towards her. Rampant. Closes on the target. Open wide in expectation. Just about to ram it in when he happens to glance towards the door. Jesus fucking Christ! There a sight he'd rather not see. Two small boys standing in the room. Abdulla Ney ranked No. 3 and Baldev Singh, Jan Scott's boyfriend. Both stare across in wide-eyed wonder. Amazement, shock and delight. She couldn't have locked the door!

"Fuck off you two! What d'you think you're doing?"

Caleb in a state of modus operandi leaves his place of entertainment and rushes to teach them both a lesson.

"AAAAAH! AAAAAAAH! AAAAAAAAAHH!"

Terrible pains shoot through his feet. Excruciating blinding pain. Followed by another and yet another. With a scream of agony he crashes to the floor where more torture lies in wait. Ready to strike if he moves an inch.

"AAAAH! AAAAAAAHH! FUCK! FUCK! BASTARD! FUCK!"

It's the drawing pins that are the problem. The ones he scattered about during the row with his conscience. Caleb writhes around in a rack of torment. His wounds beginning to bleed.

Angela scrambles to hide behind the desk in a futile attempt to remain anonymous. She steps on a pin in her haste to escape and screams out with the pain. Begins to cry. Not

daring to move in case she puts her foot on another. She's stranded helplessly in the middle of the floor with the two boys chuckling over her fate. Caleb is similarly stuck. Bellows like a madman at his two deaf pupils.

"Fuck off you two! Get out before I kill you!"

Baldev the bravest of the two speaks first. Eyes firmly fixed on the E. W. O.

"You told us to come and see you last lesson sir, because we were late for school this morning."

Caleb struggles to pick a way through the drawing pin minefield. He just wants to get a punch in. That's all. One single blow of such monstrous power that it will smite the pair of them dead.

"I'll see you both tomorrow morning! Now fuck off out of here!"

Very slowly they leave. Violent thoughts speed through Caleb's mind. They're bound to tell the others. They need to be silenced for good. He'll get Sergeant Perkins to have a word. That should do the trick.

The nightmare finally comes to an end with Caleb and his Forces Sweetheart inspecting each others private places. Searching for the drawing pins. Some have gone right up to the hilt and can only be taken out by his teeth. The only way he tells her. Especially the ones in her bum. Little or no nails to speak of. All thoughts of romance have long subsided. Mrs White is very upset. Beside herself in grief and worry.

"The Ney's are one of my problem families. I'll never live this down!"

"Don't worry. They won't say anything I promise."

"How can you be sure of that?"

"Leave it to me Angela. I've got my methods."

She's no option but to take his word for it and although becoming vague and wobbly she still knows where her duty lies. Amazing sense of responsibility!

"I'll go round and see Mrs Baxter now. I'll report back here if there are any problems. Touch wood there won't be any. To be honest Caleb I need a lie down."

Caleb helps the E.W.O. back to her car. She refuses his offer

to drive. Wants to get away as fast as she can. Just doesn't feel right in some strange way.

Caleb is full of admiration for this brave young woman who has born her ordeal so well. He vows to make room for her in his Woman's Land Army. In charge of fields of potatoes for chips for the lads. He's seen her on her hands and knees and knows she's got the build for it. Made of sturdy stuff.★

Caleb returns to Butlinland and dials the site supervisor Dave Lang. Formerly known as the caretaker. Another piece of arrant bullshit from the Nasty W.C! Money is Caleb's immediate problem. The Camp Escape Committee can't make any decisions until they know what's in the kitty. Already the tuck shop takings have been handed over and Caleb's just had another bright idea. The voice on the other end is keen and alert.

"What can I do for you then Caleb?"

"Have you got any more of the photographs of you and the cleaners?"

Dave laughs out loud.

"Ha. Ha. I've still got a few left. Do you want them?"

"Same price?"

" 'Course. You're a friend. Anything else?"

"Any chance of getting hold of some stronger stuff?"

"Say no more Caleb. Say no more. I'll have a word with the girls."

Caleb smiles to himself as he puts the phone down. He had to hand it to Dave. Every camp needs a man like him. Someone who can wheel and deal a bit.

Caleb quietly reflects on the events of the day. A long day

★ Mrs Angela White, aged 54, told the Enquiry she'd worked as an E.W.O for twenty-four years, the last ten of which she'd been attached to Walliscote School. She recalled going to Mr Duck's office the day in question on a matter concerning a pupil Margaret B. After drinking a coffee which Mr Duck made her she felt woozy. She couldn't remember much after that. Later when she was receiving hospital treatment for some mysterious wounds to her back and feet and puzzling bite marks on her buttocks and inner thigh she discovered she was minus her underwear. When she reported them missing to the police she wasn't able to account for her movements. Subsequent events superseded their enquiries. She is now off work and receiving counselling.

but very rewarding. Apart from the ending that is. But now he's aware of Angela's feelings he can make it up to her another time. The ardour the better. He climbs into the Capri a contented man. The scent of victory in his nostrils. A gentle workout now with Rosie, a takeaway pizza and a couple of pints and he'll be ready to start another day. Refreshed in mind and body. On a roll!

CHAPTER 11

Williams the Nice W.C. and Rees the Nasty look on in complete and utter amazement as Caleb opens up a tin of peaches. Swigs back the juice straight from the can then pours in a tin of Carnation milk. Picks the slices of peaches out with his fingers and proceeds to plop them into his mouth. Head back like a seal. Caleb sees them watching with mouths agape and figures they fancy one. Offer rejected with firm shakes of the head.

"No thanks Caleb. Not now."

"How about you Rees old boy?"

The Nasty W.C. flashes a look of disgust.

"I wouldn't take anything from you Duck! You're a disgrace to the profession!"

Quite easy to see how he got his name.

"You'd better take it up with my Doctor then Rees! This is his idea. I haven't dumped a load for over three weeks!"

Williams is genuinely shocked. Face a mask of concern.

"Good God! That's serious boyo isn't it?"

"Can be fatal. Look what happened to Elvis."

Rees leaps in to take advantage.

"Then why in Heaven's name don't you take some time off work and get it sorted out?"

Caleb looks him straight in the eye. Lets him know he means it. Mimics his accent when he speaks.

"Because Rees, unlike you I care about the pupils. If I left them now they'd wreck the school and academically underachieve!"

Rees scoffs. Sarcastic bastard that he is.

"They seem to be doing that already! Even when you're here!"

Caleb can't believe it! Plucks a half eaten peach slice from out of his mouth. The cheeky Welsh fucker is challenging his commitment!

"Want to repeat that Rees? Outside the school gates?"

Williams the Nice senses the tension. Calls for peace between them.

"Listen Caleb. We've got a problem. The Ofsted inspectors are coming next week. Given half a chance they'll close us down."*

Rees the Nasty has to add his bit.

"Which means everyone has to pull their weight! Including you Duck!"

"Meaning?"

"Meaning that all Heads of Department had better get their act together! A printed syllabus for every subject taught! All linked to the National Curriculum! Showing Programmes of Study and Attainment Targets! That's what it means!"

Caleb gives him wild violence of the eye. A look reciprocated with knobs on.

"So what's your problem Rees?"

"Jesus! I don't believe it! It's like talking to a bloody brick wall! You're the bloody problem Duck! You haven't produced a single word on any of the matters I've asked you to! There's teachers' jobs at stake here boy! I don't know about you but I've got a wife and family to support!"

Caleb bristles with anger. A remark below the belt. Rees is bringing his private life into the public domain. He's probably the one who tipped Sweet off! Told him Kaye was available.

"Was it you who told him she was up for grabs! You scheming little shit! I ought to break your fucking neck!"

Caleb leaps from his chair like a shot from a gun to grab Rees by the throat. Williams the Nice raises two arms aloft and hurriedly steps in between. Rees backs away. Heads for the door. A trembling finger pointing.

* In his much acclaimed paper on Education 'Tricks of the Trade' published by Taunton @ 65p Stockhausen had something to say about Ofsted inspections. Quote:

'Are teachers so insecure these days that they need to read great tropes of educational worth into the accidents of a single Ofsted inspection? There's something very odd about the hunger to over-interpret the event. To lard with deep significances the inspectors and their foibles and the exigencies of a single lesson. Personally I'd shoot the fucking lot of them!'

93

"You're mad Duck! Crazy! You ought to see a psychiatrist before you do someone some serious damage!"

He leaves in a fit of pique. Caleb allowing his temper to cool. Sits back in his chair and drops another peach in his mouth. Williams the Nice lights up a fag. Shaking like a leaf. Now the Nasty W.C. has left the room the atmosphere's more calm and relaxed. Caleb and a nervous Headmaster sit man to man discussing the troubles of the world. Ireland, Saddam and rugby union. The latest Labour spin. Williams hides his anxiety behind rings of smoke. Makes tentative enquiries about Kaye and the kids. Asks him how they're all getting on. Caleb tells him fine doing very well thank you and then they turn to his physical health.

"Are you sure you don't want any time off Caleb? To get matters sorted down below?"

"No! No! I won't hear of it. With Ofsted approaching I need to be on duty. I wouldn't dream of dropping you in it."

Williams can't hide his bitter disappointment. The smoke ring only gets halfway out. Suddenly inhales and nearly chokes. A coughing fit that causes some concern. Then with a struggle.

"I admire your commitment Caleb. Those kids worship you. Greenwood is living proof of that. His mother is continually on the phone to me singing your praises! I think she must be a little potty herself because she said twenty pounds a term is a small price to pay for the education young Gary receives. I don't know where she got that from do you?"

The long hooked nose of this crafty Welsh eagle slowly turns to point at Caleb. Beedy eyes seeking out the truth. This is Williams the Nice W.C. at his best. The genius of the man. Trying to trick him with his silver tongue but Caleb is up to it.

"I think young Gary is putting one over on her Mr Nice work if you can get it eh?"

Williams allows a ring of smoke to pass this time. Little squinty eyes at him.

"That's it! That's what he's doing! Well if it makes them both happy I won't say a word. So how about it Caleb?"

"How about what?"

"This National Curriculum business. D'you think you can sort something out? Get those Ofsted bastards off our backs. Keep Rees happy at the same time?"

Caleb downs the last of the peaches with panache. Considers the request. Smiles benevolently at his Headmaster.

"No problem sir. Stick to the rules eh? Marquis of Queensbury and all that bollocks!"

Again Williams can't fathom what Caleb means. Puts it down to something lacking in his Welsh language education but assumes it was a yes. Three smoke rings go up as a sign of agreement. Gets up from his desk and walks round to greet Caleb. Hand extended for him to shake. Patronising manner. Caleb leaps to his feet. Clicks his heels together and hurls his right arm into the air. Missing Williams by a whisker.

"Jawohl mein Herr!"

Spins on his heels. Marches with stiff purpose from the room. Stumpers codpiece leading the way. Williams collapses exhausted into his chair. Pressure mounting with the Ofsted visit. They could break him if they wanted to and he knows that's their intention. He needs the full cooperation of all his staff. Two hundred percent from everyone. And he'll get it too. All bar one. The one who stinks to high heaven.

Williams has serious worries about Caleb's state of mind. The biggest mistake he ever made was when he gave Duck the job. Two hands on his head in total despair. Two elbows on his desk. His self-esteem eroding fast. Authority diminishing. He'll be the talk of the town if his school fails the Ofsted. Front page humiliation! He doesn't know if he can take the pressure. Not as strong as he thought he was.

CHAPTER 12

Caleb leaves the Main Block building with renewed vigour. Negotiations went much better than expected and he got a good deal for his men. No more arguments about pay and conditions. Now at last he can get on with the task that God has chosen him to do.

A gang of lads are already in the boiler room clearing out the rubbish. Ready for when they start digging. Opening up 'Charlie' the old Silent 'H' tunnel. Once they've finished Caleb's in business. Out of there with the speed of light.

He breezes into the calendar room and checks the temperature by gently pressing yesterday's gobby. Fine. Nice and hard. Although it's only 9.15 a.m. the Main Hall is already crowded. Music as usual. This time it's Tchaikovsky's Piano Concerto. Yellowhead won't appear until after lunch. All night blues keeps him away 'till then. No friction until he arrives.

The table tennis is in full swing. Not an empty table to be had. Some of the kids have gone into the classrooms and pushed two or three desks together and are playing on those. Using half opened Bibles as nets. Caleb cuffs one boy for using a Maths textbook as a bat. Informs him his stroke play will suffer and he'll get into bad habits. Caleb rips the back cover off to make it lighter.

"Use that and don't forget to follow through! Stay on your toes! Eye on the ball!"

Caleb demonstrates the move with the grace of a champion. The boy dismisses the advice with a muttered curse.

"Wanker!"

Caleb ignores the comment. Heads towards the office. Lynda isn't in today. She's out on work experience. A note from the cleaner left on his desk.

Dear Mr Duck,
Im sorry but I ain't having it no more. Im nearly 70 Mr Duck. Dave use to give me 3 hours to do this job with someone to

help me. Now Im on my own and I got to do it in 2½ hours. That room at the end is disgusting. Them budgies shouldnt oughta be kept in there like that. Itll bring the mice in. Im going to tell Dave all about this, So you wont think Im going behind your back.

All my love. Janet the cleaner.

PS. It aint like the old days Mr Duck.

Her last line stirs Caleb's conscience. She is one of the few who can remember the days of the Elders. He respects her opinion and code of conduct. She demands high standards. Why, wasn't she the one who gave Shitty Shearn a fag then took it off him when he put his hand up her drawers? Not many left like Janet.

Caleb returns to the Hall to check out the Bloke/Girl's room. See the state it's in. Spies Baldev and Abdulla coming towards him. He's a bone to pick with them. Dirty little perverts. Grins of mischief on their faces and an excited gabble about the way they talk. No doubt at his expense. He hides in the doorway and lets them draw level. Leaps out as they pass. His punches sink deep into their soft padded jackets causing high-pitched yelps of fear and pain. True they're giving away weight and height but Caleb's handicapped by chronic constipation and the strange assortment of pills he's taking. Making him crazy, lazy and hyperactive. All at the same time. Fucking him up!

After threatening to cut them up into little pieces and feed them to the pigs both boys give Caleb a categorical assurance they won't say a word to anyone about him having it off with the E.W.O.

"You'd better not Singh. I know you're an illegal immigrant. I'll have your family deported!"

Caleb sets them free. Watches them scarper. Laughing heartily to himself at what he has achieved. Protecting the reputation of the lovely Angela White. Enormous satisfaction in that. This is how it all begins. The stress. Every day the same. Slowly at first like gentle waves lapping. Aggravation levels low and under control. But gradually, very very grad-

ually the pressure starts to mount. Like someone turning a giant handle. Causing huge waves of uncontrollable turmoil to build up behind the dam. Until it finally bursts through in a momentous surge sweeping everything away in it's path. And in the background like a sub-current swirling the thought of Kaye and Roger Sweet. Laughing and joking at his expense. Making him feel very exposed and vulnerable. An easy target to hit. He'll fucking have the pair of them!

Caleb continues his tour of duty. Thoughts of wreaking a terrible vengeance stirring the deep muddy waters of hate. A herd of worms wriggle across the floor. Getting in his way. He kicks them viciously to one side. Makes a point of deliberately ignoring Jan Scott's arrival. Over the top and very dramatic. She has to show off and attract attention. Wave hello to everyone. In her designer dresses she looks like Lily Savage. Only one hour late and not so beautiful! Of course there's no need to apologise darling. They should be honoured she's even shown up! Baldev makes a beeline for her and she gives him an extrovert hug. Can hardly contain her craving for him. Caleb sees him whisper something in her ear and she spins her head in his direction. Angry at what was said. The sneaky little bastard has grassed already! Caleb puts him down for an appointment with Errol. Thinks to himself fuck the pair of 'em! Part and parcel of the job. Next one please! Wheel it on! A soft Scottish voice drifts through to him. Interrupting the thoughts of evil revenge he was plotting for Kaye and Sweet.

"Oh there you are Mr Duck. I've been looking all over the building for you."

The School Nurse has arrived like Mother Theresa. Sister Young a little gem. Over and above the call of duty. Goodness in her heart.

"Good morning Sister. What brings you into Colditz then?"

"Young Mr Shearn I'm afraid. I've got him over in the Medical Room."

"Again! What's the little devil been up to now?"

"The poor wee laddie smells again. I kitted him out with a new set of clothes only the other day. He looked beautiful.

Butter wouldn't melt. This morning he's as bad as ever. Stinks to high heaven."

Sister Young has a deep understanding of the kids in her care. A quality she shares with Angela White.

"What on earth are we going to do with him Mr Duck? He stands no chance at all."

Government cutbacks in Educational Spending have hit the likes of Shitty Shearn hard. This makes Caleb angry. Civilised society is judged on how it treats the poor, sick and animals and Shitty Shearn qualifies on all three counts. And on all three counts he fails. Caleb suddenly brisk and alert. The time has come to take action direct. Hit 'em where it hurts. Show off those qualities that sets him apart.

"Go back over Sister Young. Leave this to me I'll sort it out!*

And Caleb being a truthful man was as good as his word. Left the building on an errand of mercy leaving Errol in charge again. He only went for an hour. A knock on the door of the Medical Room. Sister Young opens it and there's nobody there. Just a bulging black plastic bag full of clean smelling clothes. White shirts and grey trousers and nice school blazers. All sporting proudly the school coat of arms. Twenty or thirty pairs of shoes. Leather ones and sandals. Trainers too! Top of the range. Adidas, Puma, Reebok and Lacoste. And the extraordinary thing about every article of clothing was ALL were exactly Shitty Shearn's SIZE! An amazing coincidence Eh?

On his return to Butlinland Caleb ponders upon his good deed for the day. At last he's done something for the common good. Struck a blow for the poor and needy. But it seems he's being punished for his kindly effort. A terrible rumble in his belly sends him scurrying towards the loo. In the glorious old Secondary Modern days Butlinland was a staffroom. His and hers toilet en suite. Very handy.

Sitting astride the plastic seat trying to get steam up down

* Sister Young told the Enquiry she'd always found Mr Duck a very kind and considerate man. He always had the interest of the children at heart. He'd been very kind to her family as well. Obtaining mountain bikes for all her children at a greatly reduced price.

below. He grits his teeth and heaves away. Heave away you jolly lads! But the ship won't budge. It's stuck in the mud. Solid as Jailhouse Rock. Sweat pouring off and red in the face. A moment's respite before he tries again. Being extremely careful not to overdo it and split his heart asunder. Allows his mind to wander elsewhere. He suddenly has a brilliant idea to get W.C. Rees off his back. Can't understand why he hasn't thought of it before. Leaps off the pan and rushes upstairs a little bandy-legged. Tugging his trousers as he goes.

He calls upon Kurpal and Gazala. Two beautiful Pakistani girls who work hard with lots of ambition. Both very neat with a good sense of colour. Ideal for what he has in mind. Retrieves the old Banda machine★ out of a cupboard and presents them with the Design and Technology National Curriculum document. Tells them to start translating it into Urdu and print off hundreds of copies. Don't worry about any mistakes. Then when they've done that comes the clever bit. A touch of genius on his part! They colour it in! But only the letters that are completely enclosed. Like B, D or O. The rest like C, E, F, and G they leave unattended on the page. If they want to use patterns that's all right by him. When it comes to Art he's a bit of a colourist. Not an arrant snob from the St. Ives School! So when Rees next asks him about the I.S. syllabus he'll tell him it's all under control. Being printed off at this very moment. Even as they speak. A hand decorated copy of the National Curriculum translated into Urdu is bound to impress even the hardest inspection. Caleb congratulates himself on a great idea!

★ Banda machine. Invented by Mr Hastings Kamuzu Banda. Born 1906. Died 1997. Malawi statesman. As first prime minister of Nyasaland (since 1963) he led his country to independence (1964) as Malawi. President from 1966 till his death. Invented the Banda machine as a cheap and quick way of producing election pamphlets. Word often misused in the I.S. Department e.g., Robin Hood and his Banda Merry Men.

CHAPTER 13

Highly detailed maps and elaborate plans of escape have been cellotaped onto the walls of Tunnel H.Q. Formerly known as his office. Pictures cut from the posh Sunday supplements pasted up in a montage of visual incentives. Beautifully crafted kitchens and bathrooms. All en suite of course. Designer lounge and bathrooms. Country houses with manicured lawns. Crunchy gravel driveways with three BMWs parked side by side. This year's model of course!

This is the lifestyle Caleb has promised his pupils. The spur he's given them to escape. The shit-hole existence they have to suffer is totally unfair in this day and age. The new Labour government has done nothing to help them. Even cut the allowance of Shitty Shearn's mum. As Caleb keeps hammering it home to them. It's no use relying on others to get you out of the mess. If you want a job done properly you must do it yourself!

Caleb studies a huge plan of the prison area he's painted on the wall behind his desk. A giant effort that took a day to complete. Little flags show all the key positions and a red line marks the perimeter fence. All the rooms in I.S. have been clearly marked. A row of black dots extend from the boiler room and across the sportsfield towards the main road. Caleb is following the line of the original tunnel dug out by Jeremy Philes. Then instead of branching south and going under the tennis courts as Silent 'H' had planned he will take the shorter but more hazardous route and go under the cricket square. Willing to accept the danger of subsidence caused by the grass cutting machinery that Perks the racist groundsman uses. As he prepares the wicket. It will cut the tunnelling time by half.

High levels of steam in Caleb's brain boiler building. The pressure beginning to mount. Almost up to danger level. His doctor warned him it would be like this. Peaks and troughs. But this is a bottomless pit. And there in the depths amongst all the worms in a lather of sweat and other body fluids is the

source of all his anguish. And entwined between her legs with his tongue hanging out is that beaver munching scumbag Sweet! He can't bear to look any longer. Swallows a couple of Lorazepam to banish the thought from his mind.

His physical condition gives cause for concern as well. The swelling around his lower decks is harder and wider than ever. The Lactulose still hasn't worked its way through and the Roofies Errol sold him, he's discovered, are the date rape drug Rohypnol. Better known for heightening sexual pleasure and also a danger of amnesia. Caleb decides to start writing things down so he won't forget in future.

Finding enough timber to prop up the roof will be a major problem. Need plenty of desks for that. Some arrived last week for the Sixth Form Block to replace the ones stolen by Silent 'H'. He'll have a word with Dave. So many things that need to be planned. Designs for clothes to wear on the out-side. Lists of food to take out with them. Lighting and air-systems in the tunnel. The movements of Mr Nice and Mr Nasty W.Cs. The minutiae of the great escape. The school timetable showing where every teacher is. What lesson they're taking at a particular moment. An asterisk by those who might be sympathetic. On and on. Etc. Etc., but as the Lorazepam begins to kick in so Caleb's confidence starts to soar. Reciprocal innovation. The fear of failure diminishes with each passing second until just minutes after popping the pills Caleb is filled with a fierce but drowsy ambition. His own efficiency astounds even him. No mortal can approach the standards he sets. God did well to pick him out from all the other applicants.*

A long queue has formed outside Tunnel H.Q. It's dinner time and the inmates are waiting to buy their crisps. A knock

* Dr Nigel Hickey told the Enquiry he'd made several emergency visits to Caleb Duck's house on matters relating to his constipation and anxiety problems. The only time he could recall Mr Duck visiting his surgery was when he tried to get him to buy an executive raffle ticket for his school's 'Books for Orphans Appeal'. He didn't buy one because at £20 a time he thought them rather expensive. The tickets themselves were obviously hand-written and coloured in by children. Dr Hickey remembers it was on the same day a large number of prescription pads went missing from his surgery.

on the door which Caleb answers. The kids outside give a sarcastic cheer. It's Vincent with his fish and chip lot.

"I put plenty of vinegar on sir like you said."

"Thanks Craig. Start selling the crisps whilst I eat this lot. They've gone up to fifty pence a packet."

Screams of protest come from the pupils awaiting their only meal of the day. They can't afford that kind of money. Calls of "It's a fucking fiddle sir!" and "Fuck off yer cunt I ain't paying that!" Caleb yells to restore discipline to his mutinous troops.

"Shut up! Don't you know there's a fucking war on ignorance going on!"

Caleb fires the question at them. Eyes them one at a time. They all look guilty and shuffle their feet. They've never heard of a war. Ashamed at the way they've reacted. He continues more sympathetically.

"Let me tell you something. The profit from the crisps will buy us vital educational resource materials as well as subsidise the day trip to America I've planned for you all. D'you want to go or not?"

A chorus of approval. Of course they do! First they've heard of that as well. He raises his hand for silence.

"So as an incentive for you to buy your crisps from me and not from some bastard down the road I'm going to introduce a competition. The first person to collect a thousand empty packets of crisps with my own special mark on them wins a hundred quid."

They need no second bidding. See the sense of the scheme. Money out and rush in to buy. Two or three packets at a time. Free poppers to the first twenty. Caleb stands at the head of the queue eating his fish and chips. Using a magic marker to put his signature on every packet sold. Making sure nobody tries to bully Vincent into giving them a packet for nothing. Nobody does. Suddenly a sight unseen in the building. At least since it went comprehensive. Unbelievable!

A new boy appears at the staffroom door with a crowd of kids following in his wake. Laughing at the lad in his spick and span suit with blazer badge and shiny face. A school cap on his head as a crowning glory. Caleb calls them a bunch of cruel

wicked bastards to tease a boy who's made the effort. But something's not quite right. The boy's laughing as well! Not the least self-conscious of dressing like a prick but in fact enjoying every minute of it.

"What d'you reckon then sir? How do I look?"

The penny drops with Caleb.

"Shitty Shearn! You bastard! You had me fooled completely."

He laughs aloud. Never been so happy.

"A smart lad now sir, wouldn't you say?"

"I certainly would Shitty old chap! God, dressed like that you could get any girl in school. Where's Maria? Has she seen you yet? You'd better watch out lad. She'll be after you. How much money you got?"

The large crowd that's gathered all hoot with laughter. A sea of happy smiling faces standing joyous in front of him. Black and white together. Caleb experiences a deep inner glow of job satisfaction. It's moments like this that need to be cherished. It's what education is all about. Must be a fun experience. And by Jove this is fun! He decides to reward them all with a well deserved treat. Bellows above the noise. Tells them to make their way down to the Feeder Canal and meet him by the lock gate. Sergeant Perkins can take the motorbike and he can have first go.

It's a miracle the way they vanish so quickly. Disappear into thin air. Incredible to imagine that only minutes before the rooms and corridors in I.S. echoed to the sounds of fighting, bullying and the inevitable ping-pong with its screaming and arguing the points. Silent too for the first time in ages are the two rival Musical Societies. And Caleb can't say he's sorry. Whilst he can just about tolerate John Irving playing Stravinsky's Circus Polka for three hours at a time. Nonstop. Yellowhead's recent excursions into UK speed garage, which he claims to be the new Drum 'n' Bass, are doing his fucking head in! And he's just added another speaker! Making six in all! But all is silent now. All is calm. The silence almost like thunder. Deafening. Hurts more than the noise. Weird. Only the lingering smell of tobacco smoke and the thick rich

stench of body odour from over eighty sweaty and unwashed bodies give any clue that children have been here. Being prepared for adult life.

Caleb goes around checking out the building. Making sure no kids apart from Copperknob doing a five knuckle shuffle in the loo have hidden themselves away. There's a few he can't trust to be left on their own now the crisps have increased in value. Into Jan Scott's room just to make sure. Ha! He should have known. In here with Baldev Singh. Like lightening he removes his hand from her blouse. Dirty little sod. She looks a little embarrassed. Covers up fast.

"Baldev's been a very naughty boy this morning Mr Duck so he's staying back with me to do some extra work."

Caleb can't blame Baldev for what's going on. Screwing a teacher is an added bonus whilst learning to read and write.

"Well if you change your mind Jan you know where we are."

Baldev fixes Caleb with his eyes and gives a sarcastic leer. Knows he's safe with her.

"Thank you for the offer Mr Duck but I'm afraid this young man has got to learn he can't go around doing just as he pleases."

Which is exactly what he does with her. Bloke/Girl is just as bad. A mid-thirties Adonis who never got married. Raised budgerigars instead. Fostered them out from some Rolf Harris sanctuary and brings them up as her own. Sad. He goes into her room to see if she's coming. Loud chirping and fluttering feathers. She's let them out again.

"I've got to clean the cages out Caleb. Can't leave it another day."

Dungarees and blue denim shirt displaying her muscular strength to the full. Having a workout on the weights she always keeps in her room. An awesome display of power.

That's always her line when Caleb asks for help.

"Okay Lyn. I'll take them down myself. I'll manage don't worry. After all they're not the sort to get into any trouble are they?"

She looks at him aghast.

"Do I detect a note of sarcasm in your voice Caleb? I mean if you really want me to come I'll come. I mean I haven't got anything really important to do! I mean like the budgies will only die! But who cares about that? I mean that's nothing is it?"

She drops the weights with a crash to the floor. Deliberate act of aggression. Caleb flinches. On the alert. Flushes red at this kind of abuse. Begins to lose his sense of balance. Hangs onto the wall for extra support. Who the hell does she think she is? Short hennaed hair with a neatly brushed parting. Bulging thighs to match. Probably plaits her pubes into a six inch stump so she can shake it after having a piss. Caleb thanks the Lord for the message this morning. 'Whatever you do,' the Master said, 'Don't apply your irresistible drops today.'

"Okay Lyn you stay! I mean no problem! I mean you stay you lazy cunt!"

Caleb slams the door in a temper. Hard. Hears squawks and shrieks of frightened wildlife coming from within. The wild hysterical flapping of wings against wire. Seed and water all over the floor. Another job for Janet. Bloke/Girl comes hurtling out of the room. Screaming crazy screams. Fists clenched white and tight together. Powerful shoulders hunched high for the fight.

"You bastard Caleb! That was cruel. I mean really fucking cruel! Like they could die of fright you know! Like a heart attack or something!"

Caleb brief and to the point.

"I hope they fucking do!"

Then he runs away like the wind. A cat on a hot tin roof.

CHAPTER 14

Caleb marching down the Main School drive dressed in his finest regalia. Polished riding boots and yellow breaches. Scarlet Grenadier coat with gold braided epaulettes flashing on his shoulders. Round his waist a Bristol Rovers scarf. Must show support for the local team. He's fully aware he's being observed by the Nice and Nasty W.C.s. Acting on a tip-off from the Bloke/Girl Lyn. He can feel their eyes burning into his back. Questions poised on their lips. Where does the silly sod think he's going? Dressed like that? Caleb dares them to run out and ask him! Stop him now when he's in full stride would be like stirring up a hornet's nest!

Caleb stamps to attention at the Main School gates. Turns to face an imaginary sentry box and salutes the guard on duty. Spins around to face Williams and Rees. Unbuttons his yellow breeches. Out with the todger and waves it at them. A couple of flicks of the wrist and a shout of defiance. Drugs giving him the confidence to do it.

"Had yer eyeful! Suck 'ee if you like!"

How dare they sit in their office all day passing judgement on the likes of him. They ought to get out more into the classroom. Do a bit of teaching!

Caleb experiences a wonderful feeling of peace and solitude walking on the other side of the high prison walls. Sampling a taste of what real freedom is. Away from the maddening crowd. Keeps his head well down to enjoy every second. Crash! Straight into a pram.

"Oh, I'm awfully sorry. I didn't. Bogey Greenham! What the fuck you doing here? Why aren't you down the Feeder with the others?"

The little sod's been caught in the act. A thing the police have failed to do. Caleb pulls back the blanket that covers the pram to reveal a load of scrap. Brass taps, copper tubing and a nice drop of lead. Greenham stands humiliated before him. A

green bogey bubble swells out of a nostril then vanishes quickly again. Under pressure.

"Where's this little lot come from then Bogey?"

Hangs his head shamefaced and embarrassed. Mutters his reply.

"From the pisser down the church hall sir."

"That's where the old folk meet! How fucking tight can you get! What are they going to do now when they want a pee?"

"Ain't got a clue sir."

Caleb angry at this lack of consideration.

"'Course you haven't! You don't give a fuck do you? You were just thinking about the money. Eh?"

"Yeah. Fair comment."

And that's what Caleb does as well.

"So how much do you reckon you'll get for it?"

"About twenty sir. Give or take a few bob."

Caleb rubs his chin. Could buy more drugs with that.

"Right then Bogey. Listen. When you get your twenty quid you bring it to me down the Feeder! Any fucking about and I'll hand you over to Sergeant Torrington!"

Bogey's face is a portrait of pleasure. Beaming bright. Got off lightly. Twenty quid is a cheap price to pay for his freedom. Not that he has any fear of 'Tosser' Torrington. He's often been invited by the policeman to beat his backside with a cane. At three quid a time it can't be bad. He's done other things too for a tenner but he won't tell anyone what they are. Not even his best mates Shitty Shearn and Pater. Ranked 47 and 51.

"Okay sir. You're on. It's a deal."

Caleb watches him push the pram away. His skinny little arms knot tight with the effort of getting the weight of the wheels underway. Strains to gather momentum. A ragged-arse ranger if ever there was one.

Caleb heads towards the Feeder Canal. Wanders through the district that surrounds his prison. A proud land once fit for heroes. Now beaten and bowed into total submission. Guts ripped out by political cruelty. Thatcher wielding the knife.

That woman ought to be impeached for crimes against the country! Did what Hitler and Napoleon both failed to do. Broke the spirit of the nation. Brought the country to it's knees!

Past derelict buildings that now house squatters and psychopathic druggies. Dossers and crusties the lot. Cut through the giant shadows of the high-rise flats built by sixties loonies when Social Realism was at its height. Cribbed Eastern European tenement blocks. Scramble over the rubble of once neat and tidy terraced houses whose occupants formed the backbone of the British Empire. A complete family unit. Cosy and secure. Front doors left open for neighbours to call. Brass doorsteps polished bright. But all that vanished. Evaporated away. Just memories cherished by the Elders of a long forgotten caring age when the church hall had a toilet.

Caleb stands on top of a high green embankment that forms the natural boundary of the catchment area. He looks down on the Feeder Canal. The kids are lined up along the near bank. Looking down into the water. Caleb immediately senses something's amiss. Confirmed when Maria runs across to him laughing her head off. So deliriously happy she can hardly speak.

"Sir. Shitty Shearn's driven the bike into the water. It's at the bottom of the canal!"

"Tell me you're fucking joking Maria!"

She shrieks with laughter at the look on his face.

"No I'm not sir. You ask Errol."

Caleb charges down to the side of the bank. Generates a good head of steam. Nobody looks in his direction. All eyes are fixed on the scummy water and the long piece of rope that Errol is holding that dangles into it. He stands on top of the wooden lock gate. Caleb screams at his Second-in-Command.

"Sergeant Perkins! What the fuck you doing?"

His eyes roll white. Dart quickly left and right. There's no escape. He has to answer.

"It's Shearn sir. He's lost the bike."

The brand new scooter! Presented to the school only a

week ago as part of a massive road safety campaign. Jesus! Caleb storms towards Errol. Pressure mounting. Searing pains inside his skull and funny noises like interference roaring through his ears. A bee maybe has crawled inside? A wet trickle down the inside leg.

"Where's Shitty Shearn!"

Errol's head stays down. Ignores the gaze. Concentrates. Pulls in the slackness on the rope.

"He's looking for the bike sir."

"What do you mean he's looking for the fucking bike? Where is he?"

Caleb edges along the gate towards him. Fists clenched and ready for action.

"He's on the other end of the rope sir."

"What! Jesus Christ boy! Haul him up!"

Hand over hand he brings the rope in. Nearer to the edge of the lock gate. A body slowly emerges out of the water. Limp and lifeless. Huge pieces of masonry tied round his waist. Caleb races down to be there. The children show their great concern by laughing and cheering at Shitty Shearn's plight. They've never seen anything quite so funny. Caleb turns on them viciously. Face purple with rage.

"Shut up! You ignorant fucking bastards!"

A hush descends immediately. Broken only by a periodic giggle from Maria. The lifeless figure of poor Shitty Shearn is dragged out of the water and onto the bank. Lies still and lifeless at Caleb's feet. New school outfit ruined.

"If he's dead Errol I'm going to kill you!"

Quick as a flash Caleb's on his hands and knees pushing hard on Shitty's stomach. Pumping his chest with the flat of his hand to get his heart beating once again. A gurgling noise like a drain being emptied. Water gushes out of his mouth but still no beating heart. Only one thing left to do. Much as he's loathe to do it. No time to think about who's lips he's kissing. He feel the lungs inflate. Removes his mouth and lets them expire. Again and again he repeats the action. If only he could feel a pulse. Another thump in the place his heart should be and a groan comes sweetly from the mouth. A noise like a

sudden rushing wind wells up from deep in his trousers. The new ones he had on this morning. They fill with air like a barrage balloon. A continuous hissing sound. Wider and larger they inflate till they're lifting the lad off the ground. Then from every orifice of his body he splutters and farts into life. A rich aroma fills the air causing Caleb to turn away and puke. Shitty Shearn rides again. Ok?

Sergeant Perkins feels he has some explaining to do. Gesticulates wildly with his arms. Pleads for mercy.

"Boss, you gotta believe me! It ain't my fault. You ask Maria sir!"

"What's Maria got to do with it?"

"Shearn tried to touch her up! He did what you said sir but she wouldn't let him have it! So he ran off and got on the scooter sir. We all started chasing him sir and he looked behind him sir. Laughing at us sir, and he rode straight into the canal. I got him out sir and tied some stones around his waist sir to make him sink quicker sir. I told him to go in and get the bike back sir because I knew you'd be mad sir."

"You TOLD him to go back in Errol! You mean you asked him didn't you? Politely. You said can I throw you in Shitty? And he said yes please Errol. Put some fucking great stones around my waist! Please Errol it'll be a lot quicker!"

Caleb looks his Second-in-Command straight in the eye. He doesn't want any lies.

"Is that what really happened Sergeant? Answer me!"

He's completely shamed up in front of the others. Feels bun. The excited rabble of Caleb's army all wait in anticipation. Not a whisper. Here's a confrontation they're going to relish. The top man in Colditz versus the crazy Mr Duck. His flies undone and his thing's fallen out. Errol adopts the hangdog look. Totally submissive. He offers no resistance. Knows when he's beaten and stands no chance.

"Na man."

"So what happened then?"

"I mashed him up sir. Put the stones on him and threw him in. Told him to look for the bike."

Caleb clasps both hands tight around his head. A darkness

clouding his mind. Tries to think calmly and rationally. Makes a swift adjustment to the front of his trousers. If he's to establish authority over his troops he must be seen by them to be in total command. Even over Errol. Struggle desperately for self-control. Odds against that happening. His heart misses several precious beats. Highly dangerous according to Stockhausen.* There's a clammy mess about his feet. Looks down in shock and horror. Masses and masses of worms. Heaped upon each other in their thousands. Covered in snot and heading South. The voices he hears are a long way off and have a hollow echo sound to them. Like a seaside cave. The pain he feels on his bleeding knuckles serves only to drive the fury. A violent swishing of arms and pistons. Steaming out of control. There's a madness in his rage that's pure inspiration. As if God himself wants to test his greatness. And Caleb doesn't let him down.

When the calm descends he studies his knuckles. The skin has vanished in several places and blood flows freely from the cuts. A bruise on his forehead where the nut went in. A splashing sound attracts his attention. He turns and sees Errol floundering in the water. Screaming. Yelling for help. A dark crimson patch spreading all around him. Backwheel is hauling him into the side.

Caleb surveys the scene. Looks at the ranks of frightened soldiers crowded along the bank of the canal. Staring at him like he's a nutter. In silence. No doubt in their minds he is now the gang leader. Just proved himself in battle. Now he must lick them into a fighting unit just like Telly Savalas.

With the scooter lying at the bottom of the canal Caleb has to kill some time. A game of war seems most appropriate. The

* In his book 'Anatomy and Physiology Made Easy' Stockhausen claims that from conception all humans are allocated a fixed number of heartbeats by the Supreme Force. This sadly, he's discovered, may be as low as one, or gladly be as high as a trillion billion billion and two. Stockhausen has recently been working on genetically modified cheese taken from the male and female prepuce to see if he can discover what this unknown number is. He sees the commercial potential in making such a service available to the general public. He claims once you can unravel the mystery of the heartbeats you will be able to determine the very year, month, day, hour, minute and second of your death and thus make all the appropriate arrangements. E.g., go shoplifting or shoot the wife and her lover.

Nazis versus the Council Taxpayers Liberation Army. He puts the skinhead Kowalski in charge of the Nazis and gives them a five minute start. Sergeant Perkins should captain the C.T.L.A. but he's in no condition to take command. Sulking. So Greenwood is chosen to be their leader. An opportunity to find out if he's officer material.

Caleb and C.T.L.A. watch in admiration as Kowalski drives his army onward. Leading from the front. Across the Canal by the dangerous means of two giant sewer pipes that shoot out from the Paper Mill. There's the natural stamp of a leader about the number 14 ranked Kowalski. Bullying some and persuading others until finally they're all safely across. Greenwood shouts their time is up. Orders the C.T.L.A. to charge the sewer pipes shouting all kinds of obscenities across the water. 'Let's get the Nazi cunts!' Shitty Shearn the loudest of all. Back to the Shitty they all know and love. Soaking wet and filthy dirty with poo running down his leg.

Errol stays behind. Sullen and soaking. A split lip and badly swollen nose and face. A right eye that's completely closed. Still doesn't understand what he did was wrong.

"You didn't have to shame me up like that man. Not in front of all them pricks. That was fuckin' tight man!"

"What would have happened if you'd killed him Errol?"

"Don't give a fuck! You shouldn't have done it. Ruined my fucking coat!"

"Fuck your coat Errol! If Shitty Shearn had drowned you would have gone to prison for twenty fucking years! I'd be fucking court-martialled! Can't you see that?"

He shrugs his shoulders. He doesn't. Caleb has to explain.

"That would have been the end of it! No money from your insurance business! No money from crisps! No escape from the tunnel! Nothing! Fuck all!"

"But you didn't have to shame me man!"

"But what if you'd killed him? Can't you see?"

"I can see but."

Caleb doesn't allow him to finish his sentence. That's all he wanted to hear. Puts two arms around Errol and gives him a mighty hug.

"Good lad Errol! Brilliant! As long as you can see! Now we can move on together as a team. With you on my side we can be out of I.S. before the cricket season starts! I need you Errol. Listen. For all the inconvenience you've suffered I'll promote you to the rank of Major and make you into a prefect. I can't be fairer than that!"

An eyebrow slowly climbs up his forehead. The idea appeals to him. Caleb drives the point home with an extra inducement.

"I could even put you on a little wage. Nothing special because you get enough already and you've got the flat rent free. How about it Errol? You and me together?"

Being made a prefect satisfies his ego. It would look good on paper when he applies for a job. A responsible lad who can certainly be trusted. A twinkle returns to his one good eye. Only pride prevents him coming across.

"Look Errol I'll say it again. I'm sorry okay? Now come on. Shake hands and we'll forget all about it."

A look of resignation on his face. Slowly he accepts Caleb's outstretched hand. They smile and embrace again. Male bonding at its best. Pat each other on the back and make their way across the sewer pipes towards the Paper Mill.

Caleb feels terribly guilty about the way he's behaved and tries to think up more ways to repay Errol. If this boy's going to be his strong right arm he needs some academic clout. Stand up to media scrutiny.

"What GCSEs are you taking this summer Errol?"

As if Caleb didn't know.

"I ain't taking none sir."

"Well you are now! Maths, English, History, Design and Technology and Art. And you're going to pass!"

Winces as the cut on his lip breaks open. But laughs all the same and gives a little jig.

"Hey that's great! Boss man! But what about Science? I'm ace at that! I got more worms than anyone else last week!"

Caleb only too happy to oblige.

"You can have Science as well if you want it Major Perkins. Just leave it to me."

Errol flicks his fingers Afro-Caribbean style and erupts into a spontaneous display of uninhibited pleasure. Legs twitch and stretch to the beat of techno coming from the grassy bank. The Master I/C Music lays stretched out on smack. Syringe at his side. Yellowhead living on a different planet to the one ordinary mortals share. Mortals like Bogey who runs up to Caleb with twenty quid clutched in his grubby hand.

Caleb knows it will be easy for Errol to pass his exams. He'll nick the coursework off the keeners in the Main Block and whisper the answers in his ear. An amazing achievement for a boy from I.S. to take six GCSEs/and pass. A cap in his feather.

CHAPTER 15

Caleb hiding behind a tree outside Kaye's school. Keeping an eye on the car park. Left Major Perkins in charge back at camp which allows Caleb to sort out a few domestic matters. He's full of praise for Errol who despite the slight misunderstanding at the Feeder Canal is developing into a fine young officer. As is Ivan Kowalski the skinhead. He's beginning to emerge through the ranks as well. The struggle has brought the best out of them both. Whilst Errol is Top Dog, El Supremo, Kowalski has greatest influence over the whites. Even more so than Greenwood. If he gives the nod they're more inclined to fall into line. Caleb puts it all down to the Lancashire system of P.S.E. Which nurtures individuality. Each pupil a personality in their own right. In total control of their lives.

He sneaks another look from behind the tree. All the kids are going home. Being collected by anxious parents who wait in the playground and occasionally cast the odd worried glance in his direction. Suddenly a beat inside his breast. His breathing rate increases. Kaye and Roger Sweet come out together. Stepping gaily as they go. Not being consumed by heavy guilt at all the lives they've wrecked. Three young children under five and Caleb two years off retirement age. Nothing! No sign of any remorse. Fuck all. Just laughter. The cunts!

Caleb follows them in his car. Safely at a distance. Head well down behind the wheel. He wants to find out where the bastards are living so he can put Operation Stalker into action.

He watches from fifty yards down the road as their car pulls in and they both get out. Sweet wears a suit and carries a briefcase. In his one good hand. Puffed up little prick! The sort of chap who knows the specific gravity of all the beers. How to start a car when the battery's flat and can recite huge chunks of Casablanca. Word perfect to impress the girls. Caleb can't believe Kaye could fall for a wanker like that? He smoulders inside his car. Dreaming up excruciatingly violent ways of ridding the world of garbage like Sweet. Sees Kaye

appear in a ground floor window pulling the curtains across. The room where this betrayal is taking place. His imagination runs riot. She's at the sink wearing red rubber gloves and he's coming up behind her to whisper in her ear. Saying "I'd love to talk about your day at work but right now I'd like to fuck your brains out". What a cunt with his stupid little goatee beard resting snugly on her shoulder.

The imagery only serves to goad Caleb on. The cricket ball with note attached clutched tightly in his hand. Out of the car and rush the building. Hurl the grenade through the downstairs window then dive for cover behind a car. Scurry zigzag back to the Allied lines. On the beach at Omaha. Into the Capri and speed away. Lots of backwheel spin and smoke.

Inside the flat Kaye gives a startled yell whilst Sweet the Brave rushes for the door. Even with his right hand in plaster he's man enough to step outside. Nothing. Empty cars parked up and no one in sight. Angrily he shakes his head and returns to Kaye to comfort her. She hands him the note Caleb spent hours creating from letters cut out from newspapers.

> "Everywhere you walk
> Everything you hawk
> Every time you pork
> I'll be stalking you."

> Signed Stung.

"He's off his bloody rocker! I'm going to the police!"

Kaye remains calm. Knows what to do.

"No. Not the police Roger. I don't want that. I'll go round and see him later on. I've got to collect my things."

Hours later and Caleb's back at the family home. It's early evening and he's fraught with worry. His training schedule didn't go to plan. A lethargy tonight that caused some concern. For some strange reason he was out of sorts. Had to put Rosie down and rest. He supposes by rights he should be in bed, a bit of a cold and riddled with drugs. One sort or another. There's been important developments in that direction. The prescription pads he presented to Errol for services

rendered to the cause have finally run out. Dr Hickey's signature can only be forged a certain number of times before the pharmacist gets suspicious. However Major Perkins has managed to stockpile a considerable quantity of barbiturates and amphetamines. As well as Dianabol and Lorazepam. Poppers available from the clubs. Fast and relaxed with great big muscles all enhancing sexual pleasure. It's taken Caleb some time to get used to them all!

He tucks into his curry sauce and chips and settles down to watch Coronation Street. A flagon of cider at his side. The door bell rings in the Rover's Return. Wonders who the fuck it could be! This is the quality time he spends with himself and he hates to see it going to waste. My God! He can't believe it! Buckles at the knees and crashes to the floor. Stares up at her gobsmacked. A vision of loveliness. From where he's sitting.

"Hello Caleb. What on earth you doing down there?"

"Come in! Come in please!"

Kaye steps into the hallway he created for her. Sanded with four coats of varnish. Eyes the stained glass windows. She casts looks of approval at the stripped pine balusters supporting the mahogany rail. Her idea he did that as well. Gave a nice old Victorian feel to the value of the house. Caleb fusses over her. Makes apologies for the state the house is in.

"You should have said you where coming round. I would have got something in to eat."

Kaye cold and emotionless. Heart made of stone.

"I've eaten already."

Caleb refers to his chips.

"You don't mind if I finish these off do you?"

"Of course not. Go ahead. You look as if you need them."

He wants to say of course he does. Hasn't eaten properly since she left. But he doesn't. He's all smiles and still reeling from the shock as they make their way into the front room. Smelly clothes and dirty dishes piled up on the carpet. Cat shit on the arm of the chair.

"I'm sorry about the mess Kaye. I wish you'd let me know. Take a seat. Sit down."

She finds a chair without any litter and sits very formal and upright in it. Casts a disapproving look around.

"There's no excuse for it to be in this state Caleb. It's filthy."

"I know. I just haven't had the chance. I've been too busy!"

"We noticed. We got your message."

She takes the cricket ball out of her handbag and places it on the table. Caleb gives it a puzzled look.

"What's that?"

"Don't pretend Caleb. You know damn well what it is! One or both of us could have been seriously hurt!"

Caleb's eyes twinkle with delight. Oh joy of joys! If only. So hideously disfigured that Kaye throws up at the sight of him. The very thought of his touch.

"I'm sorry. I'm forgetting. D'you want a coffee?"

"No thank you Caleb. I'm not here to socialise. It's business."

"What business?"

"Certain things you've got to understand Caleb but I don't want you getting angry or upset when I tell you. Please try and listen to me for a change."

"Depends what you say."

She looks him straight in the eye. He studies her face. For the first time he sees her as she really is. Physically and spiritually. She's fucking repulsive! Just like Medusa.

"You've got to stop harassing us. Roger's going to the police if it happens again."

"Why didn't the brave man come round and tell me himself? Hasn't he got the bottle?"

"I wouldn't let him. He's already got one arm in plaster."

Caleb laughs.

"He's nothing to fear from me Kaye. I'm a pillar of the community. A newly appointed Head of Department. The sort of chap you can take into the jungle with you!"

To prove his point Caleb leaps to his feet and fights an unseen foe, probably Japanese, karate-style in front of her. Chips still in hand and feet stopping just inches from her face. She's not intimidated. Fixes him with that despising look

only a soon to be ex can project. She can see he's off his rocker.

"Are you seeing a doctor?"

" 'Course I am."

Chicken noises come from the back of his throat and feet move like lightning to scatter a chair. She's still not the least bit frightened. Caleb takes great care to avoid her gaze. Has no wish to be turned into stone.

"What's he say?"

"Just a load of tablets to keep me stable. Help me pass a motion. Recommended I see a psychiatrist actually."

"And did you?"

"Yeah. I did as a matter of fact. A Dr Benefield. Nothing serious really. She said I was suffering from severe depression. Wanted me to stay."

"Caleb I never believed for one moment you would take it like this. I honestly didn't."

"How then? Hold a party? Celebrate?"

"Yes I did. I thought you'd laugh. Like all those other times I threatened to leave and you said I hadn't the guts."

"I was just teasing you Kaye. Winding you up."

"You were destroying me Caleb. Why I don't know, because in those days nobody loved you more than me! I thought the world of you. I idolised you! That's why it hurt so much!"

Caleb limp and sorry in his chair. Head bowed low in shame and remorse.

"I didn't mean to hurt you Kaye. I love you. I want you back. Krees."

"Please don't tell me you love me Caleb! For Christ's sake don't expect me to believe that now! Don't kid yourself! You never loved me!"

"I did Kaye. Krees. In my own stupid useless way I did! I just didn't tell you that's all. For some daft crazy macho reason I just couldn't tell you. I'm sorry. What more can I say?"

"It's too late to be sorry Caleb. I'm a different person now. You taught me how to be hard and aggressive. You've nobody to blame but yourself."

Caleb turns towards her. One last pleading and pitiful cry for forgiveness. Careful to avoid her stone making gaze.

"Come back Kaye. I need you. It'll never happen again. I promise. Krees. We've got so much to live for together."

"No Caleb. I'm sorry. It's over. We've got to sell the house and go our separate ways."★

There's a muffled implosion in Caleb's head. Boom! Sirens go off in the distance. His heart skips precious beats. Blindness too. Never, never in his wildest nightmare did he dream she'd say such a thing. He sits bolt upright in his chair and looks at her aghast. Screams across in rage.

"Sell the house! You're fucking joking! I'm not selling the fucking house!"

Kaye remains calm. Completely unruffled.

"You'll have to. Roger and I want to buy a house together. We need the money. Besides I'm entitled to half its value."

Caleb leaps to his feet. Thrusts his dirty stubbly face into hers. Bloodshot. Eyeball to eyeball. Nose to nose. Words spit out. Foul breath forcing her to turn her head.

"After all the work I've done on it! So you can give your share to that fat idle wanker! You must be fucking joking!"

She jumps from her chair and heads for safety. She's seen him in this mood before.

"If you can't talk about it in a civilised manner Caleb, I'm going. I'll put the matter in the hands of my solicitor."

Caleb follows her out. Mood swing turned full circle.

"Listen you mercenary bitch! D'you think I've put in all that work! Hours and hours! Central heating! Double glazing! Patio doors! Pinewood fucking kitchen! For you to share it with that weird cunt, you're joking!"

She's reached the front door. Six panels and recently painted. Opens it herself and steps outside.

"Goodbye Caleb. My solicitor will be in touch."

★ When Kaye Duck gave her evidence she was asked by Judge Bradley appointed by the Government to head the Enquiry why she felt so certain her husband was lying to her when he told that he loved her. She replied, "He had his fingers crossed behind his back and kept on saying krees. He always did that when he was telling lies."

She struts down the path as if she owns it. He yells out more of the things he's done.

"Fishpond! Garage! Loft conversion! Herb garden! Quarry tiled floor in the kitchen! So I can give half to that fat bloated turd! You're fucking crazy Kaye! Fucking crazy!"

She doesn't turn a hair. Draws back the bolt of the garden gate with the crazy Caleb close behind. Building up a good head of steam. Forty-five pounds per square inch. Ready to explode.

"Sanded floors! It's my fucking house you treacherous whore! You didn't lift a finger!"

Kaye turns the corner and strides away into her brand new life. Easy. She'll champion the cause of the female warrior to the plaudits of the hairy brigade. Armpits and moustaches. The power of the Sisterhood urging her on to deeds of great destruction. The bitch! The fucking bitch!

It was Lord Denning who started the rot. Fucked it all up with his Report. Making it much easier to get a divorce by offering women equality. Opened up a can of worms! Eroded family structure. Brought about a teenage rebellion when no father was there to lay the boot! Now they reap the whirlwind they created and blame it on the schools! Teachers like Caleb and Silent H. Makes him hopping mad! No wonder Goldilocks wanted to steal the porridge. The fucked up child of a fucked-up marriage suddenly became an anti-social type. Went in and helped herself. Grabbed a bit of family fun. The three bears had it all. Mummy, Daddy and Baby Bear. A perfect template of a family unit setting a fine example. Nothing to do these days with reality!

Caleb stops screaming abuse at her. Pauses to gather his senses. Resigned to taking a beating this time. Returns to the peace and quiet of his own company. Finishes off his chips. A Beta-Blocker to slow the pulse and a Roofie to forget. They don't take long to kick in.

CHAPTER 16

When Caleb awakes about twelve hours later only one thing consumes his train of thought. Devours it like a maggot. Roger Sweet and half his house! He looks at the clock. Late Saturday night! There never was a better time.

Collecting Boom-Boom from the Bamboo Club deep in the heart of St. Pauls. It's a meeting place for all black youth where goods are bought and sold. Caleb is welcomed with open arms by all his former pupils. They appreciate what he's done for them. Set them up on the straight and narrow. The only white man in the room. Even amongst these seasoned veterans Boom-Boom reigns supreme. They all appreciate the genius of the lad and accord him reverential respect. Nothing is too much trouble for Boom-Boom.

He follows in the 'K' reg Astra he's borrowed for the night. Glides in slowly behind Caleb's Capri. Gets out and eyes up his challenge. The Nissan 200. He's already done this once before when he removed the stereo but Sweet being the uptight little shit he is must have improved the system. Caleb leaves Boom-Boom to get on with the job whilst he risks a peep through the window. Probably gorging themselves on each other's bodies. Why not if pigs can do it? Isolated themselves from all their friends. Persona non grata after what they've done. Nobody likes a woman who busts up a marriage. Especially where young babies are involved. He risks a sneaky look. Jesus Christ! Another betrayal! Jayne and James sitting at the table. Eating with the enemy. Carrying on as if nothing has happened. Fucking arseholes! Caleb can't believe it. How treacherous can you get? He's just about to smash the door down and charge in to confront them face to face when Boom-Boom gives a whistle. He's got the doors wide open and the bonnet up.

"Well done lad! I'll see you're well rewarded for this!"

Boom-Boom smiles a wicked smile. Praise indeed from the Commander-In-Chief.

"Thank you sir. But I don't want money."

"What then? Name it and it's yours!"

"I want the same as Errol sir. Five GCSEs."

Caleb is amazed. He could have asked for anything. Money. Drugs. Time off school. A one hundred per cent attendance certificate. Crisp packets. Anything! Instead he chose academic qualifications! Absolutely fucking brilliant! Proof, if ever proof were needed that Caleb's teaching methods were the best.

"You've got them lad! And may I say I admire your choice. It smacks to me of self-motivation. Now fuck off out of here before you get caught!"

Caleb runs back towards his own car. Takes out the bags of sand, cement and chippings and sets about the thing he enjoys doing most. A bit of DIY. No matter what the time, the place, the job, the thought of being creative in a practical sense sends a surge of pride coursing through his veins. There's something basic and honest in the sweating brow. The smelly armpit and dirty hands. Caleb feels it now as he mixes the concrete. A good strong mix of 1:1:4 and chuck in a cupful of quick setting solution.

Carrying buckets along the road and tipping the cement into that fucker's engine. Six times he does it before it's full then he closes the bonnet and leaves. Silent like a criminal.

As he makes his way home in the car Caleb ponders on the actions of Jayne and James. Eating at Sweet's table and sharing his jokes. Why for God's sake? Why? What could have possessed them to betray him like that? That man spreads his evil like a cancer. Needs to be cut out. Not patronised in a gluttonous manner.

Caleb in the bathroom giving it welly. All this worry and stress has caused his gut to rumble. The thought of losing half his house has triggered off the moment! Straining like fuck but having no reward for all his valiant efforts. Fixes up a system of angled mirrors from the floor to the edge of the bath. Now he can give himself a rectal examination by making a fine adjustment to the shaving mirror. Magnifying side face out. It's not a pretty sight. The swollen golf ball now

plays cricket! Complete with raised seam and much more worrying, a tiny trickle of blood! Oh my God! He's being split asunder!

The sound of the phone ringing in the hallway brings him partially to his senses. Must answer it quick. Get out of here but not as easy as it sounds with the wretched stool stuck hard in place. Needs time before it retreats to its den.

Surprise! Surprise! It's Jayne on the phone. Jesus! A fucking conspiracy! He doesn't let on he saw her earlier. Lets her do the talking. So, after much palaver.

"Look Dad. Don't ask me to make judgements. Okay. I love you both. I'm not going to take sides."

"So having a fucking slag for a mother is alright by you?"

"Don't call her that!"

"Why not? It's true."

"Dad can I give you some advice?"

"Depends what it is."

"Let her go. She's obviously made up her mind."

"Is that what she told you?"

"Yeah."

"I can't do that Jayne. I love her too much. Krees."

"All you'll do is tear yourself apart."

"I still believe we can get back together. I'm not letting her go without a fight."

"I've got to go my money's run out. Look after yourself Dad. Take care."

"Jayne. You still there?"

"Yeah. Quick what is it?"

"Did you enjoy your meal tonight?"

Silence for a very long second. A dramatic pause then hit her again. A tear in his eye when he says it.

"Did you laugh at all his jokes?"

A lump in the throat as he puts the phone down. That's given her something to think about. Bitch!

Caleb stands alone in the hallway. Trousers down around his ankles. Knees slightly bent to ease the pressure. Now he knows his kids are in the enemy camp he feels a forlorn sight. Kaye's a bitch to do this to them! A loving, close-knit family

125

unit with everything under control. All their futures mapped out neatly and living happy ever after. And now she's fucked it all up. Caleb realises just how fortunate he is to have his career to keep his mind off things. Without the intellectual challenge his job presents he swears he would go crazy.

A Mahler symphony on full blast as Caleb ponders the current state of affairs. He'd go into the boiler room and work on the tunnel except W.C. Rees has organised a P.T.A. dance. Can't risk going in and being seen. Major Perkins will be in there guarding the office as well as getting his end away. Rent free. Lucky bastard. Caleb's told him if he ever gets bored he can colour in a few pages of the National Curriculum. Kurpal and Gazala could do with some help if the document's to be ready by Monday. He thought a nice pale yellow would go down well. To match the streak down Rees's back.

Caleb slips deeper and deeper into gloomy despair. Maudlin in his Mahler mood. Empty bottles at his side he sits staring into the flames of the coal effect fire. In desperate need of female companionship. Angela White would be the one but she's away on a weekend course. Least that's what she told him when he gave her a ring. As Caleb pops the last of the Roofies he tries to remember what Errol said. He couldn't.

A body dancing in the flames. Naked and swaying in the fire. A beautiful girl. Young, perhaps only sixteen years old. Lithe and fluent in her movements. Beckoning him to be at her side. A sultry temptress if ever there was one. Very slowly he begins to make out the face. By God! It's one he knows already. Lynda Coles! That's it! Caleb clambers unsteadily to his feet and makes his way over to the stripped pine door. He did it himself with a Stanley knife blade. Colour enhanced with a light oak dye. Out into the hall. Finds his jacket and takes out her card. The one she uses for business only. He dials a number and lets it ring. A voice answers.

"Gentle Touch! Can I help you?"

"Can I speak to Karen please?"

He has to use her showbiz name. The girl's got class. Evades tax that way.

"Who's calling?"

"Mr Duck."

"You trying to be funny?"

"No. That's my name. Tell her it's me."

"Fuck off! You're taking the piss!"*

He hears voices speaking in the background. A laugh and then she comes to the phone. He tells her his problem and she says she's working. Wouldn't be allowed to knock off now. She'd lose too much money and maybe her job. Caleb hears himself saying he'll pay top whack. Whatever it takes plus twenty quid. All this is against the law he knows but because of the way he feels tonight it's well worth taking the extra risk. More muffled voices in the background and then she speaks again.

"Will you pay for a taxi?"

"Of course I will."

"Okay then luv. I'll be right over."

Caleb retreats to the kitchen for a drop of voodoo magic. A few down his pants for luck. He can just about remember answering the door and the lovely Lynda standing there. A youthful vision of innocence. Smiling and clad in a black plastic mac. Dark eyes smouldering with the love that's in them and teeth that flash their welcome. He invites her in and shuts the door. Turns and holds her tightly to him. They hug for what seems like an eternity. In total silence. He for the warmth of a human body. The companionship, the scent and touch. She for the money she's going to get. Plus the taxi home. Lynda always the businesswoman is the first to break the spell.

"Let's get on with it then shall we luv?"

"Like a drink?"

"Love one. Kill two birds with one stone. '

Caleb collecting the booze and glasses. Returns to the hall

* At the Enquiry the owner of the 'Gentle Touch' massage parlour, Mr Patrick O'Hiley denied he had ever employed a Lynda Coles or Karen to work for him. He agreed he had met Mr Duck before. Once when Mr Duck turned up at the parlour drunk one night asking for a chicken tikka with rice. The second, when he purchased a Nackmichi CD 701 car stereo system from Mr Duck at a car boot sale held in Walliscote School in aid of his 'Books For Orphans Appeal'.

where Lynda is standing. Naked. Plastic mac lies at her feet. She pulls the band from out of her hair. Allows it to tumble softly over her shoulders then makes her way slowly up the stairs. Stopping every now and then by bending forward at the waist and addressing him from between her legs.

"Seen anything you fancy yet?"

Her arms and legs splayed wide apart. Out to the edge of the stairs. Caleb's heart thumps wildly at the sight of her round tight bottom. The downy clump of her pubic mass peeping out from the upper reaches of her thighs. His breath is taken away. He can't resist the temptation. Cannot wait. Trembling. Puts the glasses and bottle down and climbs up close to hold and clutch. My how he needs this! Heart leaping like a trout. Fingers sweep the rounded contours and wander down below. Now he has her in his hand. Soft like a pheasant's breast. Warm and moist. He gently massages the Volvo opening until his fingers slip inside. Lynda moans with the pleasure of her growing wide-on, thrusts back her head by arching her back. Claws her way up to the top of the stairs and lies face down on the landing. Just her legs hanging over the stairs.

"Do it now sir if you want."

'Course Caleb wants. He stares open-mouthed at the milky white tunnel. Spread open. Inviting him to fuck her hard. Hard as she's never been fucked before. Balancing precariously on one leg he starts to remove his trousers. Holding onto the banister rail. In normal circumstances it's an easy task. One he can do everyday. But these are far from normal. His head is roaring at the sight of her cunt. His hands shaking to get a decent grip and he can't get his pants up over his prick. He can't remember it being this big! When he mentioned this later to Dr Benefield at one of their weekly meetings she played along with what he was saying. Found it all highly amusing. She suggested it was probably the weight of his hugely engorged phallus that threw him off balance and down the stairs. Backwards. Head over heels. To land in a heap in the hall below. And Caleb tended to agree with her. Seriously.

Anyway, on with the story. Thanks to his marvellous

physical condition he was saved from serious injury. The coolness of the dishcloth she presses to his forehead allows his thinking to function correctly again. The first thing it does is register joy. Joy that someone actually cares for him. Everybody needs somebody. Needs somebody to love. Caleb says a little prayer. Thanking Jesus for the strength to continue and do the work His Father wanted.

Caleb lying naked and outstretched on the duvet. The silver handcuffs Lynda brought with her keeping his arms and legs in place. Head propped up with a pillow behind it watching as she wields her magic powers. Not enough time or space to go into detail. Suffice it to say she was as good as her word. Nothing was too much trouble. Cartons of chocolate mousse came into play along with a canister of instant whip topping. Which she feasted on from every nook and cranny. Even filled his foreskin with it and sucked it out in one. Delicious.

Caleb lost count of the number of times he came. Each orgasm more mind-blowing than the last. Passing in and out of consciousness only to be awoken again and again by her gentle licking of his balls and the sweet taste of chocolate on her fanny as she lowers it slowly over his mouth teasing his tongue to pop inside.*

* Dr Benefield told a packed and spellbound Enquiry she was certain Mr Duck was fantasising the entire incident between himself and Miss Coles. In fact she burst out laughing when he recounted the incident to her and had to leave the room.

VERY URGENT

From: G. Rees B.Sc To: C. Duck
 Deputy Headmaster Acting Head of Integrated
 Studies

Date: 20.5.98
Time: 8.00 a.m.

In view of the impending Ofsted inspection certain pro-
cedures MUST be tightened up.
1. It is imperative that you check through every register and
 send the enclosed letter to all parents whose children have
 had more than five half-days absence this term.
The Headmaster wishes to express his dissatisfaction at your
reluctance to obey previous directives. He is also concerned
by your increasingly bizarre attire and belligerent attitude
towards school regulations. He will be calling you into his
office soon and asking for an explanation.
May I remind you that the following matters are still
outstanding.
1. Copies of the National Curriculum, in all subjects please,
 as used in the I.S. Department.
2. Explanation for not attending 'Stress Management' course
 to me.
3. Registers to be returned to the Main School office after
 every registration period. Not as and when you deem fit.
As a final note I should like to remind you that you are a
member of a professional body and as such you should behave
in a professional manner! You are having a bad influence on
some of the younger members of staff and a demoralising
influence on all of the others. You are also setting a shocking
example to the children in your care.

 G. Rees B.Sc Deputy Headmaster

CITY AND COUNTY OF BRISTOL

WALLISCOTE ROAD SCHOOL
WALLISCOTE ROAD
BRISTOL BS5 8KG

Headmaster:
M. WILLIAMS B.A
Telephone: Bristol (0272) 22221

Dear

We should like to seek your co-operation in ensuring that pupils attend school regularly and for this purpose we are writing to let you know that your son/daughter's absences for this term total _____ half-days. If you feel there is a discrepancy between this figure and the number of occasions you were aware of absence please contact us immediately.

Any absence has an effect on performance and even short absences can add up and badly effect a pupil's progress at school.

Yours sincerely,

Head of Integrated Studies Department

CHAPTER 17

Major Errol Perkins of the I.S. Light Infantry is marching his men into Assembly. Corporals Greenwood and Kowalski stand to attention below the pyramid of desks that Commander Duck had built at one end of the hall. To serve him as a pulpit. Daring anyone to speak or take their eyes off their leader who stands triumphantly at the helm, medals heaving on his chest as he watches with pride the scene below. Charged with the speed of Errol's prescription. He makes a very impressive sight this morning. Camouflage trousers commando style with an added touch of rock 'n' roll flamboyance. An Elvis cloak of the Las Vegas variety.

Major Perkins barks his orders out to a thundering rendition of 'The Dam Busters March'. Not really John Irving's favourite music but one he felt appropriate to start the session. Caleb believes the troops are in need of another rousing speech. One to raise their morale. The sisal plant proved to be a great success and he wants to repeat the experience. When all is finally still and quiet the Commander begins the lesson. The story of Gelert the Faithful.

"Once upon a time when Prince Llewellyn decided to go hunting he left behind his most trusted dog Gelert to guard his son the baby Prince Hywel. After enjoying a long day's hunt Prince Llewellyn returned home. He was greeted at the castle gates by his faithful hound Gelert. Prince Llewellyn looked at Gelert in alarm. The dog's face was a mass of blood. The Prince got off his horse and raced through the castle to the room where the baby Prince slept. Prince Llewellyn cried out in anguish at the sight which befell him there. The room was awash with bone and blood. No sign of the baby at all. In a rage the Prince looked at Gelert and saw the blood upon his face. He figured his dog had killed and eaten the baby. He drew his sword and thrust it into Gelert's side. Again and again. The hound stared in bewilderment into his master's eyes. Gave out one last haunting howl before dying at his feet. Suddenly Prince Llewellyn heard

a baby's whimper coming from beneath the cot. He rushed across and looked underneath. There to his horror he saw the body of a huge wolf and behind that his baby son sitting unharmed. Prince Llewellyn collapsed to the floor in shock and grief when he realised what he'd done. It was obvious there'd been a tremendous fight and Gelert had killed the wolf. Saved his son from certain death. Now to his eternal shame he had slain Gelert. Prince Llewellyn never recovered from the shock. He had Gelert buried in a beautiful grave just outside the castle wall. It's still there today and when we all get out of here I'll take you there to see it! As for Prince Llewellyn he died not long afterwards from a broken heart. Serves the bastard right I say!"

Caleb stares around the hall at his assembled troops. Fixing them with a steely gaze. A weeping and wailing sound fills the air. They all have tears in their eyes. Up to their ankles in water. Even Kowalski the hard case skinhead has a lump at the back of his throat. Caleb's face flushes success. Impressed at his ability to rouse the masses he now ranks himself with the very best. Alongside Benn, Kinnock, Scargill and Hague. William that is not the place in Holland. He gives himself a long dramatic pause. Eyes darting around for a special effect. Everyone waiting for the punch line. Caleb gives it them straight. Yells at the top of his voice.

"And that's what will happen to you if you don't obey orders! Understand what I'm saying?"

One of his voices tells him that wasn't the point of the story but to be honest Caleb can't remember what the point was. Roofies must take the blame. Who cares? They listened anyway. He points a finger at Yellowhead and the Head of Music responds at once. Under a deal hammered out with Caleb, Yellowhead gets to play after every assembly. If he's here. Much to Sir John's chagrin. Soon the huge wobbly bass booms into action. Turns everyone's guts to jelly. One after another the troops start to twitch. Slowly at first. Only a shiver. . . . But then with a disco style beat of 'four on the floor' the whole place starts to jump and jive. UK speed-garage-house. All in a frenzy of musical celebration. A mass outpouring of togetherness.

Caleb soaks up the atmosphere in ministerial splendour. Re-vitalised after one of the great assemblies. Feeling good too after his weekend adventures. Screwing Lynda and concreting a car. Both giving him equal satisfaction as well as a pair of swollen boll-ocks. His ego at an all time high. Mr W.C. Rees should witness all this. Show him how it's done. Mr Fat Twat as Lynda calls him hasn't the guts to come across. Instead he makes implied threats via the internal postal system. Cowardly bastard that he is. He knows only too well how the kids would react if he ever showed his face. But you can bet your life when he goes for promotion he'll speak of the empathy he has with these pupils. Why he's even written a book about it! Working with children with Special Needs gives him enormous job satisfaction! Lying cunt!

Caleb returns to his office and gives Lynda a snog. Deep throated tongues because that's how he feels. She makes him a lovely cup of tea and he passes over W.C. Rees's latest memo for her to file away. Neatly.

The National Curriculum does pose a problem. Gazala and Kurpal are falling behind in their task of translation and col-ouring it in. Get Lynda to round up a few more of the girls who are good at Art and working long hours. Perhaps they could follow up another idea? Fold every page of the docu-ment into eight equal sections then rule with parallel lines! Shade each section with a different colour? That's bound to keep Rees quiet for a bit and impress the Ofsted team!

The World Table Tennis Championships are in full swing. Corporals Greenwood and Kowalski are in charge of the pro-ceedings with refreshments provided by the girls. It's their practical exam for GCSE Cookery and if they do a good job they'll get a Grade A pass. Yellowhead's been given the rest of the day off. He had to go downtown and make a raise but before he left he made a deal with Caleb if he kept an eye on his stuff. Gave him a tiny sample of a thing called Horse. Wrapped in a piece of tinfoil. Told him to heat it and inhale the smoke. It should make him feel a lot better.

Sir John takes full advantage of his opportunity. Steps grate-fully back into the spotlight. Proud to perform at such an important event. He conducts his way through 'The Ride of

the Valkyries'. Wields his chair leg with great aplomb. When he's in this mood he's brilliant. Has a far greater depth of interpretation than Sir Georg Solti in his prime.

The teaching staff are both very busy. Jan Scott has Baldev in her room again. On a one to one. Leaning heavily over his shoulder and pressing her tits into the small of his back. Pretending to mark the work she's made him do for being a naughty boy last night. He went round her house and tapped on the window after she told him her husband was going out. She invited him in for a good telling-off after a shag on the carpet and a cup of tea in bed. No wonder the boy's confused. Totally fucked up or whatever they call it.

Lyn 'Bloke/Girl' Jones has got a problem. She's broken a leg in a rugby match. Not satisfied with doing that she entered a beer drinking contest in the clubhouse afterwards. Fell off a table and snapped her wrist. But just to prove how hard she is she reported for duty at nine this morning. Came by taxi in a wheelchair. The first time she's been early this term. Basically she's a caring person. After pints with the lads and poses in mirrors. Using each to emphasise her muscular bulk. She actually cares about her budgies. Dedicated her life to her birds. Trying to get them to live in peace and harmony. Making sure they're fed and watered. Kept nice and warm in their cage. Teaching them all how to talk. In fact all those things she's paid to do for the kids in her class. But doesn't or can't.

Andy Powell is in Weston again. Phoned up sick early this morning. Looking for a pub where he can stop for a drink and take a well-earned rest. Nice bloke Andy. Idle cunt.

The Commander-In-Chief of this enthusiastic team is down in the boiler room directing operations. Twelve feet below the level of the adjoining playground. The sportsfield is beyond that again. Caleb's discovered the best way of shoring up the tunnel is to copy the method of Silent 'H'. Use the new plastic-topped desks from the Sixth Form Block. They stretch from one end of the tunnel to the other and when enough earth has been dug out the whole line is shuffled along to the face and a new desk added onto the end. A marvellous system that worked! All the earth is shovelled into

a wooden box which is then dragged back to the boiler room. Here Negat and Sima studying GCSE Geology spoon it into the stolen socks captured in a Sports Hall raid. These are handed over to Corporal Kowalski and trusted inmates dispose of them. Carrying it under their skirts or down their trousers. Around the district and down the drains. In fact anywhere they like. Caleb's made the job of earth disposer a much sought after position. Not only was the prisoner paid two empty packets of crisps per shift but they also had the freedom to wander the streets. All day if they wanted to! Marked present in the register of course!

Caleb has never before felt as exhilarated as this. The tunnel is an incentive to drive him on. Achieve a worthwhile ambition. The Speed which Dr Perkins prescribed has given him the power and excess energy to cope with the mammoth task. The strange thing is the harder he works the less sleep Caleb seems to require. So he decides to keep a diary of events for future researchers to read. Help him to keep tabs on things. Thoughts, actions, meetings, plans. Dreams and ambitions for the future. Along with the progress being made. Caleb found he could write for ages. A kind of Captain's Log.

Even at this early stage he can see enormous problems arising. The longer the tunnel the slower the job. More and more pupils will have to be employed. Inevitably this will lead to a shortage of manpower with the project grinding to a halt. An urgent problem to be solved. But one that Caleb relishes. Anything to take his mind off Sweet and the house he's trying to steal. He closes his eyes to hear the voices. Receive Heavenly advice from above. Squeezes his head for additional pressure. Make sure he gets it right. And sure enough it comes.

"Use the same idea I gave to Isambard Brunel. Use trolleys on rails my son!"

Caleb reacts immediately. Passes God's words on to Corporal Greenwood who sees the genius in the plan.

"A fantastic idea Bwana. What d'you want me to do?"

"I want you to get the rails old chap."

Greenwood's knees buckle. Lines of worry begin to show.

"But where do I get rails from?"

"From the railway line you fucking idiot! Where else?"

Greenwood looks aghast. Not even his half-crazy teacher Commander Duck would ask him to go and steal railway lines. It's a two hundred pound fine if you're caught trespassing. Secure Unit treatment if you throw stones at trains! Christ knows what you get if you knock off the lines!

"I can't do that Bwana. They'd kill me!"

Caleb in no mood to accept refusals. He stares steely-eyed at Corporal Greenwood and grabs hold of a pickaxe leaning against the wall. Raises it above his head.

"It's an order lad! Remember the Home-School contract you signed for me? They'll never find your body son! Just the letter you left behind!

Greenwood backs away. He's seen that look in sir's eyes before. Puts two hands up to protect his head in case the pick descends in a hurry.

"Now you be a good boy Corporal Gary and get me those railway lines!"

Corporal Greenwood is drawn and silent. Shaking. The confidence he had a while ago suddenly seeped away. He's trapped and there's no way out. Caleb gives him an additional task. He's not allowing him to get off lightly whilst Major Perkins and the other boys risk their lives down here?

"One other thing Greenwood. Keep an ear open and find out who's got the most empty crisp packets. We can't have anyone actually getting the lot! Everyone else would stop working wouldn't they?"

Greenwood nods his head despondently. By the look on his face he must have a few himself. Choked now he **knows** they're valueless.

"Don't say anything to the others mind Corporal. Just give me their names and I'll pass them on to Errol. Right. Up straight lad! . . . Shoulders back! . . . Attention! . . . Dismiss!"

Gary Greenwood one time scourge of Greenhill Comprehensive leaves the boiler room in a disturbed condition. He's in the shit. Up to his neck and there's no one he can turn to for help or advice. Just as Caleb likes it.

CHAPTER 18

A moment's respite in the boiler room gives Caleb the chance to collect his thoughts. Horse gives off a pungent smoke which Caleb finds invigorating. He's followed Yellowhead's instructions to the 'T' and chases the dragon with the tube his Head of Music provided. A wonderful warm relaxing sensation. Enables him to think.

He contemplates the calibre of kids he teaches and is proud and honoured to do so. They may not be the most academically gifted but give them a task they enjoy doing and they'll deliver the goods. Far better to have lads and lasses like these on your side than the spoilt pampered brats of the public schools who'll let you down in the jungle. These boys are the ones who command the terraces. The scourge of European soccer. Never been conquered in a thousand years. No wonder they feel inspired. Unity through brotherhood.

Sounds of straining and heaving distract Caleb's attention. He turns. Sees Junior Williams ranked No. 24 (C.A. 16.1 R.A. 9.7) crawling out of the tunnel. Dragging the box of earth behind him. Naked except for his swimming trunks and the protective pads on his knees. Crawls in agony across the floor and flops exhausted on the mattress. Caleb's gaze shifts keenly towards the box. Coal! Large lumps of the stuff! Where in hell's that coming from?

The computer-like brain ticks over again. Since God appointed him to make this brave escape ideas have flown from his brain like confetti. The coal can be used as a source of fuel! Power the giant steam bellows that will ventilate the tunnel. What a stroke of luck!

Before he has the chance to investigate further there's a shout from the top of the steps. Corporal Greenwood has returned to raise the alarm.

"Bwana, come quick! Ms Jones's budgies have escaped. She's taking a head-fit! Wants me to wheel her across to the Head to complain about all the noise!"

139

Caleb knows he must act at once. Must stop this woman reporting to Williams. Charges into her classroom to see if she's gone. Relieved to see the Bloke/Girl still there. Shouting and screaming from her wheelchair like some rabid banshee. But nobody's taking the slightest notice. With an arm and leg bound up in plaster it's impossible for her to move without some assistance. And one of the lowlife scumbags has made doubly sure by tying her up in a rope. Tightly to a radiator. Tears of rage and frustration stream down her face as she pleads for someone to let her loose. Implores her birds to return to their cages before something dreadful happens. No chance. Both sets of wildlife choose to ignore her. Deaf-Head Doris, No. 79 and the Bloke/Girl's pet, bellows out her welcome. Never wears her hearing aid because all the others would take the piss. Thinks she has to shout.

"WHERE HAVE YOU BEEN SIR! MISS HAS BEEN GOING MAD WITH YOU! HAVEN'T YOU MISS!"

Bloke/Girl twists her bull-like neck around to speak to Caleb. Huge great slabs of trapezius muscle bulging with the effort.

"Untie me Caleb! Untie me! Let me get my hands on Greenwood! I'll wring his BLOODY NECK!"

Greenwood bristles at the insult. Won't be spoken to by a woman like that.

"Shut yer mouth you fuckin' LEZ!"

Bloke/Girl's face contorts with rage. Struggles hopelessly with her ropes. Impossible with one arm in plaster. Veins and sinews the thickness of rhubarb grow alarmingly from her neck. Grotesque.

"See what I MEAN! Bring him over to me Caleb. I'll THROTTLE the diminutive little BASTARD!"

Greenwood takes up an aggressive stance. Clutches his fists tight-white.

"Come and fucking TRY IT DYKE!"

Even in his drug hazed state Caleb recognises matters could get out of control. Must be seen to be fair and not take sides. Begins to untie her ropes. Talking a load of teacher bollocks. Eyes as glazed as cherries.

"Who's been giving you trouble then Ms Jones? I'll sort them out. We can't have kids going on the rampage. Doing what they like. I mean, that's not on is it? Where's Jan and Andy? Aren't they around?"

"Andy's not in yet. You know damn well he isn't. And Jan's in her room with Baldev doing something. I mean they talk to me like I'm a lump of shit! Greenwood he's the one! Struts about giving orders to everyone as if he owns the place. I asked him to give me a hand with the budgies and he told me to go and fuck myself! Then when I asked one of them to push me across to Williams the skinny little shit tied me up!"

Caleb flashes a look at Corporal Greenwood. Has difficulty in focussing.

"Corporal Greenwood! Shun!"

He springs into the upright position. Eyes fixed firmly to the front.

"Sir!"

"I'll see you in Butlinland at the end of the day!"

Terrible memories are revived. He tries to explain. Trembling badly.

"But Bwana?"

"Shut up you ignorant cunt! How dare you use language like that to Ms Jones!"

Caleb feels genuinely sorry for Greenwood. Only doing the job he's paid to do. Running the Table Tennis Championships. Smoothly and efficiently. He doesn't want to be bothered by some muscle-bound tart who keeps fucking up the order of play. Who even now is giving him grief. Chasing him around the room. Using her one good arm to propel the wheelchair round and round in circles. Her broken leg in Plaster of Paris sticking out like a battering ram. Hoping to jam him up into a corner and crush his bollocks to pulp.

Caleb decides to create a diversion. Get Bloke/Girl Jones back on side. His priority is to return the birds to their cages. More difficult than it looks.

He grabs a pile of Philips' Atlases originally ordered as table tennis nets. Much too big and thus redundant. Sends them spinning one by one in the general direction of the chirping

budgies. Perched high in the ceiling on the iron bars that support the whitewashed beams. The air is filled with squawks and feathers. The voices tell Caleb to keep them flying and not give them the chance to rest. As they'd been locked up for most of their lives they won't have the strength to fly for long. Drive them to the point of exhaustion.

Caleb is getting more and more excited. High as a kite if truth were told. The wonderful feeling of Horse in his head. Soon he runs out of books to throw and looks around for more ammunition. Sees the wastepaper basket in the corner and hurls it up at the foe. Follows this up with chairs and tables. Easily handled with the power he feels surging through his veins. Bloke/Girl Jones still on the charge. After Greenwood and his bollocks. Misses him and crashes into a cupboard. Tons of books crash down on her head. All mostly on budgies and bodybuilding. Rendering her dazed and slightly concussed. Field Marshall Sir Caleb Duck continues to lead from the front. Whoops and yells of blood-curdling menace.

"Come on men! Show 'em what you're made of! Hit the bastards in mid-flight! Kill the fucking budgies! Kill! Kill! Kill!"

Caleb doubles the reward for the first one captured. It's now two empty packets of crisps. At long last the fury of the bombardment begins to pay off. One poor little creature has taken enough. High in the classroom its engine stalls. It crashes in an obscene heap on the floor. A mixture of feathers, bone and blood. A dozen grabbing and greedy hands reach out and tear it apart. All after the big reward. Deaf-Head Doris holds up a wing.

"I'VE GOT A BIT MISS! WHAT D'YOU WANT ME TO DO WITH IT!"

Bloke/Girl vomits. Mortified. Sheer horror marbled white on her face. Starts bashing her head with her plastered arm with all the force she can muster. Begins to scream. Huge heartrending shrieks of impotent anger whelm up from deep within.

Caleb's brave legionnaires take this as their cue. A trumpet call to spur them on. The smell of blood rich in their nostrils.

They look around to follow their leader who's dancing about in a demented state. Brain roaring with all the Horse that's in him. Watching the worms as they head due south. Wriggling their way through the slime. D. of E. knapsacks on their backs. After their Gold Award. He prances on one leg and then the other. Smearing the blood of the slaughtered budgie on his chest and face emitting the growling noises of a wolf. Fangs grow long outside his lips. A snarl at the neck of the petrified Bloke/Girl Jones who's beaten herself unconscious again. He begins whipping the kids up into a devilish frenzy, ignoring the stream of human waste flowing down freely over his boots. He sets up an eerie chant of death that sends a frightening chill down Greenwood's spine. Even young Gary begins to wonder if he should be doing this.

> If I should die
> Before I wake
> I want for lunch
> A piece of hake!
> Un-gowa! Un-gowa! Un-gowa!

The other soldiers take up the cry and soon the room reverberates to the chant of Un-gowa. It stirs the darkest evil in everyone present. The children follow Caleb's example and begin to take off their clothes. Flaunting the laws of Christianity they dance naked around the passive Ms Jones. Paying their respects. The bird-woman of the I.S Department stirs slowly in her wheelchair. One eye flickers open. It cannot believe what it sees. Never seen so many pricks in all her life. Flopping down like ostrich heads. Then slowly hardening for the challenge to come.

> Un-gowa!
> Un-gowa!
> Un-gowa!

Reality smacks her right in the face. Slapping her to her senses. She screams in utter terror. Tries desperately to pull

143

herself onto her one good leg. Alas she cannot. Fails. Crashes to the floor in agony. Squealing like a pig. Somehow manages to twist herself onto her enormous frontage and using the power of her magnificent quads pumps her way out of the room. The boom-boom sound of the Evil One's chanting drowning out her screams.

In a corner of the battlefield Deaf-Head Doris consummates her marriage with the Devil. One by one the soldiers come to her where she's lying naked on Bloke/Girl's desk. They massage her breasts with budgie blood then pour their passion into her with the power of men possessed. Only Caleb left.

"COME ON THEN BWANA! YOUR TURN NOW! HA! HA!"

The Mighty Caleb turns to greet her. Dances his way forward. Arms above his head. Steam upon the windowpanes and glory in his heart. Brightly coloured budgie feathers decorate his pubic mass. She welcomes him with open legs. Laughs and pulls him in.

"HEY BWANA! WHAT HAVE WE GOT FOR HOMEWORK TONIGHT!"*

Bloke/Girl watches from the doorway. Lapses into another stupor. A fate worse than death awaits.

* Ms Jones had to give her evidence to the Enquiry with a nurse in constant attendance. Judge Bradley had difficulty communicating with her. The court heard she could only answer his questions by blinking her eyes. Once for yes, twice for no.

"Is it true Ms Jones that since the day of the alleged incident you have not gone back to work?" Blink.

"And you are receiving regular counselling?" Blink.

"But isn't it true Ms Jones that you willingly took part in this orgy after instigating the whole affair by deliberately allowing your budgerigars to escape?" Blink. Blink.

"SO THAT YOU COULD RETIRE FROM TEACHING ON A NICE FAT BREAKDOWN PENSION!" Blink. Blink. Blink. Blink. Blink. Blink. Blink. Blink. etc.

The Judge then ordered extracts to be read out from Caleb's diary. In it he'd written "Bloke/Girl was the best shag I've ever had. She had the firmest gluteus maximus I've ever come across." At this point in the proceedings Ms Jones had to be physically restrained. It took six officers to hold her down.

CHAPTER 19

The following day up bright and early. With the lark and the cockerel. Something brilliant about to occur. Eventually. Finally. At last it came. Right there in Butlinland in the loo. Not as a copious discharge of abnormally liquid faeces as he'd imagined, but as one spectacular, never-ending, two inch thick, tubular continuum of pure unadulterated poo. The lactulose had finally won its battle and worked its way through Caleb's gut. Just as the doctor said it would. Incredible!

Caleb had given up sitting on the pan with a book to get things moving like he usually did. Considered that a waste of time. He started immediately in the full squat position. To give him extra purchase. Cunningly he'd taken the extra precaution of putting newspaper down on the floor. The Bristol Evening Echo. Checking also the door was locked before he started to push. Didn't want any witnesses to this historic moment. His roller coaster crap of a lifetime.

Caleb red in the face straining and grunting but this time winning the battle! Magnifico! He heard the cause of all his previous anguish hit the newspaper with a clunk and took that as a sign of victory. Fantastico! He relaxed and expected the thing to snap off. Fall to the floor in cool relaxed fashion. But it didn't. It kept coming out like a hydraulic jack. Lifting him slowly onto his toes and edging him forward in the full squat position. Two or three inches at a time. He was fast approaching the door to the loo when he realised to his horror he would run out of space. Forced into doing a three-point turn. Very difficult in cramped conditions. Very strenuous too. But still it didn't stop. Another page of the Evening Echo laid on top of the last. Open the door and move into the wide open spaces of Butlinland. Shuffle past his desk and chair to the opposite wall and back again. Out into the playground and through the car park. Knees beginning to ache. Over high mountains and barren deserts. Up heather strewn hills and down leafy dales. The last of the great adventurers! Through

rivers and valleys in tropical forests. In and out of Tesco! Three times he did it without a break before the stool gradually tapered off to a very sharp point and slowly collapsed to the floor. A large sigh of gases to signal its end and bring about blessed relief. Caleb pulls up his pants without wiping his bum and collapses exhausted into a chair. Closes his eyes to regain his strength. Refusing to believe what he'd done.

Finally after about half an hour he dares himself to take a peep. Just to check it wasn't a drug induced mirage. He'd been doing a lot of that recently. But not this time! This was 100% official! Caleb stares at the fruits of his sweat driven labours. An achievement of such Olympian proportions even Hercules himself would be proud. Butlinland was at least twelve feet across and he had traversed it an incredible three times! Plus the three-point turn in the toilet. Half a mile at least! Absolutely fucking amazing!

Such an extraordinary accomplishment mustn't be allowed to go to waste. Caleb hits on a brilliant idea. One he puts into operation at once. Fortunately as fate would have it Roger Pater is there to help him. The in-house weirdo ranked 59 follows Caleb's instructions with relish. Wraps the steaming motion up in newspaper. Thrilled and delighted to be taking his Art GCSE. He cuts it into six foot lengths which he then shapes into capital letters. Later that morning when the first teachers arrive the school motto had appeared on the Main School drive. 'WELCOME TO WALLISCOTE RD SCHOOL. STRAINING FOR ACHIEVEMENT'. The words acting like a sleeping policeman forcing staff to drive slowly when they turned up for work. Typical of Caleb to put the health and safety of the pupils first. Kind and generous to a turd. With the three or four furlongs he had left over Caleb leaves a message in the Deputy's parking space. 'RESERVED FOR MR. FAT TWAT W.C. REES'. As a final flourish to his morning's work he gets Pater to paint all the letters white. Rewards him with a Grade A pass. Pater in his element. Claimed it was the best art lesson he'd ever had.

Now Caleb's rid his body of its putrid waste his bloodstream clears dramatically. Sees things sharper than ever. Gives

him the chance to think and take stock. Achieving the Fourth Level of Awareness was like being given a key to unlock the door of all life's precious secrets. A privileged position to be in. No going back now. He must press on. Going up! Level 5! The tunnel and National Curriculum Targets. Prove to the bastards that he could do it.

All the physical effort spent in passing the stubborn stool has left him in need of a stimulant. Just something to arouse the motor end plates and put him back on track. Caleb goes to the top right hand drawer of his desk and takes the stuff out Major Perkins had given him that morning. He'd run out of Roofies so try this instead. Using the method Errol showed him Caleb cuts the snowy white powder into neat thin lines. On a mirror for some strange reason. Then snorts it up with a crisp rolled up tenner to whack the nasal membranes. Deep so that it reached the back of his head. Absolutely fucking electric! Ready now for the rest of the day.

Caleb full of a wonderful feeling. Lighter on his feet with the buzz. Up into the hall to spy out the land. No Bloke/Girl this morning for some strange reason and a boy in the corner he'd never seen before. Handsome and black. Dressed in blankets draped over his shoulders with the majestic brave look of a warrior about him. A few tribal scars across his face and an enormous earring dangling down. Twenty-two carat gold. Yvonne Campbell glowers in front of him. Spitting out her usual venom. Taunting him with her evil tongue. He ignores it all with a princely reserve and proudly stares right through her. Caleb steps forward to intervene.

"Leave him alone Yvonne! Grow up!"

"Who you talking to with your stinking pork breath!"

Caleb gives a heavy sigh. Here we go again. Shouldn't really be in school. Belongs in a Special Unit for Disaffected Nutters but the bastard Tories closed them all down. Along with Approved Schools and Detention Centres. Claimed kids like Yvonne need to be assimilated into mainstream schooling. Quote. "To learn patterns of acceptable social behaviour. So they can see where they are going wrong." Bollocks! How fucking stupid can you get? It only needs one apple in a barrel.

So rotten it contaminates all the rest and Caleb's dealing with at least fifty of the bastards! An explosive mixture doomed to fail. But not if he can help it. In with his left hand to grasp her hair and the right to smack her across the face. She crashes screaming to the floor. Indulges in a fit. Caleb turns his attention back to the stranger. He hands Caleb an envelope. Opens it and reads. It's from W.C. Rees B.Sc Brief and to the point.

To Head of Integrated Studies. C. Duck.

Another one for you. Name: Hamid Massoud. D. O. B. Unknown. Has no English. A Somalian refugee. Parents killed in Somalian Civil War. Lives with Uncle Omar. Hamid wounded in war. Has shrapnel injuries in both legs. Nurse has been informed.

<div align="right">Deputy Headmaster
G. Rees. B.Sc</div>

Caleb looks at Hamed and smiles. Puts out a hand for the boy to shake. He takes it and clutches it tightly. Pulls Caleb into a full embrace. Beams a beautiful smile at him and jabs him in the chest. Utters a single word.

"Father."

Caleb laughs in embarrassment. The love and trust he has acquired already is easy to understand. The I.S. Department is warm and inviting. Has that effect on everyone. Caleb turns and indicates all the kids in the hall. Then points proudly to himself.

"Me father to all children Hamed. I want them all to be Masters and Mistresses of their own destiny. All I am is a catalyst."

Hamid grins. He's overjoyed. Understands completely.

"Father Catalyst! Yes!"

He steps in and gives Caleb another hug. A kiss upon both cheeks. A friend for life not just for Christmas.

Caleb strolls amongst his pupils. A leader with the common touch. Everyone apart from the still shrieking Yvonne seems very calm and relaxed. Full of the joys of Spring. Backwheel scurries about his business bringing in his latest prize. A

Saracen limited edition mountain bike needed for his B.Tech in Mech. Eng. Caleb's given him the use of one of the classrooms to share with Boom-Boom and his in-car hi-fi's. A tenner a week off each for the rent which Errol collects on Fridays. Everyone's happy. If only it could always be like this. Maybe it's the amount of shit being smoked that's causing them to act subdued. With Yellowhead's posse it's something else but Caleb doesn't mind. As long as he can have some peace and quiet. A rare and beautiful commodity.

Hamid has taken it upon himself to accompany Father Catalyst wherever he goes. As a self-appointed bodyguard. When Caleb stops he stops. When Caleb walks he walks. Like a faithful dog. So as an act of homage to the hound Caleb decides to rename him Gelert.

Lounging feet up on his sofa with hands behind his head Caleb watches with tremendous pride the socks coming up from the boiler room. Corporal Kowalski has a never ending queue of enthusiastic volunteers desperate to distribute the coal specked earth. Anywhere in the district. In all his years as a chalkface teacher Caleb had never before seen such motivation. All aimed at Key Stage Four. Design and Technology. Attainment Target 1. He can just relax and enjoy the mood knowing Major Perkins is doing a tremendous job with the Boiler Room Brigade.

All thoughts of Kaye and that cunt Sweet have by magic disappeared as if they never existed. All that belongs to a different age. Now is the moment to spiritually expand with another line of Charlie.

But all good things must come to an end. Caleb feels a sudden chill. Shivers. The hairs on the back of his neck start to bristle. Senses something's wrong. The vigilant Gelert is on the alert. Steps closer to Caleb's side. Sniffs danger. Yellowhead's Music and Movement class gradually comes to a halt. The table tennis stops mid-rally. All eyes turn to the main swing doors that lead into the I.S. Hall. There standing bravely in full view of everyone is Sergeant 'Tosser' Torrington.

Tosser looks around to survey the scene. He can't believe his eyes. Nor his nose for that matter. Never before in his

entire career had he seen so many emotionally deprived kids with such severe behavioural problems so meaningfully employed. He blinks in disbelief. Caleb arises from the sofa and walks towards him slowly. The C.T.L.A. troops circle around their leader and begin to crowd in on Tosser. Forcing him back against a wall. A look of panic on the copper's face. A bead of sweat on his brow. You can taste the tension in the air. Cut it with a knife. Tosser gives Caleb a look that pleads mercy.

"Listen Caleb. Serious man. Call your posse off man!"

Caleb studies him closely for a moment. His phoney street talk sounds ludicrous.

"Nobody comes up here without good reason. What d'you want Tosser?"

"Personal. No pig work. I swear to God. Tell the boys from the hood this ain't a raid."

His eyes have a genuine shit-scared look. Practically every juvenile thug known to the police is staring at him in hate. Daring him to make a move. Revenge. That's all they want. Caleb senses his concern.

"Okay men. Take it easy."

Reluctantly the department moves away. Slowly go about their allotted tasks. Whatever Attainment Target they think they're on. Yellowhead sucks hard on his gold capped teeth and turns the bass back up. Real loud. Gets on his horse and rides. Tosser is safe for the moment.

They enter Bloke/Girl's room for peace and quiet. Now all the budgies are dead. Gelert at Caleb's side. But Caleb seeks further guarantees of safety so invites Bogey along as well. The things he gets up to with Tosser Torrington will strengthen Caleb's hand. As well as cause nasal distraction. Even now he has a green trail of slime running out of his left nostril and flowing into his mouth. And miraculously back up into the right.

"Thing is Caleb. Your wife and her fancy man this Roger Sweet both think it's you. Who else would want to fill his car with concrete."

Caleb looks him in the eye. Hard and unblinking.

"Lost me Tosser. I wouldn't waste my energy on scum like that!"

Tosser smiles with relief. Pretends that's all he wanted to hear.

"So I can report back and say you know nothing about it?"

"That's right. Sorry you had a wasted journey."

Tosser gets to his feet. Puts his note book away then craftily plays his hand.

"Oh by the way Caleb. I'm putting a garage base in over the weekend. You're a good DIY man. What mix would you use?"

"1:1:4 chippings, cement and sand. With a cupful of quick drying additive in case it rains. I've got some leftover if you want."

A triumphant stroke of his Desperate Dan chin. Tosser's just cracked the crime. In line for promotion now. Cunt!

"Interesting. Exactly the same as what we found in the car."

Caleb's heart thumps loudly against his ribs. Alarm bells sound inside. Cursing himself for falling for one as simple as that! He has to bring the clever bastard back down to earth. As quickly as he can.

"'Course Bogey here could tell you how to do it! You'd use a cane Bogey wouldn't you?"

Bogey gives a huge deep throated snort. Two long warm green worms shoot back up his nose.

"Too fucking right I would! Eh Tosser? Eh?"

Sergeant Torrington goes red in the face. Flees from the room in a hurry. He won't come snooping around again. Pretending to be clever.

The end of the day approaches slow but serene and the majority of the kids go home. They need a break from all the fun and excitement. But quite a few remain. Keen to impress and pass exams. Two Indian girls Luckbeer and Biant are translating the English National Curriculum syllabus into Hindi. To keep Rees the Nasty off Mr Duck's back. Of course they'll shade it in before delivery. Apparently Design and Technology went down well when Kurpal and Gazala took theirs across. Two hundred copies of the National Curriculum

delivered at his door. All in Urdu and brilliantly coloured brought shouts of praise from Rees. "Jesus! What the hell have I done to deserve all this!" he yelled before the Race Discrimination Act stopped him going further. Patronising git!

A gang of black blue-collar workers are converting a classroom into the Dug-Out Club. Caleb has at last addressed Yellowhead's special needs and given the boy his own space. Definitely needs it. A place of refuge where his posse can relax. Get up to their tricks unseen. He's brought his own gang of heavies in to provide the bar and decor. Help him build a wall of sound at the far end of the room. Hundreds of speakers piled on top of each other. Look out anyone who stands in front of that! A megawatt surprise!

CHAPTER 20

Mr Williams the Nice was addressing a Governor's meeting. The impending Ofsted inspection is causing furrowed brows and Williams is desperately trying to ease their concern by telling of the measures he's already taken. To prevent the closure of the school. He's solved by far his biggest problem by appointing Caleb Duck as Head of I.S. A man of vast experience and calm temperament who has a wonderful rapport with disaffected pupils. Duck, he tells them has the extremely rare gift of being able to channel rebellious streaks into something incredibly worthwhile. Why even in the short time he's been in charge he's managed to achieve an amazing one hundred per cent attendance record for every pupil in his Department! Absolutely splendid! And on top of that he's taking steps to develop outside links with the local community that could transform the School into a Community College! A very progressive move.

At this point of proceedings Rees the Nasty gives a little cough. Williams isn't slow to pick it up and adds a cautionary note. He explains to those governors who hadn't already met him that Mr Duck is quite a character. Given to flamboyant behaviour and extremes in fashion. But the kids loved him for it and showed him true respect. The predicted grades in the forthcoming GCSE exams were nothing less than extraordinary. The Nasty W.C. is dying to interject. He wants to say that as Master I/C external exams he's seen no evidence of the Mock Exams that Duck was supposed to have set. He secretly believes Duck has made all the figures up. There'd been no exams at all. However Rees keeps his counsel to himself. Thinking of promotion!

The one at the centre of all this lavish praise was at that particular moment doing some serious training. Being watched in amazement by Gelert the Faithful who wondered what the fuck Father Catalyst was doing running round a field with a cow on his back. Caleb would have told him if he

153

could understand. A gentle twenty minute workout with Rosie prevents the pipes from furring up. Regular cardio-vascular exercise to keep the old ticker in trim. And when that was over a rare visit home. To check out his mail. In case there's a written apology from Sweet or a letter from Kaye begging to be allowed to return.

Only one letter inside the front door. Foolscap white and very officious. From the bank maybe? Caleb is puzzled. He can't be overdrawn? Not unless Sweet is using Kaye's credit card. He wouldn't put that past the cunt! Caleb rips open the envelope and reads the contents. Jesus Fucking Christ! His legs give out from under him. Tumbles to the floor. Fights to keep the contents of his stomach in situ. A haunting scream from the dawn of mankind echoes throughout the house. Soft at first like a baby's cry then louder into ape-like whoops. Gelert the Faithful joins in. He thinks it's a popular tune from Top of the Pops and follows Father Catalyst note for note. In the true descant fashion of an-all boy band. Caleb checks to read the letter again but his eyesight lets him down. Only the words 'divorce' and 'sell' are distinguishable to him. Pierce their way through his skull. Just below the hairline.

Crawling on his hands and knees to a sheltered corner of the porch. Stares up at the stained glass inner door. The one he made at night school five years ago. The motif being the flower of the broom. His famous family emblem. Worn by them in many a battle when they called themselves Planta-genets! What would they think of him now?

Prince Hal searches fanatically through all his pockets. Dis-covers a couple of Lorazepam and washes them down with a whiskey. Doesn't give a fuck! All he knows is they'll bring relief. Relief from this sickening blow! Only an hour ago he'd been in the pink. Fine and top of the morning. He could have taken on the world. Now he's been reduced to a hollow shell. A husk of his glorious self.

Caleb struggles to retain a hold on his mind. Think clearly and concisely. A cool head needed in this moment of crisis. No way is Sweet the bastard going to get his hands on his money! His sixty-seven and a half thousand pounds! Slowly out of this

monstrous confusion a plan begins to form. One of such delightful simplicity it causes Caleb to smile. Sweet can't have half of what's no longer there. He built it so he can destroy!

He sets about the task in methodical manner. A Fury under control. Gelert helping where he can by slashing with a knife. They start upstairs and work their way down. All the ceilings for a start. The ones that Stockhausen helped him put up. Dividing walls and sanded floorboards ripped out in a frenzy of hate. Tins of gloss paint to colour his madness. Hurled and splattered about. A Black and Decker electric saw to chop the banister into logs with the grinning face of Roger Sweet looking up and goading him on. To do his very worst. "It doesn't hurt" Caleb hears him smirk. "I'm screwing your wife" he laughs. "Cooking meals for Jayne and James! Soon I'll have your money as well!"

Caleb goes on like a man berserk. The tablets beginning to take affect. Demolishing walls that shouldn't be touched. In danger of collapse. Some with a sledgehammer some with his fists. Some even with his head! Blood pours into his eyes from the self-inflicted wounds. Making him feel like a boxer. Frazier versus Ali. Kitchen, bedroom, front room, lounge all come under attack. Completely destroyed in an attempt to purge the demons that inhabit his head. Everything he's ever made. Days, weeks, years of work hacked and sledge-hammered into smithereens. Until finally the madness begins to subside and the tears begin to flow. Trickle down the cheek to become a flood of huge sobs of self-pity that drown his spirit. He writhes on the floor amongst all the rubble. Watches as the worms squirm over his hands. Head splitting pain and dizzy spells. Total confusion going on in there.

Gelert watches from the doorway not knowing what sick-ness ails Father Catalyst. He'd seen this before but only in cattle when maggots got into their brains. All he can do is stand and stare and wait for his suffering to end.

But Caleb's heartache and anger hasn't yet been quenched. There must be something more he can do to get rid of all the pain? The vacant staring eyes of a living corpse search and survey the scene. Take in the carnage and ruin. Settle on the

gas fire in the Victorian fireplace when the answer finally comes. What better way to destroy all this? Dreams and aspirations for himself and Kaye. Ambitions for Jayne and James to do well. End all that now. Go up in smoke. Get rid of it all and start again. Surely the ultimate sacrifice? Proof that possessions have no real value! The Fifth Level of Awareness! To see all is to understand all.★ Caleb smiles as he piles the rubbish high in the grate. Books, photographs and original paintings. Chairs and Victorian mahogany tables. That should get things started. Light the gas fire and watch the flames take their hold. A life consumed by fire.

Satisfied it's going to work he slips quietly into the night. Free at last of the chains that bound him. Under his arm his prized possession. The only thing he saved from the fire. The only thing that has any real value. His 1970 Esso collection of the England World Cup squad! Heroes one and all!

Gelert limps softly in his wake. Proud to be with Father Catalyst in these troubled times. Having witnessed firsthand his stirring deeds Gelert wished Father Catalyst were a Somalian. How they could have done with him during the Civil War. When the rebel forces were at the gate. His own mother and father would still be alive and he would have inherited the throne! Gelert swears on the graves of his dead parents he'll protect Father Catalyst with his life. Beware anyone who stands in his way. They will surely die!

★ Stockhausen said that to destroy something you had real affection for was not the action of a vandal but rather a display of inner beauty and truth upon the realisation that possessions were of precious little value in a coffin. No pockets in shrouds either he added.

CHAPTER 21

After the traumatic events of the previous night Caleb returned to C.T.L.A. Headquarters. To rest up awhile and recharge the batteries with well-earned rest and slumber. As he yawns and looks around him he realises he needs something more powerful than sleep to stir the cockles of his heart. He wants to recapture the glow of yesterday morning when he was master of all he surveyed. What he needs is a drug induced steam-up. A line of Charlie up his nose. Fortunately he's got some. Errol has given him a month's supply in lieu of rent he owes. And when Caleb was done he felt fucking brilliant! Much more alive and on the ball. He can't wait to get loaded and at 'em lads! He opens the door to step outside. Immediately goes flying. He's tripped on the javelin that Gelert was carrying as he guarded the door to the room. Protecting Caleb from the Forces of Evil who may come in the night to steal his lesson plans.

Father Catalyst sees to it that he is well rewarded. Presents Gelert with a silver bugle nicked by Bogey Greenham from the local scouts. Gelert puts the silken cord around his neck then falls on his knees to kiss Caleb's feet. Caleb wants none of that. There's a long way to go before he becomes a God.

Together they patrol the corridors of the I.S. Department to check on progress being made. Although it's only five thirty in the morning the building is already showing signs of life. The earth distributors are about their business. Desperate to earn their crisp packet bonus and be the first to win the hundred quid prize. A mixed economy message from New Labour. All in favour say aye!

Nod good morning to the incoming maestro. Staggering under boxfuls of records and tapes. Record player strapped firmly to his back. Today is semifinal and finals day and Sir John wants to make sure that the music runs smoothly. In early to set his equipment up. He appears more happy and relaxed now that Yellowhead is off the scene. A dark horse Sir

John. He once confided in Caleb he had another job as well as being a great conductor. He was also a secret agent. Working for I can't tell you that sir. The only clue to this other career is the large brass telescope that swings around his legs. Tripping him up every now and again.

"Morning John. Anything to report this morning?"

He blinks at Caleb heavily through the inch thick lenses. The amiable manner of the rustic about him. Bearing out Stockhausen's claim.*

"No sir, not really."

He pauses awhile to give it second thoughts. His brain clicks forward another notch.

"Well just one thing sir, that happened last night. Caused us a bit of a problem really."

Caleb genuinely concerned.

"What was that then John?"

"Me fuckin' mother died."

No hint of sadness in the voice. So matter-of-fact he could have been saying the Rovers lost. Caleb taken aback.

"Oh, I'm sorry to hear that John. Terrible news. Anything I can do?"

"It's alright sir. Me dad's taking care of it. Better than just fucking about at home innit?"

John gives a kind of yokel chuckle. He sees humour in that scenario. Shuffles off laughing to himself.

Caleb and Gelert continue their rounds. Gelert blowing a

* Stockhausen claimed intelligence was transmitted around the body via the circulatory system. He said that as each individual carried exactly the same amount of blood i. e. 9. 3 litres this caused large people to be cerebrally challenged. He offered as examples heavyweight boxers and Rugby Union second row forwards. Terms like 'Gert lumbering oath' and 'Gentle giant' spring readily to mind. On the other hand vertically challenged people like himself are cerebrally advantaged because their blood is much thicker thus rendering the intelligence factor much more potent. Stockhausen offers as further evidence the fact that short people are generally far more successful in life than large people because of the aforementioned reason. The cleverest people in the world he says are the vertically constrained amputees. The names of Douglas Bader and Long John Silver spring readily to mind. When told that L. J. was a fictional character Stockhausen said that this only went to prove his point. That a fictional character could rise to such prominence in history said much for the quality of his blood!

blast on his bugle to signal their approach. Can already string a few notes together. Stopping just once to put today's date on the pipe and mark the registers for the rest of the week. Everyone present and correct. It saves a lot of hassle later and keeps that bastard Rees at bay.

Proceeding to the Boiler Room to prepare the schedule for the day. Caleb tries the door and finds it locked. Funny. Somebody should be there. The night shift don't clock off for another hour. He gives the secret knock with his fist. A frightened whisper from within. It's Corporal Greenwood.

"Who is it?"

"Bwana Duck, open up!"

Sounds of heavy bolts being pulled back and a key being turned in the lock. Caleb pushes his way in. Leaves Gelert on duty outside. Glory be to God! A sight to behold! Six bright and shiny railway lines. Each at least twenty feet long rest on the steps that lead down to the boilers.

"Well done boys! A magnificent show!"

Caleb laughs crazily. A thrill of success shivering through his body. Wonderful, brilliant endeavour! Corporal Greenwood and his men sit quiet and huddled. Faces pale and drawn by their mammoth efforts of the previous night. There's an air of gloom and despondency about them. Muddy clothes and dishevelled hair. Besides Greenwood there's Bogey Greenham, Shitty Shearn, Craig Vincent and Grabber Newell. All on the point of collapse. Commander Duck attempts to rouse their spirits.

"Come on lads! Cheer up! I'm very proud of all of you. The rails will speed the digging up. Just wait 'til Errol and his men see these! Go and make yourselves a cup of tea and take things easy for the rest of the day. Save all your energy for tonight!"

Greenwood looks at the others in disbelief.

"What do you mean Bwana, tonight?"

"We'll need more rails than this *Captain* Greenwood."

Greenwood's face wears a puzzled look but then as the words begin to slowly sink in it breaks into a self-conscious smile.

"Captain?"

"Yes, Captain Greenwood. You deserve it. I'll see it's mentioned in despatches and you and your men are given extra rations and a bonus of five empty crisp packets each. Well done."

Caleb moves to each of them in turn. Proud to shake them by the hand. Then gets them to say their two times table.

"These rails will only take us to the playground wall. We've got to get right across the sportsfield remember."

Greenwood drops his head. Groans with the enormous pressure he's under. There's obviously something bothering him. Shearn chips in with some advice.

"You'll have to tell him Corporal. I mean Captain. Perhaps he don't know yet."

Caleb gives them a quick questioning glance.

"What is it Captain? Something wrong?"

Greenwood clears his throat. Tired bloodshot eyes look up.

"A train came off the rails at Tower Hill Bwana. A lot of people were killed. It's the place we took the lines up."

A missed heartbeat causes Caleb's knees to buckle. But again a swift recovery. He puts it all down to the training he's doing and the fact his bowels are functioning correctly again.

"Why that's absolutely brilliant! A superb achievement against all the odds! Fine show!"

Shearn always the worrier asks a question.

"Will we get into trouble Bwana?"

"Only if you're caught Dale! They don't know who did it do they?"

"No Bwana."

"And you're not going to tell them are you?"

"Too fucking right I ain't!"

"Right. And nor is Captain Greenwood or Vincent, Grabber or Bogey! Eh?"

Caleb stares at each one in turn. Eyes charged with the euphoria of Charlie. Daring anyone to contradict the logic of what he's saying. None do. All afraid to speak.

"Fill me in with all the details then Captain!"

Greenwood revelling in the newly won promotion. Takes on a new lease of life. Voice clear as a bell.

"It said on the news this morning sir that twenty-seven were killed. They reckons the crash was caused by vandals."

Greenwood's words provoke an angry response.

"You're not vandals Captain! You're the C.T.L.A.! Fighting for an integrated programme of study! You can all be proud of what you've done!"

Even Shitty Shearn cheers up at this. Allows the stink of rotting seafood to permeate the room.

"I heard it too Bwana. A couple of trucks of sheep got derailed as well. People is still trying to round 'em up!"

Sheep! Voices tell Caleb to act at once! A fresh supply of meat for the camp. They'll need it when the siege begins.

"Right. Listen chaps. See if you can find any of those animals and bring them back here to me."

Craig Vincent plucks up the courage to ask a question. Glazed by the enormity of his first big crime.

"What do we say if anyone stops us Bwana? When we're driving the sheep along the road."

"Tell them you're helping the police to round them up! Sergeant Torrington asked you to do it!"

Commander Duck shakes hands with them all. Firm grasp. Look 'em straight in the eye. Awards them World Cup medals. Stiles, Cohen, Wilson, Ball and Hunt.

"Good luck men! And all the best!"

They leave quietly. Fearless and ruthlessly efficient. These men who will build a land fit for heroes. Where everyone can read and write. Know their nine times table off by heart.

Commander Duck is left on his own. Inside his head at this crucial moment there's a callous disregard of the human life lost. No qualms or feelings of guilt. Instead a hugely uplifting surge of triumph over an evil system that denied his pupils hope. Life chances previously locked away have suddenly been let loose. Never in Caleb's wildest dreams did he imagine success on this scale so soon. This brave action will buy him time. Keep the authorities busy whilst he's digging the tunnel. Caleb's chuffed to fuck it was his men that did it.

There can be no turning back now. It's all or nothing! Time for another well-deserved hit. By Christ he needed that!

Gelert announces Father Catalyst's arrival with a two note blast on his bugle. He enters H.Q. with a magnificent flourish. Boots of Ambition pounding out. Charged with enough zeal to conquer the world. Lynda's there to welcome him. Wearing dark glasses to hide a black eye.

"You had a phone call from the Headmaster luv. He wants to see you as soon as possible. He says it's urgent or summat."

Caleb is not surprised to hear this news. The enquiries would have started already.

"How long ago was this then Lynda?"

She flicks a cigarette out of a packet and lights it with some aplomb. Long dramatic pause while she exhales.

" 'Bout ten minutes ago luv. Had the bloody cheek to ask who I was. I'd let him wait if I were you. Let me make you a cup of tea first. You looks done in. Wanna wank or summat?"

"No thanks Lynda. Offer much appreciated. Got too much to do. Just a cup of tea for now."

"Later maybe then?"

"Yeah. Maybe later."

Caleb feels blessed. How can he go wrong with this kind of affection? Men and women who care and understand him. He senses there's a powerful bond developing here. Something he's never experienced before. He knew it existed but hadn't felt it himself. Now Caleb has it for the very first time. The spirit of the underdog has been unleashed. These disaffected lowlife underachievers have finally ignited the yob in him. He feels honour bound to make a gesture to show he now belonged. Gelert and Lynda watch transfixed as Caleb carves the words "love" and "hate" on the knuckles of either hand. Fills in the gaps with Indian ink. Signed up as a member!

From: Deputy Headmaster To: Head of Integrated Studies
Date: 24.5.98
Time: 9.00 a.m.

1) The Headmaster has noticed that a considerable number of pupils in the Integrated Studies Department are arriving late for school every morning. Could you ensure that this stops immediately.
2) Please arrange for the enclosed form to be sent out to the relevant pupils.
3) As you've chosen to ignore all previous communications from me, the Headmaster wishes to see you in his room this morning at *10.10 am.*

Please make *no* excuses. Failure to attend could hold serious repercussions on your future position in this school!

G. Rees. B.Sc
Deputy Headmaster

WR/Pun/1 WALLISCOTE ROAD SCHOOL
WALLISCOTE ROAD
BRISTOL BS5 8KG

Dear Parent/Guardian,

School Punctuality

Pupil ...

Tutor Group House

Your son/daughter is not coming to school on time. Full details and comments are listed below.

———————————————————————————

———————————————————————————

Let me assure you that the greater majority of our students do arrive punctually. Most parents welcome and support this school policy as they realise it is excellent training for later life when their children will be expected to start work on time.

Please support us, as we consider this an important part of the social education of your child. If you wish to discuss this problem, please do not hesitate to get in touch with me.

Yours sincerely,
Maldwyn Williams
(Headmaster)

CHAPTER 22

Caleb outraged at the implied threat contained within Rees's latest memo. Just goes to show how out of touch the diminutive little fat twat is. The kids he sees arriving late for school are the ones who've been in since five every morning. In early to collect the sockfulls of earth and earn a few extra empty packets of crisps to take them on the trip of a lifetime. When Williams looks out of his window at ten to nine he sees them coming back for more! Not arriving late for school!

After inhaling the fumes from a piece of tinfoil Caleb steams across to the Main Block Staffroom. Going to put the record straight. Sticks Rees's memo onto the noticeboard and sets it alight. Leaves when the room is well ablaze. Along the marbled corridor and knock on the leader's door. A summit conference between two Heads of State. White light flashes 'Enter'.

An anxious Williams the Nice is pacing up and down his office floor. Studying the morning newspaper. Turns to face Caleb and nearly faints on the spot. His legs give out from under him. Has to hold onto his desk for support. He's stunned by Caleb's outrageous appearance. Silver spurs jingle jangle their way into his room. Newly washed and ironed breeches with a deadly scimitar dangling down from the waist. A jewel encrusted belt. Rows of hard won bottle tops decorate the Grenadier jacket. More fanciful than any Pearly Queen. Epaulettes of blackboard rubbers and polished brass buttons shining bright. And on his head the prized possession on permanent loan from Bristol Museum. A Spartan war helmet with purple plumage.

"Jesi Maur Caleb! Why on earth you dressed like that?"

Caleb snaps to attention and salutes.

"A positive role model if you like. W.C.! A corporate sense of identity."

The normally unflappable Williams the Good looks suddenly old. He wears the haunted look of a man under pressure.

Gaunt and pale with bags under his eyes big enough to keep his sandwiches in. He groans.

"You've heard about last night's train crash boyo?"

"The lads were telling me about it this morning Mr Nice. Sad that things have come to this."

Williams struggles to fight back tears of frustration. He faces Caleb hollow eyed. A trembling in his voice. If he wasn't on the other side Caleb could feel some sympathy.

"Caleb. Tell me the truth mun. Honestly. Are you alright? You'd tell me if you weren't wouldn't you?"

"In the pink squire. Never felt better. Why?"

He gives Caleb another sideways glance. Expresses the secret dread he has bottled up. Close to breaking point.

"Listen Caleb. I'll give it to you straight. I had Sergeant Torrington in here just moments ago. He says the train derailment was caused by vandals. He thinks some of your boys were involved."

A look of shock on Caleb's face. Angry and insulted.

"Bollocks! What makes him think it's them!"

"Some of the trucks in one of the railway sidings had 'Bwana Caleb's C.T.L.A.' sprayed on them. Definitely done last night."

Thud! Thud! Caleb winces with the pain of another heart-beat lost. Recovers brilliantly to remain on his feet. Sways a little, that's all.

"But that doesn't prove they stole the rails W.C!"

"I hope to God you're right Caleb. Just think of the outcry if they did! What does it mean? C.T.L.A.?"

"No idea squire. No idea."

Williams starts sweating profusely. The thought of losing face at Education Headquarters is too brutal a burden to bear. Disturbs him deeply. He staggers hand over hand along his desk and slumps heavily into the swivel chair. Snatches at a cigarette. Lights up with trembling fingers. No smoke rings now. He's lost his cool.

"Something I've got to tell you Caleb. I only found out yesterday. I couldn't get hold of you or I would have told you then."

Caleb's suspicions are aroused. The bastard's found out something! What? The tunnel? Drugs? Kaye has left him? The arson attack on his house? Screwing Lynda and Angela on school premises? What for Christ's sake? Spit it out!

"They've stopped all early retirement Caleb. The Authority have decided to end the scheme. You won't be able to retire at fifty!"

Williams studies Caleb's face for the obligatory angry reaction. Surprised when he doesn't get one.

"I thought you'd be upset mun!"

Caleb tosses his head back and laughs with derision.

"I couldn't give a cup of dog's wank! I'm going to be out of here anyway!"

As soon as the words slipped from his mouth Caleb knew he'd made a mistake. Curses himself for being so careless. Williams is on to him in a flash.

"What d'you mean Caleb? Out of here? You leaving boyo?"

Caleb desperate not to give the game away produces a chemically induced response. Smiles serenely as he says it.

"I'm thinking of going in for the church Mr Nice. Playing football for God's team."

Williams's face begins to twitch. Expressing joy, fear and disbelief all in the same split second. If this is true then his prayers have been answered.

"Seriously?"

"Yes. He's spoken to me on several occasions and I'm on the verge of signing the contract."

Williams hands shake badly. Can't get the cigarette to stay in his mouth.

"If that's the case you might as well hear all the other bad news boyo."

Caleb not interested in the slightest. More intent to discuss his contract with God.

"We've already agreed terms. I'll be on forty thousand pounds a week plus a thousand for every goal I score. A big bonus if we win promotion. Heaven United's a sleeping giant."

Obviously Williams didn't hear. Tells Caleb that the Ofsted inspectors are coming next week to check on the Integrated Studies Department. They'll be in every day for over two weeks judging every lesson using the strictest criteria. It's imperative that Caleb is on the ball. Gets things sorted out. Registers, timetables and National Curriculum Targets will have to survive the closest scrutiny. Following their last visit here three months ago, when poor Jeremy Philes offered them a scrap of paper, this time they'll be out for blood. Do everything in their power to close them down.

None of this cuts any ice with Caleb. He wasn't even listening. The two men continue with their high-level discussion. Both firmly convinced they've got their main points across whilst at the same time totally ignorant of what the other was saying. W.C. Williams saying Angela White had resigned. The pressure of work had finally got to her. Caleb responds by talking about a 4:4:2 and deep-lying centre forwards. Williams counters with Ms Jones has been committed to hospital under sections 2 and 3 of the Mental Health Act. For immediate assessment and treatment. Seen the last of her. Caleb not the least put out. Thought the Bosman ruling would see the re-introduction of attacking fullbacks into the English game. He wanted to be part of total football playing centre forward in Heaven's attack. Jesus can cross the ball with either foot.

This latest bit of information sparks Williams off again. He takes a turn for the worse. Tries another fag. Fails to get it into his mouth. Breaks it in two instead. The events of the last few hours are beginning to take their toll. Somewhere in the building a fire alarm goes off.

"I don't know what's going on boy. I've got parents complaining about their sons' clothes being stolen from the Sports Hall. Wondering what kind of school I'm running? And I can't say I blame them. Two hundred brand new desks gone missing! Vanished into thin air! I'll tell you something else boyo. Top secret. I've got photographs of some of the cleaners posing naked with a mop. Handed in by one of the pupils' dads. What can I do? Complaints from parents about their kids being bullied. Some West Indian

boys are demanding money with menaces and talking about a trip to America. All the lead has been ripped off the main school roof and Uncle Omar, Hamid's guardian rang up to say he didn't realise this was a boarding school! Apparently the boy hasn't been coming home. Been sleeping somewhere in school!"

At last Williams's monologue comes to an end. He gives a heavy shrug of relief. Purged his soul and feels better for it. Trembling fingers come up to mop his sweating brow. The shrunken skull-like face wears a pathetic look. He knows he's losing control. Impotent against the forces of darkness that are building up in his head. Deep down inside him a voice screams out. Begging him to act at once. The cause of all his torment and stress is standing right before him now! Love and hate tattooed on his knuckles. A huge gold ring hanging from a nostril. What he should do to save further anguish is lock this madman in his room. Call the police and hide. But he doesn't. Hasn't the guts.

"I'll try and get a replacement for Ms Jones Caleb but I can't promise you anything. Most unemployed teachers prefer to remain on the dole rather than teach the bastards you've got over there. D'you think you'll be able to manage?"

Caleb cocky and eager to impress. Leave no doubts in Williams' mind as to his true ability.

"No trouble at all Mr Nice W.C. We've an excellent spirit developing in the Department. All extremely well-motivated and academically ambitious."

The weak strained smile of a beaten man crosses the Headmaster's face. The voices again cry out to him to dial 999 immediately. But he's much too tired to act. Caleb snaps sharply to attention. Helmet under his arm. Shouts as loud as he can.

"Will that be all sire!"

Williams winces at the noise. The sound of sirens in the playground rising to a crescendo. Rees the Nasty W.C. rushes into the room.

"There's a fire in the Staffroom Mr Williams! We'll have to evacuate the school!"

Williams groans and slumps deeper into his chair.

"Yes that's all Caleb. Thank you."

He turns to give Rees a look of resignation. Why oh why didn't he consult his Deputy Head before he appointed Duck? A decision he'll regret for the rest of his life. A thin, strained voice that's hardly audible. Close to breaking point.

"I'll let you handle the situation Mr Rees. Do what you think is right."

Caleb sneers at Rees the Nasty W.C. Can't resist a caustic aside.

"Can you trust him not to make a mess of it Mr Williams? Like everything else he does!"

Williams waves the question away with a limp wristed flick. Rees speaks with venom through gritted teeth so only Caleb hears.

"Get back to your asylum Duck before they find you missing!"

Supreme Allied Commander Sir Caleb Duck proudly dons his headgear. Laughs in the face of this squat little turd and accelerates away. Right! Left! Right across the playground and back into I.S. ignoring the fire engines pouring into school. No power on earth can stop him now. Not a moment to lose as he heads for the sound of Ravel's Bolero. Sir John is approaching the exciting part. Telescope in hand. Louder and louder than ever before with one eye fixed on the Great North Gate, in case any strangers should appear and try to take them by surprise. Only a couple came in he said. Black businessmen in suits. Didn't give me any trouble sir. Went straight to the Dug-Out Club.

God tells Caleb he hasn't much time. It won't be long before the inspectors arrive and begin to ask questions about what's going down. The voices boom out all around him. Warning him to be on his guard.

CHAPTER 23

The Supreme Commander looks around him. Decides the perpetual leering of Baldev Singh is finally beginning to get to him. Will put a stop to that at once.

"Singh! Report to Major Perkins at the double lad!"

The Indian boy with an attitude problem pleads with Caleb to change his order but all to no avail. His presence in the Main Hall is beginning to annoy him. Has a demoralising affect on the men. If he's screwing one of the teachers and bragging about it why can't they grab a bit of the action?

Caleb unwraps the latest parcel that Dave's sent across. Twenty-five new poses of some of the cleaners. Some showing lesbian sex. He calls Copperknob over to his side to get his opinion of the batch. Copperknob is impressed. Buys picture No 23 showing two vanishing broom handles in explicit detail. Rushes out of the hall and into the toilet. Starts wanking off into his sock. Caleb congratulates himself on the brilliance of the idea. Raising money for the C.T.L.A. Makes the kids line up in single file and puts Corporal Kowalski in charge.

The lads in the boiler room are under strict orders to make separate piles of coal and dirt. Errol is boss and teaching them well. Issues his instructions like a tribal king from an armchair he's collected from the Main Block Staffroom. Discarded his designer labels for something far more practical. An academic gown drapes over his shoulders and on his head a Russian hat. He cuts a magnificent figure.

Four of the railway lines are already in position on sleepers made out of door frames from the Art Department. Captured on a raid. Caleb is making every effort to keep within the constraints of the National Curriculum and given the circumstances he's doing a brilliant job.★

★ Design and Technology Key Stage 4
Health and Safety –
Pupils should be taught further knowledge and understanding of subterranean tunnels. This should include taking responsibility for recognising hazards and through discussion make the workplace a more happy and safer environment.

No signs of stress amongst the Jamaicans. All smiling as they set about their appointed tasks. They have a happy-go-lucky approach to life. Nothing prevents them from enjoying themselves. So unlike the Pakistani and Indian kids who take things much more seriously. Indians! Fuck! Caleb's forgotten all about him!

"Hey Errol! Where's Baldev?"

Errol laughs. Sucks hard on the spliff that Hubcap hands him.

"In there Massa Caleb. Him doing alright with just his bare hands."

The workers snigger amongst themselves. Obviously a joke at Baldev's expense. Caleb wants to know more.

"Why hasn't he got a shovel?"

Errol just grins. Very relaxed.

"No blood clot But-But using my tools man! No way!"

Although Caleb's sense of fair play is outraged he decides not to press the matter further. Wouldn't do to undermine Errol's authority. Could have them all out on strike if he did.

"Very good Major Perkins. As you wish. But remember ten boxes of earth per shift is required. Otherwise no pay!"

Satisfied Major Perkins will hit the production target Caleb makes his way back to his office. The faithful Gelert at his side. Sniffs a line of Charlie off a window ledge then proceed on their way. Once more imbued with a wonderful feeling that what he's doing is for the good of all. These lads and lasses who'd always been failures. Left behind in the brainbox stakes now achieving targets previously unheard of. Not vandals or yobs but engineers! Right up there with Isambard Kingdom Brunel.

Caleb realises only too well there are Seven Levels of Awareness and at the moment he's on Level Five. Above all earthly betrayals. He has a deep-rooted feeling in his gut that something magnificent is about to occur. Call it intuition. The spirit in the camp has never been greater. The momentum of the escape bid is changing gear.

Gelert strides on ahead of him limping slightly with his shrapnel wounds. This veteran of a thousand civil wars knows

instinctively when trouble will flare. He's more alert now than ever before and has added a dustbin lid shield to his armoury. Eyes peer left and right. Suddenly he stops! Freezes on the spot! Shield at the ready and spear poised high in his throwing arm. Kaye screams hysterically. Scared out of her wits. She thinks she's about to be killed. A madman moves up close to Gelert's side and laughs at what he sees.

"Fuck me! Look what the cat's brought in!"

Kaye for the life of her can't see who it is. The skirt, the beard, the ring through the nose. An awful smell between them. It's the voice that gives him away.

"Caleb! What the hell's going on? Why are you dressed like that?"

"This O treacherous one is a sarong! It emphasises my feminine side. Like Alexander the Grate!"*

Caleb smoothes his Skirt of Fortitude gently over his thighs. Just to emphasise their strength to Kaye. Show her what she's missing. But Kaye is not impressed. Shakes her head in disbelief. Points to Gelert. Coiled and ready. Hair trigger temperament about to let fly.

"Who's he for God's sake? Tell him to put that thing down!"

"This is Gelert my faithful companion. Follows me wherever I go."

Caleb bids Gelert to lower his spear. Reluctantly he obeys. Kaye looks bewildered. She realises now, rather belatedly of course, what a terrible mistake she's made. Had she stuck by Caleb she could have shared in the glory instead of the anonymity her future now holds.

"Caleb can we have a word in private please? We've some urgent matters to discuss!"

"Of course. Step into my office."

Gelert outside guarding Tunnel H.Q. Just like a Grenadier. Lynda inside puffing a fag. Beavering away in earnest. Looks up and scowls at Kaye.

* Provenance: 'The Analects of Confucius'
 He said. "Man with cock up chimney feel grate."

"I've already told her you were busy luv but she wouldn't take no for an answer!"

Kaye looks at her incredulously. Can't believe the over-familiarity and rudeness.

"D'you mind? I want a private word with my husband! Would you mind leaving the room!"

As a junior school secretary Kaye knows how to handle naughty boys and girls. Talk sharply and watch them crumble beneath her fearful gaze. Never met one like Lynda before who scoffs and blows smoke in her face.

Caleb decides to intervene. A million things he's got to get on with. Can't waste his time on domestic disputes.

"Anything you've got to say Kaye can be said in front of Lynda. She's my secretary. Does the same job as you."

Kaye almost speechless at the insult. Off her scale of normality.

"You're going mad Caleb! D'you know that? What's wrong with your Headmaster? Why does he allow you to carry on working? You need treatment!"

Caleb thinks how typical of her. Anything that goes against her twisted values is construed as madness on his part. Nothing wrong with her of course! He could tell her about his psychiatrist. The lovely Doctor Ruth Benefield and his fortnightly meetings with her as a voluntary outpatient at Dorset House. A place where the mad people go. How he craves the calm and tranquillity of her soothing voice that slots everything into perfect peace. Sees everything in perspective. He's already asked her out to lunch and she's agreed to come. He could tell Kaye but doesn't.

"You're the one who wants her head examined Kaye! You're the home wrecker living with the Evil One."

"Why did you tell the police it was Roger who burnt our house down?"

"Our house! You're joking! My house Kaye! You left it remember! Didn't want it anymore!"

"I didn't want you anymore Caleb! Half that house was mine. Why d'you tell them it was him?"

"Because it was him that did it! It's the only way that

bastard could keep hold of you! He cut off your line of escape!"

"The only person I want to escape from is you Caleb! He'd never do a thing like that!"

"Oh no! He's not the sort to leave a wife and three young kids either, is he? Leave them with no money so they have to go to the DHSS for help!"

"That's not true!"

"Yes it is. She phoned me and told me!"

Kaye goes silent for a moment. Never thought her knight in shining armour could be such a first-class cunt. Then. After a long dramatic silence.

"What are the insurance people saying?"

Caleb shrugs his shoulders. Couldn't care less.

"Don't know. I haven't contacted them."

"What! Why not, for Christ's sake?"

"Couldn't give a fuck to tell you the truth. Houses are symbols of a materialist world. Madonna taught me that."

Kaye is being reeled in very slowly. Shouts. About to flip.

"All our money is tied up in that house! Everything we own! Can't you get that into your thick, stupid skull?"

Lynda had been pretending to type away but obviously listening to every word. She's not going to stand by and have Caleb spoken to like this.

"Then you shouldn't have run off with that fat little wanker should you!"

That does it for Kaye. She's had enough. The simmering anger explodes.

"You foul-mouthed little tart! How dare you speak to me like that!"

Spins back on Caleb to spit her venom.

"You told her that? You told this little slut about my personal business? Caleb you bastard! You fucking bastard!"

She flies at Caleb like a whirling dervish. Fingers outstretched. Ready to blind and kill. Fortunately for him before she gets the chance Lynda lands one on the end of her nose. Crashes to the ground. Blood flowing freely from her nostrils.

She makes a brave attempt to get back on her feet and have another go. It was only the point of Gelert's javelin thrust tight to her neck that prevented her. Draws a trickle of blood. Caleb raises a hand to halt his progress. Just about to run her through. Kaye glares up at Caleb dazed and bewildered. Frightened out of her life. For a once proud member of the Labour Party she makes a pitiful sight. Still Lynda isn't satisfied. Outraged at being called a slut. Drags some phlegm up from the back of her throat and spits it into her face. Then tips her coffee over Kaye's head. The traitor beaten and bowed. Caleb looks down and scoffs at her.

"If you want to do anything about the house you'll have to do it yourself. I can't be bothered any more."

He signals Gelert to remove his spear and Kaye scrambles onto her knees. Total degradation. Snot, blood, coffee and tears dripping to the floor. Crawls her way out of H.Q. Her backside presents too tempting a target. A kick up the arse to help her out. Cries of pain and humiliation. Brave now she's out of the room. Screams of police and solicitors and how much she's always hated him. Caleb rushes to the door to reply to that.

"Not as much as I hate you! Fucking whore!"

If Kaye thought her journey through Hell was over; that nothing could debase her even further she was wrong. A sound of terrified bleating on the stairs below her. Then the rushing of a thousand feet. Boys pretending they were dogs. Crammed tight on the stairway there was no way to pass. Kicking, shitting gasping for air they scramble over her prostrate body. Nostrils and eyes agape in fear. The sheep as well as Kaye.

Caleb steps onto the half-landing outside his room to see what the commotion is all about. A sight to set his heart racing. The stairway is full of rising steam and slowly emerging are three of his finest. Grabber Newell and Shitty Shearn barking like sheepdogs, obeying the whistled instructions of the No. 3 ranked Vincent who removes his stocking mask. Speaks with a new found pride in his voice.

"We brought in all we could find Bwana."

"Whizzo Craig! We've got enough rations to see us through now. Fine show!"

Shitty Shearn stops barking and yells out a reminder.

"Don't forget our GCSE in Animal Husbandry Bwana!"

"Of course not Dale! You'll get a grade A pass! By the way where's Captain Greenwood?"

Shearn flashes a desperate look across at Vincent. No help there so he tells Caleb himself.

"He chickened out sir. Fucked off home."

Caleb swoons. Goes weak at the knees. Another heartbeat wasted. Staggers back inside the room. Can't believe his ears. Greenwood has broken his Home-School contract! Deserted in the line of duty.

"The cunt! When was this Shitty?"

"Just after we found the sheep Bwana and drove 'em back through Tesco's."

Caleb fights to control an inner rage. So Greenwood was a stool pigeon after all! He'll make him pay for this! A job for Major Perkins.

"OK Dale. Thanks for telling me. I'm promoting you and Vincent to the rank of Corporal. Congratulations. Well done. Take the sheep along to Bloke/Girl's room. We'll decide what to do with them later."

Shitty Shearn and Vincent acknowledge their thanks. Grabber Newell is bitter about not being promoted. Vows to take his frustrations out on the next pair of tits he sees.

Caleb watches the last of the sheep being driven upstairs. He has never seen Shitty Shearn as happy as this. There's a cocky strut about his walk and an air of confidence fills his pants. Loads of self-esteem. Shrouding the stricken Kaye with a terrible stink. A warm and clammy mist. Caleb receiving immense job satisfaction. His troops were becoming men.

Meanwhile in his office Mr Nice W.C. had just put the phone down on the leader of the Ofsted team. Made the final arrangements for next week's visit when he happened to look out of the window. He'd already seen the flock of sheep being driven through the main school gate with three of his pupils barking like dogs. Watched transfixed as they were herded

177

into the Integrated Studies Department. Now as if that weren't bad enough he's witnessing a woman who bears a remarkable resemblance to Mrs Duck running screaming from the building. Clothes ripped asunder and covered in blood. Yelling out, "He's fucking mad! He's fucking mad! I tell you!" All too much for him to take. The final straw. He makes his way slowly to his own private loo. Shoulders stooped low with the weight of high office. Crying as he goes. Climbs up on the toilet seat and wraps the chain around his neck. Jumps off into oblivion. Couldn't take the pressure any more. Not the sort of man to take into the jungle.★

★ A man of words
 And not of deeds
 Is like a garden
 Full of weeds
 Taken from Stockhausen's 'Poems From The Builder's Yard', published by Blackthorn.

CHAPTER 24

The death of Williams the Nice W.C. came as quite a shock to Caleb. To the core. It only goes to show how these men in grey suits aren't the gods they would have us believe. Fragile and vulnerable just like we ordinary mortals. Each with their own DNA Achilles heel. Caleb sees cracks developing in the authority's ranks. Fantastic! Who will be the next to fall? Crumble before the message of the Elders. A return to fine values and family units. He takes a fiver out of his pocket and rolls it up into a tube. Snorts a few lines of coke before the memorial service. Although Williams the Nice W.C. was on the other side he can still respect him as a man. Unlike the cunt who replaced him!

Summon Major Perkins to gather the troops. All assembled in the hall to pay their last respects. A dignified two minutes silence. Broken only by the sniffs of Bogey Greenham and rip-roaring farts of Shitty Shearn. Gelert plays a four note tune on his bugle, coming on in leaps and bounds, and then Sir John Irving offers a selection of classics. Ending with Verdi's Requiem. Caleb makes them all bow their heads in silence and says the Prayer of the Nine Times Table. A very moving occasion with a lot of tears shed.

Now let the game commence! Ti We Nim from North Korea is playing Raymond Watson the West Indian No 1 in the Final of the World Table Tennis Championships. A potentially explosive match. Raymond is a very poor loser and things aren't going to plan. He's losing in the fifth. Storms up and down in a maddened rage. Kicking out at anyone or anything that gets in his way. Screaming insanely at the North Korean all the abuse he can muster. It's difficult to make out what Raymond's saying because the William Tell Overture is blasting out of brand new speakers that Sir John Irving has installed in the hall. Now Yellowhead's moved out he's able to express himself more.

The capacity crowd are in splendid humour. Laughing at

the crazy antics of the No. 1 seed. Even the Pakistanis see the funny side and this makes Raymond even angrier. Poor Raymond can take no more. Snaps. Charges the source of his greatest irritation. The Promenade Concert. Frothing at the mouth and eyes ablaze. He heaves at the table carrying all Sir John's valuable tapes and records and hurls it at those who mock him.

"You fucking cunts! Fucking blood clots! You don't want I and I to be champion! You fucking jealous man! You."

The last words he speaks for over a month. Sir John has whirled his heavy brass telescope around his head. Two or three times to gather momentum then smashes it over Raymond's head. The boy falls poleaxed to the ground. Blood oozing out of a four inch gaping hole in his skull. The only sign of life his twitching feet. Sir John with the dignity and calm of all great conductors stoops and reassembles his orchestra. All the West Indians are on the floor. Pissing themselves with laughter. Even the black girls in the Dug-Out Club have come out to be entertained. All except one enjoys every moment. Yvonne Campbell glowers across at Caleb. Hatred still burning deep.

The high pitched bleating of sheep in pain draws Caleb's attention away from the fun. For some strange reason known only to himself Yellowhead has arrived. Furious to find his Dug-Out Club full of grazing sheep. He kicks them out Kung-Fu style and yells across at Caleb.

"Who's in charge of these fucking sheep man? Sort it out or I'll fucking sort it out myself!"

With that he slams the door. He's a dangerous character Yellowhead and Caleb is getting rather worried by the number of heavy looking black guys turning up in the hall. All asking for the Dug-Out Club. Guys in expensive business suits and wearing cool-dude shades. Carrying padlocked briefcases. He makes a mental note to ask Yellowhead what's going on in there. But not today. This matter of the sheep causes minor irritation. He yells above the noise.

"Captain Kowalski!"

Out of the laughing crowd of ping-pong fans leaps the

skinhead Pole Kowalski. A bayonet dangles from his waist. The Doc Martens clatter loud on the floor as he stamps proudly in salute.

"SIR! YES SIR!

"What the fuck's going on here Kowalski? Who's supposed to be guarding those sheep?"

"SIR! Corporal Shearn SIR! In Bloke/Girl's room SIR!"

"Put him on a charge Kowalski. I'll not have my men deserting their posts. Is that clear?"

"SIR! YES SIR!"

Poor Shearn will be in for it now. The Pole is a hard man when it comes to punishment. Taking his GCSE in Crowd Control. Draws his bayonet and charges across. Caleb yells after him.

"Put that knife away Kowalski!"

It's a pity in a way it has to be Shearn after all that man's done in the last twenty-four hours. Risked life and limb for the C.T.L.A. cause. But Caleb must have discipline. He knows that if the others see him getting away unpunished they'll all want to try it on. The entire operation would degenerate into farce.

Kowalski shoves the bayonet back into its sheath and continues on his charge. Fists club their way through Corporal Shitty Shearn's feeble guard. Blow after blow thuds into his skinny body until he finally drops to the floor. But brave Shitty Shearn has a lot of bottle. Calls Kowalski a fat Polish cunt and kicks him in the bollocks. A futile gesture that only serves to increase the ferocity of the mad Pole's attack.

"Okay Kowalski! Knock it off!"

The boy freezes in the position he's in. Boot suspended in midair. Stopping just inches short of the Corporal's head. Immaculate discipline. He leaps to attention and salutes. Heels clicking hard together.

"SIR! YES SIR!"

"See that those men get medical attention at once Kowalski and give them both a three day pass."

"SIR! YES SIR!"

Here he goes again. Caleb on a rollercoaster ride of stress

and strain. Everything happening at once. Two unconscious bodies pouring blood and Yellowhead acting suspicious. Now Major Perkins comes in at the double.

"Massa Duck come quick man! Down the tunnel. We are digging up fuckin' gert lumps of solid coal man!"

Caleb responds immediately.

"Captain Kowalski!"

"SIR! YES SIR!"

Caleb returns the salute.

"Assume command *Major* Kowalski! I'm going down the boiler room!"

"SIR! YES SIR!"

Not a flicker of emotion at this swift promotion. He takes it all in his stride. Kowalski has grown in stature. Acquired an enriched and deeper understanding of the role he can play in society. Of the right stuff.

On his way down to the boiler room Caleb takes the opportunity to inform his Second-in-Command that Captain Greenwood has deserted his post and must be brought back for questioning. Alive if possible. Errol grins and gives a little nod. Knows what he has to do.

The atmosphere in the boiler room is electric. The discovery of a rich seam of coal has caused a lot of excitement.

"There Bwana. Look! That looks like fucking good stuff to me!"

Huge lumps of top grade household coal lie piled up in the trolley. Some weighing at least a hundredweight. Caleb is overjoyed. If ever further proof was needed that God was on his side then surely this was it!

"Take me down to the coalface Errol. I want to see this for myself."

The workers busy themselves unloading the trolley. Errol and Caleb climb in. Hubcap and Junior start to push. Send the trolley hurtling beneath the Sixth Form desks and under the playground wall. Just like a white knuckle ride. A roaring sensation fills his ears as the legs on the desks rush by. Barely inches away from their hands and heads. Too close for comfort for Caleb's liking.

Commander Duck is shocked at the condition he finds Baldev in. Gaunt and dehydrated. A shadow of his former self bent double over a huge lump of coal. His eyes sunk deep within their sockets stare out demanding pity. Gone the arrogant and belligerent manner. The cocky reply to a civilised word. Naked except for his coal-blackened 'Y-fronts'. His clothing discarded in an attempt to keep cool.

"How's it going then Baldev old boy? It looks as if you've been jolly active. What?"

Jan Scott's lover casts an evil look. Summons up his last remaining dregs of energy and spits out a huge lump of black phlegm. Caleb turns in disgust to his Second-in-Command. Annoyed at this mark of disrespect.

"I hope you're not working him too hard *Major-General* or he won't be around for the breakout!"

"Na. Na. Bwana. Baldev like it down here. He told me. Besides I'm paying him double the rates."

Caleb looks hard at Baldev to get at the truth but the glance he gives Errol tells him what he wants to know. One thing Caleb won't tolerate is bullying.

"Don't worry Baldev, I'm going to see you alright!"

A look of hope crosses the Indian boy's face.

"I'm going to put your wages up to twenty crisp packets per shift and promote you to the rank of Stoker. The C.T.L.A. depends upon men like you Stoker Baldev. Our factories are crying out for coal! Here take this for services rendered. Well done lad! Well done!"

Caleb pushes Paul Reaney into the palm of his hand. One of his World Cup medals. Gives him a brisk salute. Baldev emits an exhausted sigh. Slumps back heavily against the huge lump of coal he's just hacked out with a compass. Swoons into welcomed unconsciousness.

Caleb has a problem. Conditions in the tunnel are plainly intolerable. The temperature is close to boiling point and the air is thick with dust. Nobody will survive in here for long unless he gets the bellows working. He has to make a decision. Whether to concentrate on mining coal and provide a priceless source of income for the C.T.L.A. or continue to work on

the tunnel? The plan is still to get out on June 13th and nothing must prevent that from happening. He owes it to his men.

Caleb pauses for a second and squeezes his head for the answer. The voices are trying to get in touch. Attempting to discover what wavelength he's on. One of them at last succeeds. Thunders out instructions. For his ears only.

"Open up a Second Front! Keep the tunnel going as well!"

Caleb chortles to himself. The simplicity of the answer. Like all great leaders in moments of crisis he's received his instructions from a higher being. Fucking brilliant eh? How can he go wrong?

CHAPTER 25

Back in Tunnel H.Q. Caleb spreads the contents of a file marked 'Ventilation' neatly out on his desk. Drawings he's made of a giant pair of bellows to go in the boiler room. Made from the finest leather from the jackets the posh kids wear to school. The air pipe itself is easy. Drainpipes removed from the outside of Colditz and fixed to the end of the bellows. Giant pistons will pump the air through just like they do in Cornish beam engines.*

Yet another worry over for Caleb. Something else to cross off his list. He wishes everything was so easy. Next a rota to see who looks after the sheep. Keep them in a classroom during the day out of sight of the public gaze. Keep Yellowhead at bay. They can only be put out to graze at night. On the sportsfield with volunteer shepherds. Perhaps Peter and Valti the Indian gypsies? They've had plenty of experience in that sort of thing. Guarding village cattle from man-eating tigers on the plains of the Punjab before they came here.

Speaking of the sportsfield. Caleb noticed earlier that day Perks was making the first cut of the season. Up and down the cricket square in beautiful parallel lines. The outfield though contained a message for other racist bastards. 'Keep Britain White', in large block capitals cut into the longer grass. Perks's evil little protest. A wry smile breaks out on Caleb's face at the plan he has in store for the groundsman. And his fucking dog!

Caleb starts having one of his turns. The result of Dr Perkin's latest prescription. A tab of LSD that morning. Shaking profusely and sweats. The heavy mantelpiece of responsibility is beginning to weigh him down. Objects around him in H.Q.

* Design and Technology Making Skills.
 Pupils should be taught to have an understanding of the importance of ventilation in confined spaces. They should have an outline plan that includes the materials, equipment and processes to be used, and suggest alternative methods of breathing if first attempts prove useless.

begin to swoon and move around. Pressure mounting in his brain. Thirty pounds per square inch. Visitors appear from out of the blue and take advantage of the state he's in. Chickens gather at his feet and even Rosie makes an appearance. They all watch as the worms wriggle across the room. Heading due south before winter sets in. Then all begin shouting at each other. A rabble complaining about their lot. The whingeing minutiae of their sheep bleating gossip driving him insane. N.Q.Ts and R.O. As! N.V.Qs and P.S.E! All a load of teacher bollocks! Key Stage and Attainment Targets. All the ingredients of a first class wank! It does his fucking head in!

His boots start filling with wet again. Triggered off by this hallucinogenic trip. Finds its way down his inside leg and forms a puddle on the floor. Caleb lights the gas fire in the room and stands astride to dry himself. Clouds of steam rise up like smog. Giving off a pungent odour he sucks deep and heavy into his lungs. A blissful moment of calm and relaxation. Clears the mind of stress and torment. But only for a second. Voices tell him to act at once. Put in a public appearance. Prove to his gang he's still alive. That despite ugly rumours to the contrary he hasn't been taken away in chains. But before he does that he needs a fix. Something to calm him down a bit and put him back on par. A ride on Yellowhead's horse. Chasing the dragon through a straw. With a pinch or two of somatotropin the undetectable growth hormone favoured by Chinese swimmers.

Caleb sits calm and quiet in his chair and waits for the drugs to kick in. It doesn't take them long. A matter of minutes before he begins to swoon in relaxed detachment. Cotton wool clouds sweep over the horizon and carry him out to sea. A gentle lapping of waves in his system dreaming him into a wondrous sleep.

"I thought I'd find you in here you bastard!"

Caleb is living on a desert island. Coconuts and dusky maidens. Pretty girls all in a row. Still in a semicomatose state he feels himself being roughly shaken. A crude attempt to rouse him from his heavenly slumber.

"No use pretending to be asleep! Come on! Wake up you bastard!"

Caleb manages to stir one eye open. For what appears to be an age it tries to focus on this rude intruder. The shape of a face forms slowly before him. Fat bloated cheeks with goatee beard! Jesus Christ! It's Roger Sweet!

"What the fuck you doing here?"

He waves his plaster clad arm in Caleb's face. Menacing fashion. Obviously not come in peace. Commander Duck sits up straight and tries to get his bearings. Gradually coming to his senses. He sees Gelert standing in the doorway. Spear at the ready just in case.

"It's time you and me Caleb had a little chat. Just to put the record straight."

"What time is it?"

"Five o'clock."

Father Catalyst can't believe it. He must have slept for hours. The entire afternoon session has gone in a flash! No rude interruptions from any of the kids. A credit to Major Kowalski.

"Listen Caleb. I saw the state Kaye came home in the other day. No one, and I mean no one, should have to go through that! It's over between you two! Finished! Why can't you be man enough to accept that and cooperate in the divorce?"

Caleb slowly coming out of his stupor. Focuses two blurred eyes on this uptight little shit.

"What the fuck has it got to do with you, you cunt?"

"Everything! Kaye lives with me now. I don't want her hounded by obscene phone calls at work or in the middle of the night! We both know it's you so it's no use pretending otherwise."

As Caleb's brain begins to clear so his temper starts to rise.

"I don't know what the fuck you're talking about!"

"Oh come on! Why did you tell the police it was me who burnt your house down? That was a lousy thing to do!"

"Did Kaye send you to do her dirty work?"

"No. She doesn't know I'm here. This is just between you and me."

Probably in a junior school the thrusting beard and hard held gaze do much to intimidate and get their own way. Not here. He doesn't know Caleb's a Plantagenet. A direct descendant of Henry V! Victor at Agincourt!

"Have you worked out yet how you were going to spend my money? A new car perhaps? Concrete engines are going out of fashion!"

"You don't frighten me Caleb! I've got friends. I'm warning you! Anything else happens to me or Kaye you'll be getting a visit. You're not the only one who knows how to play dirty!"

Caleb remains sitting in the chair. Laughs in the little turd's face.

"Is that a threat? You wife stealing wanker!"

"Take it any way you like."

Sweet gives what he thinks is an intimidating look then turns and walks away. Pushes past Gelert in a state of high dudgeon. He really fancies his chances. Caleb gets to his feet and follows him out. Along the bottom corridor.

"I hope you're not a heavy sleeper Sweet! You may not hear the sound of the back door opening!"

He turns to confront Caleb yet again.

"I'll tell you something Caleb. I always carry a knife around with me. I wouldn't try anything stupid if I were you."

"I don't believe you. You wouldn't be so childish, you stupid little prick!"

Sweet puts his good hand into his car racing jacket and pulls out a switchblade knife. Presses a small chrome button on the handle and a six inch blade shoots out. Very impressive. He wasn't kidding.

"Kaye must feel very proud. Living with a real girl guide."

Sweet ignores the taunt. Turns his back and continues to walk away. Caleb with his anger rising issues a passing shot.

"If you ever come here threatening me again Sweet you're dead!"

Uses his plaster cast to lift the old-fashioned latch and

pauses for dramatic effect. Turns and scoffs at Caleb. His other hand still points the knife.

"You're mad Caleb. You know that? You need treatment! It's no wonder Kaye wants out! Wants me instead!"

If he hadn't stopped to say those last few words he would've been okay. As it was, Gelert seeing which way the knife was pointing and the imminent danger it presented to Father Catalyst decided to take matters into his own hands. Do the job he was paid to do. And how efficient he proved to be. The javelin was hurled from a good thirty paces. A good ten yards from behind Caleb's back. He felt the wind of the tip as it flew over his shoulder. Watched as it passed right through Sweet's chest and pinned him to the door. A look of utter amazement on his face. No question about it. For all his brave talk and belligerent manner the Deputy Head was a goner. Slowly the look begins to fade. Mouth sags open and lower jaw drops. Goatee beard upon his chest. Blood forming a puddle at his feet. Spreading rich and red and thick. Kaye will have to rethink her plans. Sweet won't be there to share them.

That night when all was still and quiet Caleb and his faithful servant paid a visit to the Main School Building. Let themselves into the Cookery Department and helped themselves to the largest chest freezer. Carried it back to Butlinland and there laid the rotter Roger Sweet to rest. Covered him over with pizzas and icecreams, apple tarts and bread. Caleb gave Gelert the job of guarding the body whilst he went out and contacted Boom-Boom Campbell. Paid him four more GCSEs at Grade A level to dispose of Roger Sweet's car from the car park. Boom-Boom dumped it in the Feeder Canal.*

* Dr Benefield told the Enquiry that she did on one rare occasion arrange to meet Caleb Duck away from the controlled and intimidating environment of the hospital. She thought in the more relaxed setting of Tesco's cafe she would be better able to gauge the nature of his psychosis. She can remember it being a pleasant meeting with Mr Duck seeming in good spirits. He bought her a coffee and a cake and began to tell her about his plans for the future. At this point in the proceedings her memory failed her. She apologised to Judge Bradley for not being able to recall what happened next. Most unusual really because she always kept notes.

From: G. Rees B.Sc To: Head of Integrated Studies
 Acting Headmaster Department

Date: 26.5.98
Time: 15.00 hours

VERY URGENT

Your presence is requested at a Governor's Meeting to be held in my room 3.6.98 at 16:00 hours.

AGENDA

1. To discuss the forthcoming Ofsted inspection and the implications it has for the Integrated Studies Department. Please bring with you the following information:

a. Copy of the National Curriculum Syllabus as followed by the pupils in your Department. *In all subjects.*

b. Each individual pupil's exam entry at GCSE level and expected level of pass/failure.

c. Attendance figures for each class. Worked out as a percentage.

d. Number, and names of all pupils statemented in the I.S. Department and listing their special needs.

e. Names of pupils seen by the Educational Welfare Officer since you became Head of Department.

f. Names of all pupils referred to the Educational Psychologist.

g. Copy of the Personal and Social Education Programme (P.S.E.) implemented by you in the I.S. Department.

Please give this matter your urgent attention!

 Geraint Rees. B.Sc
 Acting Headmaster

CHAPTER 26

The first thing Rees the Nasty did when directed by the Board of Governors to assume command of Walliscote Road School was to dictate a letter to his newly promoted secretary Mrs Harris. Ordering that crazy bastard Caleb Duck to attend the Governor's meeting. This was a moment he was going to savour. Get rid of that madman once and for all. The cunning W.C. realised that Duck's outrageous appearance and appalling behaviour would guarantee him the sack.

True to form Rees didn't deliver the letter himself. In all the years he'd been at the school he'd never once set foot in I.S. Department. Too scared. To be called a cunt by the likes of Shitty Shearn was more than his fragile ego would allow. So he sent Mrs Harris over instead. Her husband is a Tory councillor who has ambitions to become Lord Mayor. Also happens to be Chairman of Governors at Walliscote Road School. Rees had craftily plucked her from the ranks when the job of Headmaster's Secretary became suddenly vacant. The previous holder of the post having quit in a hurry two days ago. Bursting for a pee that fateful afternoon she'd rushed headlong into W.C. William's private loo. Ahhhh! The sight of his post-ejaculated penis, bulging eyes and purple face, feet dangling lifeless in the pan caused her to scream and shit her pants. Hence the vacancy.

With all the confidence of an ex-public schoolgirl Mrs Harris strides into the I.S. Department in purposeful manner. Pushes open the door on a charge. She fails to notice the half-inch round hole at about chest height perfectly formed in one of the panels. Nor does she detect the large bloodstained patch dried into the mat on the other side. True, she blinks as she marches past Butlinland and sees this pupil draped in blankets holding a javelin and clutching a dustbin lid. Standing proudly to attention. He seems to be guarding a large chest freezer. Thinks it odd but carries on. Frowns when the same boy suddenly rushes past her and blows a bugle in her ear. These

lads will have their bit of fun. What? It doesn't seem to bother her either that fifty or sixty rowdy types jeer and mock her up the stairs. She takes no notice. In her stride. Hardly spares them a glance.

Yes, she does express some annoyance at the racket coming from the musical knight's recently repaired equipment. She enters the Hall to a rousing accompaniment of Elgar's Unfinished Third. A stirring passionate bit. Frowns. Thinks it loud and rather unnecessary. But nothing's prepared her for what is to come. Walking past the Dug-Out Club, when three very smart chaps in business suits, advisors or social workers she believes, happen to emerge. Looking very pleased with themselves. It was then the noise hit her like a laser. Speedgaragelectroacidhouse! Fanfuckingtastic! Yellowhead's wall of sound. Knocks her clean off her feet and pins her to the wall. Begins turning her innards into jelly and blows her skirt right over her head. Too much for Grabber Newell. He can sniff an overripe gusset from half a mile. He's in there like a shot. Makes rude intrusion into her undies. Quickly fills his grubby little hands with fistfuls of tit and arse. Even risking one round the front before she boots him in the bollocks! After a valiant struggle lasting a good half-hour she manages to free herself of the force of Yellowhead's speakers. Scrambles to her feet. She looks around in a fearful rage. Desperately seeking the teacher in charge to harangue him about his pupil's vile behaviour and the frightful row coming from one of the classrooms. It's surely a danger to health!

But no-one is interested in Mrs Harris's plight. Hers is just an everyday incident as far as they're concerned. Everyone's gathered at the far end of the hall where something far more entertaining is taking place. Kids screaming out in hysterical laughter. The girls especially. Some hiding their faces in embarrassment. Mrs Harris heads towards this group. Storming at the double. That's when the penny finally drops that she's journeyed into another world. Another planet even! Something outrageous is taking place. Duck is naked and taking a shower. In the interest of Design

194

and Technology, Health and Safety. So the miners can wash after a shift at the face. A practical application of an idea he'd had now being put to the ultimate test. In full view of everyone. Certain modifications need to be made of course, like walls and a floor to stop the water escaping. And a certain degree of modesty perhaps?* Maria and 'Foreskin' Sandra are in there with him soaping his back and other bits. Much to the amusement of the crowd. Mrs Harris thought she'd seen it all. In her early years she'd been in the Army. Seen lots of service abroad. Once had a serious relationship with a donkey but never, never in all her days had she seen anything so depraved and disgusting. She pushes her way angrily through the crowd waiting for Duck to acknowledge her presence. Eventually he does. Steps out of the shower with carefree abandon drying his bits with an enthusiasm that borders on self-abuse. Asks her what she wants.

"I'm under instructions to give you this!"

Desperately trying to avert her eyes from his large and lazy protuberance. Swinging backwards to and fro like a giant pendulum. She hands him the letter that Rees has given her. Caleb reads it with a scoff and then turns rather nasty.

"You can go and tell Rees to fuck himself! And if I were you I'd get out of here fast! How dare you come waltzing in here uninvited! Who the hell d'you think you are?"

Mrs Harris takes a deep breath. Stares at him with hands on hips. About to launch into a spectacular tirade. Just like she does at her Conservative Club. But Caleb anticipates her move. Orders Delroy Wong to step swiftly forward to escort her off the premises and see she doesn't return. The sight of the seven foot three Chinese-Jamaican ensures Mrs Harris keeps her thoughts to herself. Rushes from the building in

* Key Stage 3. Design and Technology. Attainment Target 12.
 When designing and making things pupils must think up ways that embroider already existent external and internal influences and use their comprehension of familiar products. Pupils to explore and generate ideas for the purpose the product is intended for. Consideration must be given to the function, reliability, communication aspects, clarity of thought and expression, hyperbole, hydrology, hydrant and hymen.

fear for her life. N'er to return again. She won't talk about this to anyone. Her husband is Chairman of the Governors and she doesn't want to implicate him!†

Whilst Caleb was towelling off on top of a table Major-General Perkins arrived with the nine o'clock shift. Not their usual cheery selves. There's a shit-scared look about them.

"Come quick Bwana! Something spooky going on!"

"What you talking about?"

"Stoker Baldev Bwana. He ain't down there no more."

"Rubbish Errol! He's got to be."

Errol gives his men a worried glance.

"He ain't Bwana. I've looked."

Caleb angry. Another of his men has done a bunk.

"You mean you let him get away when you weren't looking?"

"No Bwana. On my mother's grave!. He's vanished into thin air!"

Caleb decides this needs further investigation. Prepares to organise a search but before he can do so Lynda arrives.

"You've got a phone call luv. From your son James."

Caleb had forgotten all about his kids. Too many things on his mind. Besides they weren't his favourite people at the moment keen as they were to dine with Sweet.

"What d'you want I'm busy?"

"Mum told me the house had burnt down!"

"That's right it did. But that doesn't concern me any longer. I couldn't give a fuck."

"Dad try to be serious. Who did it d'you know?"

"Fucking obvious isn't it? That weird fucker she's living with!"

A pause before he answers.

"She isn't living with him any more."

† Mrs Harris told the Enquiry that Caleb Duck was a very caring and thoughtful individual who always had the interests of his pupils at heart. He gave freely of his own time in an attempt to conquer the twin forces of social deprivation and ignorance. She was extremely shocked and saddened by the tragic events that later took place.

Caleb laughs down the phone as he says it.

"What's happened then? Has he got cold feet?"

"He's gone missing. Nobody knows."

"Perhaps your mother froze him out?"

Caleb goes on and on. Weak puns at Sweet's expense. If only James knew what really happened. If only everyone knew. Kaye included. It's funny how little he's thought of her in the last few days.

"Dad you oughta see a doctor. My money's run out. I'll ring again next week."

Caleb waits for James to put the phone down. Laughs his way out of the room. Heading for Butlinland and a bit of Charlie before meeting up with Errol. Lynda listening to his high-pitched cackling echoing down the stairs. If she didn't know it was Mr Duck she'd swear it was a looney!

Gelert bless his heart is still on duty. Guarding the freezer with his life. But he seems to be having a bit of trouble. Two foreign looking blokes pinned against the wall. Javelin cocked ready in his hand and a look in his eye Caleb's seen before. The two men are obviously petrified. Gabbling away in an alien tongue but some words, "Yellowhead" and "Dug-Out Club" are easily understood. Caleb gives them directions on how to get there and watches them walk away. Staggering under the weight of four large suitcases with Columbian Airways labels stuck on the side. Caleb's puzzled. Scratches his head. Who does Yellowhead know from there?

A couple of lines did the trick. Something that gave him great physical strength and astounding mental powers. The electric tingle as the drug kicks in. Jesus! How sweet it felt! Doesn't know how he'd coped without it. Nothing like it in the world! Makes his way down to the boiler room where Errol and his posse await. No words are spoken between them. Just anxious looks on frightened faces. Pondering the fate of Baldev.

They enter the tunnel on their hands and knees and come to the spot where it branches off. The coal seam going away to their right. Here Errol shows true leadership qualities. Splits up the Boiler Room gang. Junior and Backwheel to continue digging the tunnel whilst he goes exploring with Bwana

Duck. In the urgent search for Stoker Baldev. Backwheel not happy with that arrangement.

"That ain't fucking fair man! We've already done a five hour shift!"

Errol hurls the threat at him in menacing fashion.

"And you'll do another five fucking hours if I tell you! Else you'll end up like that traitor Greenwood!"

Caleb's ears prick up. Can't let that remark go unchallenged.

"What about Greenwood Errol? Have you seen him?"

Errol rubs his chin in rueful fashion.

"Don't you worry none Bwana. You gotta nuff on your plate already man. Leave that blood clot Greenwood to me. I'll handle that side of the business."

Caleb senses it would be unwise to press the matter further. He must trust Errol to do what he thinks is best. Part of growing up. He turns and crawls into the squareshaped tunnel. Pitch black and highly intimidating. They use the portable gas lamps from a sportshall raid. The ones the Duke of Edinburgh carried for his Gold Award. Not! Eerie shadows flicker on wet and shiny walls. Water drips down and plops into puddles. Altogether a frightening place. Errol follows close behind muttering curses to himself.

"This is fucking scary man!"

Caleb creeps ahead. Astonished at the progress Stoker Baldev has made. Gone completely out of sight. And only with a compass!

"Stoker! Stoker! Where are you?"

They anxiously wait for the echoed reply. None comes. Only a host of phantom listeners that dwelt in the coalmine then listen out and look into their grey eyes where they stand perplexed and still. Progress halted by a huge lump of coal that's fallen across their path. It must weigh at least six tons. Caleb shines his light up to examine the hazard. Beyond it the tunnel goes on.

"Hey Errol! Come and take a look at this!"

Pit props and cables can just be made out. No way could Baldev have done all that.

"This is the coalmine that Dave was on about. Amazing to think men used to work down here!"

This fascinating bit of historical information doesn't impress Errol one bit. He peers over the top of the giant boulder to get a better view. His breathing coming in terrified gasps. Eyes rolling white with the jitters.

"You frightened Errol?"

"Too fucking right I is Bwana!"

With that he puts his foot down on something round and soft. Soft? Nothing soft down here! This is a coalmine. A heavy-duty industrial place. He scans the midnight black of the tunnel floor to see what it could be.

"AHHH! AHHH! AHHHHHHHHHH!"

Errol sees the eyes staring up at him. The fixed horror-struck expression on Stoker's face. Leaps off the ground with a reflex action triggered by hysteria. Cracks his head hard on a rotting beam and collapses in a daze. His torment doesn't end there. Somehow gets tangled up in arms and legs that don't belong to him. They're cold and very stiff. Demented thrashing around as he tries to brush them off. High-pitched screeches of unabated terror. Clouds of choking dust.

Caleb directs his lamp for a closer inspection. Jesus fucking Christ! Stoker's under the lump of coal! Squashed flat as a pancake and dead of course. Twice the length he should have been. Twice the width as well. There's a massive thump inside Caleb's chest that almost knocks him out. The bee crawls into his ear again. Works its way inside. A hard shooting pain explodes in his head as it plants its sting in his brain. Throbs underneath his arm.

CHAPTER 27

Meanwhile Rees was cock-a-hoop. Everything under control. Blissfully unaware of Duck's horrific discovery. He'd just completed his Development Plan to save his ailing school. He'd stayed up into the wee small hours working on the document. Put into place a whole raft of ideas he knew would impress the Ofsted team. The flagship of his hundred page report was a network of support systems for staff and pupils to be implemented at once. These included Key Workers to work with L. S.As, Literary/Numeracy Support Groups, Peer Reading where Key Stage 4 pupils work with Year 7, Achievement Groups for the highfliers, a 'Buddying System' for each faculty so colleagues can call upon help from an adjacent classroom if a pupil needs to be sent out. A Quiet Room for disruptive pupils. A Social Skills Base, a Careers Guidance Service, Family Computer Club, a Reward System and Celebration Assemblies, School Council, Peer Meditation and Disabled Access. Book Checks and a Year 11 Responsibility Charter that commits all Year 11 pupils to a responsibility.

Rees couldn't believe how clever he was. Page after page of sparkling new initiatives that were designed to impress and dazzle. He was following the golden rule of Senior Management success that bullshit baffles brains.

Just put the final touches to his dog-wank waffle when the phone rings in his office. Sergeant Tosser Torrington no less. The bearer of terrible news. Stops him in his tracks. The worst thing that could ever happen. Rees throws up over his precious document. The only copy he has. Can't believe it's true!

At about the same time he was being sick Caleb and Errol were crawling out of the tunnel displaying a conflict of styles. Errol trembling with heavy fear. Several shades lighter than normal. Finds a quiet corner of the boiler room and collapses head in hands. Moaning and groaning in a traumatised state.

Caleb less emotional and more in control sees the broader picture. The unfortunate accident to Stoker Baldev won't

signal the end for the project. Oh no. Quite the reverse in fact. It will only serve to galvanise his Department. Inspire them to carry on. The standards they seek remain the same. Grey flannel trousers with smart striped blazers. Top it all off with a tasselled cap that fits tightly over brylcreamed hair parted neatly down the middle. Is it wrong to demand that pupils do lines? I must obey the school rules. Page after page. Front and back. And fill in all the spaces! Are they so frail and insecure they'll lose their individuality if such oppressive demands are made? Are they fuck! Stoker Baldev didn't seem to think so and he sacrificed his life for the cause.

Caleb moves swiftly back upstairs to assess how things are progressing. Most of his gang have left the building on earth distribution fatigues. Six of the Indian girls who remain behind are taking their GCSE Needlework exam. Earning extra packets. The paper is a stiff one. Design and make the nun's uniforms they'll be wearing on June 13th. Suddenly a terrible scream of "Fuckin" hell!' draws Caleb's attention away from them. Puts him on the alert. Corporal Shearn emerges from the city farm in a highly stressed out state.

"Yer sir! Come and take a butcher's at this!"

The boy's hysterical and close to tears. Caleb follows him into the room. The stench is terrible. The gut-wrenching stink of seventy odd animals penned up in a room. No grass or water to relieve their suffering. Can only be let out at night you see. Otherwise Perks the groundsman might start to complain. Set his dog upon them. Bastard.

"What is it Corporal?"

"Some of the sheep have lost an eye sir!"

He points to a miserable looking creature in a corner. A bloody socket where the eye should be. Caleb is taken aback.

"There's another one sir! Look! Over there!"

Altogether they counted at least five sheep who'd had an eye removed. They certainly weren't like that when they brought them in. All passed their medicals hundred per cent.

"Any ideas who could have done it Corporal?"

"Ain't got a clue sir. It must be done at night when they're out on the field."

"Special lookout tonight then Corporal Shearn. Find out the cunt who's doing this . We owe it to the sheep."

"Yes sir. Leave it to me sir!"

Shearn wipes away a tear. Surrounded by sheep shit he's in his element. No complex about being the odd one out. Caleb leaves before he vomits. Returns to Tunnel H.Q. for a well deserved break. Top up on his drugs. A Frontline Special if Lynda's around but a ringing phone scuppers that idea.

"Shitty Shearn's sheep sanctuary for the safety of sheep!"

The nasty W.C. Rees is on the line. Sounding subdued and all forlorn.

"Sergeant Torrington has just called me Caleb. They've just found the body of Gary Greenwood on the railway line. What was left of him at least. . . . Caleb? You still there?"

A blinding pain shoots across Caleb's chest. At least three heartbeats unaccounted for. Fights for breath on a swell of panic.

"Yes I'm here."

"They found bits of him over a two mile stretch. It took dental records to identify him."

"Silly sod! If he hadn't gone A.W.O.L. it wouldn't have happened."

A silence on the other end as Rees tries to fathom the comment. Fails. Carries on regardless.

"It gets worse I'm afraid Caleb."

"Go on."

"The last known sighting of young Gary was about a week ago. He was being chased by a gang of kids from this school."

"Any names?"

"Who d'you know wears a Russian hat and Georgio Armani suits? Any idea where he is? The police want to ask him some questions."

Wing Commander Duck collapses into his chair. Emits a cry of despair. Just enough strength left to replace the receiver and retain semi-consciousness for a while. The drugs beginning to work. The scenario unfolds in dream sequence before him. Errol had caught up with Captain Greenwood and taught him a lesson he'd never forget. How else could it be

explained? Now he's gone and fucked it all up. Thrown away a first-class education! This should be a job for the School Welfare Officer but for some obscure reason she's resigned. It's a thankless task and who can blame her? With cunts like Errol on her books.

He immediately seeks him out in the boiler room. Orders the others to leave. Slams the door shut and bolts it across. Could be a painful business. Errol sucks on a spliff and looks thoroughly beaten. A shadow of his former confident self. Looks up and sees Caleb staring at him. Peering eyes seeking out the truth.

"I swear I didn't do it Bwana! That Baldev must have done it himself. An accident or summat!"

"I'm not concerned about Baldev Errol. What d'you know about Greenwood?"

As if he'd been hit with a hammer. He slumps to the floor. Goes down on his haunches. Covers his head with his hands. Distraught beyond belief.

"Oh my God! Lordy! Lordy! I'm in deep shit ain't I?"

"You are if you did it Errol. The police are looking for you."

His mood suddenly changes dramatically. Starts to get angry and shouts.

"What the fuck do they know about it? Eh? Tell me! Were they there? Eh? Were they?"

"So what happened then?"

"I wanted to bring him back to you Bwana. Like you said for questioning. He just ran in front of the train. Honest to God Bwana that's the truth!"

He breaks down and begins to sob again. Rocks backwards and forwards on his haunches. Pleads with Caleb to believe him. Caleb's heart goes out to the lad. Of course he believes him. He's telling the truth. Exactly what must have happened. Puts two arms around to comfort him. Brushes the tears off his face.

"You'll have to hide down here until this is over Errol. It's the only place you'll be safe."

Errol looks at Caleb as if he's barmy.

"I ain't staying down here man! Not with flat Baldev lying in there! No fucking way! I'm out of here!"

Caleb blinks hard. Can't believe he's hearing this from his Second-in-Command. Gross insubordination. Prepared to put at risk the entire escape just to save his own neck. Inconsiderate bastard! The red mist descends on Caleb's head. Clouds his thinking somewhat. Grabs a shovel and approaches Errol. Madness shining from the eyes.

"Listen Errol you stay here or you'll be joining Baldev! Understand? That's an order! I'll send down some food with one of the girls."

Errol's seen that look before. Knows better than to argue. Sees the sense in what Caleb said. Hands up in surrender.

"Okay Bwana! You're the boss. Whatever you say."

Caleb lowers the shovel and smiles. Shakes him by the hand.

"Well done Major General! That's more like the spirit I wish to see!"

CHAPTER 28

Despite continual interruptions from the police enquiring about the whereabouts of Errol Perkins and the hysterical rantings of Mrs Duck who was accusing him of harbouring a raving lunatic Mr Nasty W.C. had somehow managed to present the Chair of Governors with his Development Plan. In it he claimed his rationale was to provide a secure and purposeful learning environment in which achievement is shared by all personnel. He would actively discourage domination of any space or activity by one particular group. He had Caleb in mind when he wrote it.

Mr Owen Harris, husband of Over-Bum in Reprographics and the Chairman of Governors at Walliscote Road School was delighted. Here was a man after his own heart. Knew exactly what he wanted and went out of his way to get it. He immediately sanctioned the course of action Rees was about to take. Together they stride across the playground heading for Caleb's kingdom.

There's a dreadful knocking at the gate. Loud and unrelenting. Rees and Harris stand outside the I.S. Department trying to get in. Corporal Shitty Shearn on duty inside refusing to open the door. Stands bravely at his post. He only takes orders from Commander Duck. More than his life's worth to disobey instructions. Kowalski would see to that.

Rees the Nasty puts his eye to the hole left by Hamid the Somalian. A.K.A. Gelert. What he sees causes his Rhondda Valley temper to rise. Corporal Shearn adopts an aggressive stance in the downstairs corridor. Knife in hand and on the alert. Rees yells out his warning.

"Open this door boy or you'll be in trouble!"

Shitty Shearn is not one to be threatened. A thin shrill voice comes piping out. Speaks with quintessential English charm.

"Fuck off sheep shagger!"

Mr Nasty W.C. cringes with embarrassment.

"If you don't open this door at once you'll be suspended! I've got the Chairman of Governors with me!

"He can go and fuck himself as well!"

Rees goes puce. Steam from his nostrils. Never felt so small in all his life. Hammers on the door in a violent rage.

"What's your name boy? Open up! Open up at once!"

Brave Shitty Shearn still not intimidated. Replies with jutting chin.

"My ping-pong rank is Forty-one and under the terms of the Geneva Convention you can stick it up your arse! Welsh cunt!"

Rees turns to Harris. Completely crushed.

"You see? This is the sort of thing that goes on over here."

The mellifluous sounds of Gelert's bugle brings Caleb rushing down to investigate. He's just come out of the upstairs shower Mk. III and snorted a line of coke. To put him in the pink and prepare him for the work that God had decreed or was it someone else? He arrives with a towel wrapped around his waist. Opens the door to speak to Rees. Annoyed his routine has been rudely interrupted.

"What the fuck are you doing over here Rees?"

Caleb points to Mr Harris.

"And who the fuck is he?"

Rees is delighted at Caleb's behaviour. Exactly as he hoped it would be. It gives him enormous satisfaction to explain the purpose of his visit. He's in his element. Smug, puffed up fat Welsh prick that he is. Dia Minutive. Smarms a sickly smile of triumph.

"Mr Duck, allow me to introduce you to Mr Harris the Chairman of the School Governors."

He goes on to explain, brown nosing style. As Caleb hadn't attended the Governors meeting, had chosen to ignore all his previous memos he had no other option but to bring in Mr Harris. What with the imminent arrival of the Ofsted inspectors Rees can envisage a short sharp closure of the school. His career gone to ruin and his reputation in tatters. No way is he going to allow that to happen. There's no doubt in his mind

that Duck must go. Mr Harris takes this as his cue to step forward. Bravely into the frame.

"As Chairman Mr Duck I'm relieving you of all responsibilities. I'm sorry but as of now your contract with this school is terminated. Of course your salary will be protected and you have the right to appeal."

Caleb blinks. Looks at him aghast. Thinks the man is fucking mad!

"Have you any idea what you're talking about?"

"Yes I have unfortunately. The pupils in this Department are out of control. I witnessed that for myself just now when one of your boys used the most foul language to Mr Rees! I'm sorry Mr Duck but I owe it to the parents and all the other teachers to take this drastic action!"

Caleb looks across at Shitty Shearn and frowns. It had to be him. Gelert still doesn't speak any English. Gelert! Fuck's sake! Caleb can't believe it! He stares at the Somalian in utter horror. He's taken a handful of sheep's eyes out of his pocket and is picking through them for a nice one to chew. Finds it and pops it into his mouth. Mr Harris turns green and looks away. Pukes up in the corner. Caleb blinks and shakes his head. Pretends it hasn't happened. Addresses Shearn in stricter fashion.

"Corporal Shearn! Anything to say to Mr Rees?"

Shitty Shearn snaps to attention. Salutes the Acting Headmaster.

"I'm sorry sir! Under a lot of stress sir! My mother wet the bed last night sir! Had to sleep with me sir! She wanted me to you know what sir! 'Course I had to do it!"

Rees looks a little confused. He's been wrong-footed. Caleb as always the master strategist takes full advantage of the situation. Orders Gelert to sound the Assembly. Five clear notes in ascending scale and from all corners of the building they run. Trained to respond to the emergency call.

The bottom corridor is soon teeming with screaming pupils. Clambering over each other. Pushing and shoving. Just like a rugby scrum. Caleb turns to Rees the Nasty W.C. and Mr Harris the Chair of Chairs. Eyes them fiercely for their slanderous remarks.

"I find your remarks extremely offensive. I'll show you how disciplined these pupils are. And when I've finished I'll expect an apology."

He tightens the towel around his waist and signals Kowalski to assume command. Ever since Caleb told him he was wanted for questioning there'd been no sign of Errol. Disobeyed orders and ran like fuck just as soon as he had the chance. So the Pole was promoted to be the new Second-in-Command and given the rank of General. World Cup medals bounce proudly off his puffed out chest. A Union Jack tattooed on his shaven skull.

"SIR! YES SIR!"

"Get the troops ready for inspection General!"

"SIR! YES SIR!"

Kowalski turns to face the screaming rabble. Bellows out a solitary word.

"ATTTEEEN-SHUN!"

An unbelievable response. Immediate silence and respect. All faces turn to the front. Rees and Harris taken by surprise.

"TROOP! IN ASCENDING ORDER OF SIZE! SHORTEST AT THE FRONT! TALLEST AT THE REAR! LINE UP!"

In seconds they've taken up position. Little Alison Long at three foot eleven standing at the front whilst Delroy Wong at eight feet two grows proudly at the rear. Absolutely fuckin' brilliant. Rees and Harris gape in astonishment at Kowalski's control of the mob. Caleb has a sudden idea. Calls Kowalski to his side.

"Have the men assemble the other way General."

"SIR! YES SIR!"

Kowalski back to assume command. Waits for all eyes to be on him.

"TROOP! IN DESCENDING ORDER OF SIZE! TALLEST AT THE FRONT! SHORTEST AT THE BACK! LINE UP!"

This time even quicker. The huge Delroy Wong now eight feet six. Bean sprouted in a matter of seconds. Stands rigidly to attention in front of Rees. Much to the Nasty W.C.'s con-

sternation he only comes up to his knees. Makes him feel small and insignificant. Which of course he is. Caleb takes command.

"Thank you Kowalski."

Caleb stands on a chair so all can see him. Towel bulging with job satisfaction. Shining eyes upon his face. In respect and honour of the man who's done so much to help them. Caleb's never felt so proud in his life. Ordered discipline and ready for battle. They stand before him. The salt of the earth. When it comes to the crunch.

Caleb tells them all to listen very carefully. Hearken to his words. Two errand boys from a rival gang have brought grave news with them. Caleb points a finger at Rees and Harris. The intended hint of a threat.

"They want to appoint a new Commander in Chief! Someone else to take my place! What d'you think of that?"

The assembled throng are shocked and outraged. A violent protest erupts. Angry cries of bollocks! and fuck off! are hurled towards the visitors. Even before Kowalski can stop him the usually mild-mannered Delroy has sprung into action. Fingers circumnavigate Rees's neck and hoist him high in the air. He's held aloft above the rafters. At arm's length screaming out in fear. Delroy smashes his head against the ceiling. Again for the pleasure he got. Booms into Rees's face.

"You do that man and I'll fucking kill you! Understand man what I'm saying?"

Caleb orders Delroy to put Rees down. In normal circumstances he'd allow him to continue but Harris is witness to the assault. He looks on appalled as Rees crashes to the floor. Bounces to lie in a heap. Making all kinds of funny gurgling noises. Caleb looks at Delroy and gives a rueful smile.

"I was going to say Delroy that was BEFORE they saw how well-behaved you all were."

Delroy grins in huge embarrassment. Shame. Feel bun. Inner rage subsides. Mutters his apologies to W.C. Rees and pulls him to his feet. Dislocating his shoulder. Rees screams a mixture of pain and hysteria. Only too happy to still be alive.

Caleb seizes the moment a second time. Shouts aloud the battle cry. Time to rally the force.

"Troop! Name the best school in Bristol!"

Eighty voices yell out in unison. Proud to give their reply.

"WALLISCOTE ROAD SCHOOL SIR!"

Then absolute silence as they await the next chant.

"Troop! Whose the best teacher in Bristol?"

"BWANA DUCK SIR!"

The echoing cry of a million voices enough to stir the hearts of the most bitter and cynical. Even Rees has to admit to himself he's impressed. But there's even more to follow. Caleb strides up and down the ranks of his army. Urging them to give of their best.

"Troop! Who's the best Headmaster in the world?"

The loudest reply of all. They truly believe in what they're saying. Plaster comes down from the ceiling.

"MR REES THE NASTY W.C. SIR!"

Absolutely brilliant! Rees takes it all in good part. His mood's changed dramatically since he first came across. To hear his name yelled out with such obvious sincerity has done his ego the power of good.

Next Caleb leads them in communal singing. Gelert plays the tune. A rendition of the I.S. National Anthem. The Raggle Taggle Gypsies O!

> 'Last night you slept on a goose feather bed
> with the sheets turned down so bravely-o!
> but tonight you'll sleep in a cold open field
> along with the raggle taggle gypsies-o!'

All the verses beautifully sung. Word perfect in harmony. Mr. Harris can't handle all the high charged emotion. Breaks down and weeps unashamedly. Bless his heart. Never in all his life had he heard such magnificent singing. He has to be consoled by Caleb's secretary who's recognised him as one of her clients. And finally to prove his point Caleb leads them in the Prayer of the Eight Times Table. Absolutely perfect. Spot on. Everyone knows it off by heart and it stirs within them a

spiritual awakening. One based on the knowledge of power and thought. Shows them the path to greater things. Helps destroy the cycle of deprivation that's ground them down for years.

And when the prayer was over and Caleb said Amen Kowalski ordered 'TROOP DISMISS!' Rees and Harris were gushing in their praise. Apologised profusely. Have no hesitation whatsoever in re-appointing Caleb as Commander in Chief. A huge myth has been exploded. Caleb was indeed a wonderful teacher. A man blessed with a precious gift from God. All worries and concerns about the Ofsted inspection vanish from Rees's head. He can see himself cashing in on this.

"I take my hat off to you Caleb. I was wrong about you boy. I'm sure Mr Williams would still be alive if he knew such quality teaching was going on over here. I'm going to recommend you for The Teacher of the Year Awards. I've never seen anything like it!"

Caleb magnanimous in one of his finest victories. Escorts Harris and Rees to the door. Orders Corporal Shearn to lie face down on the floor and act as a doormat to these worthy gents. The least he could do after being so rude earlier on. Lots of shaking of hands all round and gushing congratulations. Caleb closes the door behind them both. Spies them through the peephole. Sees Rees looking down and inspecting his shoe. He's trodden on something very nasty and smelly. Shitty Shearn has done his bit. Had the final word.

Caleb allows his eye to wonder for a while. Something else has grabbed his attention. Yellowhead taking special delivery of two heavy parcels from the Columbian gentlemen who were in the other day. What's he up to then? Eh?

Before he returns to the Main Hall of Colditz Caleb makes a note in his diary. A World Cup medal to be awarded to Delroy for magnificent bravery in the face of the enemy. Jeff Astle with bar even though he missed a goal.

CHAPTER 29

Caleb knows it's just a matter of days before the Ofsted spies come snooping around. Asking embarrassing questions. How he could do with Errol's help now to drive the men along. The bastard ran away.

Before putting in an appearance at Tunnel H.Q. Caleb pops into Butlinland for a quiet word with Gelert. One or two things he needs to sort out. He straps the boy's arm down firmly to the desk and searches his pocket for the stolen sheep's eyes. Places them in the palm of Gelert's trapped hand and raises his sword above his head. Makes to chop it right off. Into the wastepaper basket. A spot of fundamentalist retribution. A hand for an eye and all that bollocks. See how he likes it without anaesthetic. Gelert resigns himself to take his punishment. Gives a little sigh.

"You must do what you deem right Father Catalyst. Let your conscience be your guide."

Caleb astonished at Gelert's mature philosophy coupled with a dramatic improvement in his command of English. Lowers the scimitar to the ground.

"My God! How long have you been able to speak like that?"

"Spending all my time as I do guarding a stiff in a freezer has sharpened my cognitive powers Father Catalyst. That combined with your words of wisdom has honed my capacity for intellectual growth."

Caleb takes a backward step. Utterly amazed! Can't help but feel a little proud of his astonishing success with Gelert. He came to him but a primitive savage and now just twenty-four gobbies along the pipe he's equipped with all the necessary skills for life survival. Proof if more proof were ever needed that his teaching methods are correct.

"Okay Gelert. You're off the hook. But no more sheep's eyes! Understand?"

"Point taken Father Catalyst. It was an ephemeral moment

in my development. There'll be no repetition of the barbarous act. You have my word on that."

"I hope so because next time I'll do it for real."

Caleb takes his leave of Gelert. Upstairs to check out the shower Mk. IV. To test its impact beyond the purpose for which it was designed eg. on the environment.

Mission accomplished okay. Returns bollock naked to Tunnel H.Q. and catches up on the mail. Lynda hands a note across. Smiling as she does it.

Dear Caleb 4.6.98

Just a brief note to thank you and the pupils for the tremendous reception you gave me and the Chairman of the Governors yesterday. I can honestly say it was a genuinely heart warming and learning experience for both of us. I can also confirm I've sent for the forms recommending you as Special Needs Teacher of the Year. You deserve the award for all the incredible work you do in I.S.

Well done Caleb and roll on Ofsted!

 Geraint Rees.

Caleb gives a little laugh. Amazing how Rees has come round to his way of thinking. Pins the note to the wall as a seal of approval.

Lynda hands a coffee across. Watches him towel off after taking the shower. Eyes his swinging pendulum.

"D'you want a hand job before you starts love? Looks as if you need one."

"No thanks Lynda. Later okay? Got too many things on my plate."

She frowns. Her disappointment only too transparent. She enjoys seeing him come and thrash around in an orgiastic frenzy. Crash to the floor in a writhing mass. Screaming and gasping for air. She loves doing things that make people like her. Enjoys the praise and friendly thanks. It makes her feel good about herself. Makes her feel wanted and loved. Caleb's heart goes out to the vulnerable ones like Lynda. Victims who

fall easy prey. Children who've never had a chance. Abused and neglected in their own homes by worthless mums and dads. He looks at Lynda. Studies her face. Sees an anxious worried frown of rejection that's stirred up ghosts from her past. Caleb feels guilty. Somehow responsible. There must be something he can do to help? There is! A fantastic idea. Promises her a room in the bottom corridor where she can run her own business. Much safer next to Butlinland. Part of the Mini-Enterprise Scheme.

"You're kiddin' luv ain't yer? You'd do that for me?"

"Of course I would. You're a fine girl Lynda. Don't let anyone tell you otherwise."

Lynda can't refrain from expressing her joy. Rushes towards Caleb and gives him a hug. Nothing sexual. Innocent child-like love and honest affection. In all her life she's never been treated like this. As a young, intelligent, mature businessperson with a quick-fire brain and digital expertise. With respect. Her self confidence soars to unheard of heights just like the end of his dick. He pushes her off before things get started.

"Sorry Lynda. I've got work to do."

"I'll never forget this Mr Duck. You're ace. D'you know that?"

The sound of shouting in the Hall causes Caleb to tear himself away. It's Bumhead Mason i/c leather jackets and General Kowalski. Struggling with a ladder that goes up into the roof. Seeking out more space to store the topsoil before it's sold off by Bogey Greenham. Their efforts have disrupted a ping-pong match and an argument has started. All this to the rich accompaniment of Stravinksky's, 'The Rite of Spring'. The one he wrote for Diaghilev. Swelling to a climax. Caleb's attention is drawn to Bumhead's jacket.

"I hope that leather coat you're wearing Mason is for the bellows and not for your own personal use!"

It's Bumhead's job to provide the leather for Kiran and Gurdash's Design and Technology project. On five empty packets per hour.

" 'Course it is mate. They can have it when!"

Caleb's sure Bumhead would have gone on to tell him more

214

but Kowalski smacks him in the mouth. Knocks him to the floor. Stands astride him and points a finger. Roars.

"Don't you ever address the Commanding Officer as mate again Mason! YOU CUNT! He's sir or Bwana to you! UNDERSTAND!"

The sly, fat leather jacket thief smudges the blood away with the back of his hand. Spits out a tooth.

"Yes sir. General Kowalski sir!"

"I SHOULD FUCKIN' THINK SO TOO!"

Mason halfway through his punishment of the five times table, aloud and standing on a chair, when the doors of the Hall burst open and the first one eyed sheep of the morning charge in. Hurrying and scurrying in all directions. Knocking over the ping-pong tables and part of Sir John Irving's orchestra. Behind them the Y. T. S. shepherds in an excited state. Peter and Valthi Singh. They drive all the sheep into the city farm and slam the bolt across. Rush to report to Commander Duck. Peter the first to speak. Gives his account of what has happened.

"Vee're out on de sports field last night Sahib. Poleece car come and speak to us. Say what the fuck we doing out here with de sheep. We tell them that we're guarding them for Commander Duck Sahib against de tigers and de black men who come in de night and steal them. We tell them it's all part of our GCSE Course in Agricultural Studies Sahib."

Caleb is very impressed. Proud of the way Peter handled what could have turned out to be a tricky situation.

"Jolly good show Peter. Well done old boy."

Valthi the smaller of the two has managed to adjust his language. He is the businessman. Speaks demanding better terms.

"Because we give jolly good show to de poleeceman last night Duck Sahib can we have more empty packets of crisps pleese? Me and Peter only need another twenty-seven then we win the prize of a hundred pounds!"

Caleb can't believe his cheek. Not content with a free education, welfare benefits and free school meals, the scheming little cunt's demanding higher wages.

The business side of Caleb's brain receives a sudden jolt. He never expected anyone to get anywhere near the total. He thought Errol and Greenwood had seen to that. Of course! In their absence the two Indian shepherds have taken swift advantage. He makes a brave attempt to cover up.

"Gosh! Well done the pair of you! You deserve to win after all the efforts you've put in and I'll consider your request."

Peter and Valthi retire from the Hall. Proud of the praise Bwana Duck has bestowed. They'll sleep content for the rest of the day knowing they'll each be fifty pounds richer by the end of the week. This development puts Caleb in a difficult position. He can't be seen to welsh on his promise. It would undermine his position as gang leader. Prove to them all he was a lying cunt. Can't have that. Oh no! He must show them he's a man of honour. Of the highest calibre.

Just about to return to Tunnel H.Q. when Commander Duck's suspicions are aroused again. Through the same swing doors that the shepherds departed enter three smart business-men in suits. Black guys wearing shades. They head straight towards the Dug-Out Club along a well trodden path. Caleb waits for them to close the door then climbs Kowalski's ladder. It looks right into the club. Spies Yellowhead receiving a vast sum of money which he carefully counts into piles. Satisfied it's the correct amount he hands over the plastic bags. All containing white powder! Caleb always knew Yellowhead was a user and pushed it around his posse. Earned a few bob to supply his habit. Nothing wrong with that. But he had no idea he was a big time dealer. In league with the fucking Yardies and Columbian drug barons!

Caleb slides down the ladder as fast as he can and retreats to the safety of his office. Has no intention of challenging the dealers. He's read in the papers they're a heavy breed.

To help take his mind off his dangerous discovery he starts crayoning in the line of escape. Calculates how much further there is to go. Time is running out. The gobbies on the radiator calendar have nearly reached the door! Once they get there it'll be much too late! Most of the I.S. kids will have already left. Officially! Legit! That's no good at all! Defeats the

object of the exercise. Caleb wants them out before then. Pupils must have freedom of choice when it comes to leaving school. A knock on his door snaps him out of his thinking.

"SIR! You ordered me to report to you SIR!"

"Yes I did Kowalski. Come on in."

Caleb explains to his Second-in-Command the gravity of the situation. How Peter and Valthi are about to undermine the entire economic structure of the organisation by claiming the hundred pound prize.

"I've got a tough job lined up for you General."

The Pole's eyes stare straight ahead not blinking. His reply is deep and patriotic. An American accent creeping in. A sure sign he's been doing the homework he's been set and watching all the war films on telly.

"That's what this man's war's about SIR!"

Caleb orders General Kowalski to shut the door. A secret briefing regarding the two Singh brothers. Since Greenwood's defection he can't trust anyone.

"I've no need to tell you General what would happen if the target of a thousand packets was ever reached."

"Fuck everything up SIR! BIG TIME!"

"Too right it would General. We'd be right in the shit!"

"SIR. Permission to speak SIR!"

"Go ahead General."

"SIR. Why don't I waste the bastards in some dark alley! PROBLEM SOLVED SIR!"

There's an evil glint in Caleb's eye. The Polack cunning of this lad could rival that of a fox. He's university material at the very least. He could be a doctor even.

"Okay General, but get their crisp packets off them first. I don't want any of this traced back to the I.S. Department."

Kowalski stubs his unfinished cigar into the palm of his hand. Jumps to attention. Smiles through the gaps in his gums where his front teeth should be.

"SIR! YES SIR! A FUCKING PLEASURE SIR!"

He salutes and turns smartly on his heels. Marches out of H.Q. with the steel studs on his boots ringing out on the

concrete. Sounding out their deadly warning to Peter and Valthi Singh. Watch out! Watch out! There's a nutter about! A touch of Robert Mitchum about him. In "The Night of The Hunter".

CHAPTER 30

Caleb has decided upon an early morning run. Doing something about the state of his health. As he runs around the field he plans the tasks that need attention. Rosie helps sort them out in his head. Prepare himself for the Ofsted inspection. A faked syllabus for a start. Lesson aims and objectives. Forged GCSE certificates for all his Department. The disguises they'll wear on June 13th. And the leaving certificates they'll present to the police if any of them are unfortunate enough to be stopped. All signed by him stating they're all hardworking and willing to accept responsibility. Can be trusted. But the one that presents the biggest problem is how to get the huge boulder that crushed poor Stoker up into the main hall of the I.S. Department. Erected as a monument to his memory and serve as an inspiration to them all. He needs a complicated system of levers and pulleys that strictly adhere to National Curriculum standards.*

Rosie has put on a lot of weight and Caleb is struggling with the effort. Takes a few more paces then begins to stumble.

"Put that fuckin' beast down you varmint! Or I'll blow your fuckin' 'ead off!"

Caleb nearly jumps out of his skin. Turns and sees an irate yokel pointing a double-barrelled shotgun at his head. Lowers Rosie gently to the ground. Keeps his eyes fixed on the gun. Fiercely protests his innocence.

"No. No. You don't understand! I'm in training! This is how Hercules did it! Surely you've heard of Milo's methods?"

* Key Stage Three. Understanding.

Structures: Pupils should be able to understand that if too much weight is put on a structure it can collapse either by bending, buckling or twisting.

Making: Pupils should be able to recognise that simple mechanisms can cause movements in various directions. Up and down. Forward or backwards. In and out.

Safety: A heavy object lifted high in the air can fall to the ground and do a lot of damage if not supported correctly.

An air of desperation in Caleb's voice. He's pleading for his life. That's the trouble with countryfolk. Too slow and thick to understand. Too much cow shit on their toast.

"Milo? Milo? What the fuck yoom on about cunt? No fuckin' Milo lives round yer!"

"Milo the Greek! The father of progressive resistance exercise!"

"Greek you say? Should 'ave known. They'm bastards gettin' all over the place!"

"Yes. Yes. He started it all off!"

"Did 'um now?"

"Yes. Nearly two thousand years ago!"

"Yoom got me now boy. No two thousand yer old Greek lives round yer. Not called Milo any roads. We'm got a silo? But he'm made out of corrugated iron. What's yorn look like?"

Caleb can't take the pressure. Swoons to the ground in a fainting fit. If ever confirmation was required that education needed a thorough overhaul this turnip-brained cretin pointing a gun at his head proved it unequivocally. Probably a product of the liberal sixties when there was no such thing as a naughty child. No problem pupils just challenges. Bollocks! The man's a fucking idiot!

The yokel marches Caleb back to his tumbledown farm. Walks behind him with the shotgun. Locks him in a cowshed whilst he phones the police. Puts his retarded younger brother in there with him. Just to make sure he doesn't escape. They tie Caleb down over the bonnet of a tractor. Head down one side, legs over t'other. Backside up in the air. Caleb shivers. Mouth goes dry as he observes the cretinous sibling. He's never seen such an ugly looking beast. He looks like a cross between a pig and a chicken. Snout twitching fiercely one side then the other. Grunting noises and scratching his boots on the floor. He was obviously getting overexcited. About what though Caleb can't understand. Surely to God! Not that!

Caleb watches the pig-man bolt the cowshed door. Grins at him through black festering gums. Puts the gun down and

unzips his fly. Pulls out a short stumpy rotting penis. Swollen green at the end and dripping yellow pus.

Caleb screams out loud and begs for mercy as the pig-man approaches with evil intent. Tongue lolling out of the corner of his mouth. Little piggy ears twitching with excitement. Little piggy eyes all eager and bright.

"Fuckin' teach you to steal our cows. Cunt!"

His breath so foul it acts as an anaesthetic. Tears Caleb's breeches down below his knees. Smears his arse with engine oil.

"Who's a pretty boy then?"

The pig-man puts his hand on the small of Caleb's back and manoeuvres himself into position. Caleb screams out in the name of everything that's holy. Prays to God to intervene. Save him from this perverted mongol. Drooling saliva like a tap.

"Jesus! Why hast thou forsaken me?"

The pig-man gobs on his hands and rubs them together.

"Right my babby! Let's go to work!"

When Caleb comes round he's in the farmhouse kitchen being plied with tea and cakes and jam. By the farmer's wife or mother he couldn't tell. Either way she was old, fat and ugly. Hairs on her chin like the branches of a tree.

"Yoom alright boy? Yoom seem to 'ave fainted."

Caleb desperately trying to gather his senses. Looks around the room. The local bobby standing there. Notebook in his hand. Next to him the yokel farmer, the one who pointed the gun. Funny, no sign of the pig-man at all. Caleb examines his breeches. All neat and well-pressed. Maybe they've been cleaned. Feels his head. Again very strange. Hair has been washed. A parting down the middle. He smells clean and fresh like he's had a bath. He can't recall doing that.

"Where's your brother? I'd like a word with that pervert."

They stare at each other and shake their heads. Don't understand the question.

"What brother? What yoom on about boy?"

"The one you put to guard me in the cowshed!"

The yokel looks at Caleb and scratches his head. Laughs.

"I don't know what yoom talking about! I ain't got no brother you silly sod! Yoom ill boy. Sick in the 'ead."

Caleb stares at them all in turn. Doesn't know what to say. No point in arguing any further. Just wants to get out of there as fast as he can. He puts it all down to an hallucinogenic experience. The tab he took earlier on. It's either that or the lead.★ Whatever it was it's scared the shit out of him. Felt so real all the same.

It was Tosser Torrington who came to his rescue. Confirmed his story to the village bobby and arranged for his release. Much to the huge disappointment of the Turnip family who'd wanted him to stay. Even offered a period of free convalescence to help Caleb recover from the shock. Sadly he had to decline.

In the car on their way back to school Tosser starts asking police type questions.

"Any news of Errol yet Caleb?"

"No. The word on the street says he's hiding in London. You don't *REALLY* think he did it do you?"

"Don't know. You know him better than me. I just want to ask him a few questions. . . . By the way your missus came into the station the other day."

A swarm of bees take off in Caleb's head. Buzz! Buzz!

"Oh yeah?"

Tosser keeps his eyes fixed firmly on the road.

"Yeah. Apparently her fancy man's gone missing as well. Vanished. Not a trace. Seems to be catching."

Caleb puts on a magnificent show of couldn't give a fuck.

★ In his book 'Handy Hints for Inner City Builders', Stockhausen claimed that working near a busy main road (which Caleb did) could raise the amount of lead in the blood/IQ stream to a dangerous level. The only way to rid the body system of lead was to inhale vast quantities of steam and the best way of doing this was to drink huge amounts of very hot tea. Holding the cup firmly in two hands just below the nostrils and inhaling deeply. Builders have known about this for generations. (See Stockhausen's 'Tricks of the Trade'. Published by Blackthorn. Price of a pint.) Unfortunately the man in the street is unaware of this practice and when he/she sees builders continuously sipping cups of tea they think, quite erroneously, that the builder is taking yet another undeserved break, and not following strict health and safety procedures.

Fighting the pain in his skull.

"Didn't take him long to suss her out did it? Poor bastard's probably sneaked back home."

"No, we checked. His wife won't have him back anyway. Well rid of him she said."

Caleb laughs and cracks a joke.

"Looks as if he's been frozen out then?"

Tosser glances across at Caleb and smiles a copper smile.

"Yeah. You could say that."

CHAPTER 31

Two hours later Caleb's back in his office. A place where he normally feels safe and secure. But not now. Events are beginning to overtake him. A freak show going on in his head. A rushing of waves pounding out on the beach. Bees riding the surf with stings at the ready. Loads of pain, confusion and stress. He presses his thumbs tightly into his temples and tries to massage the hurt away. An opportune moment for a face in a mirror to poke his nose into his business. Speaks to him in earnest.

"What you need is another fix old boy. Things are beginning to get you down."

Caleb is amazed at this caring quality. Uncanny how he knows his every need. But where the fuck did he put it? It's not in the usual place. In the folder marked Mr Happy. Caleb slides swiftly into an agitated state. Shaking and sweating with fear. Needs it now more than ever before. But where the fuck is it? Been thrown out! Lynda must have tidied up. Put it somewhere else. But where? Caleb starts tearing at the drawers. Throws files of paper across the room. Praying to God to help him find it. The plastic envelope containing his stuff. He gets more and more angry and frustrated. Screams aloud at the two N.Q.Ts in the corner who've just come in for a quiet chat. Rosie the cow and a ginger-haired cockerel making themselves a cup of coffee. Ignoring Caleb and his problem and his plea's for help.

"Why don't you two just fuck off then! Go and mark some books!"

He hurls a chair and box file at them. They just pretend he isn't there. Carry on talking pseudo-intellectual teacher crap! Quoting SATs and Records of Achievement. Performance related pay and Attainment Targets! All a load of fucking bollocks! And all the time his hurt's increasing. Shivering out of control. Screaming.

"Jesus! Help me please! Powder! I need the fucking powder!"

Caleb craves the buzz. The rush. To send his body higher than the last time. The last time he did all this!

He crashes the metal filing cabinet over. Palpitations creeping in. Looks down with panic-stricken eyes. Not daring to believe what he's seen on the floor. Reaches out to test his damaged judgements. Glory be to God it's true! Thank the fuck for that!

He chops a couple of lines of the magic Charlie. Thin and fine for efficiency. Rolls a tenner into a tube between his thumbs and fingers. A giant snort to whizz it along. Crack! Hits the back of his head like a fiery comet. A million stars explode in his brain. Wow! Twinkle down slowly to smother the pain. Almost instantaneous.

Caleb eases into the arms of his comfy chair. Nearly human the way they enfold. Closes his eyes to absorb the joy. The warm heavenly feeling that sweeps over him. Gives him an inner glow. Cool, refreshing and calm. He doesn't give a fuck what they say about drugs. Nothing can better this wonderful world.

Lynda slips unnoticed and silent into the room. Can see the state that Caleb is in and works around him on tiptoes. Picking up things and filing away. Everything in it's proper place. A place for everything. Careful not to rouse him from his slumber. She knows exactly what he's been through. And when she's finished doing that she looks down at him lovingly through young caring eyes. This man who's done so much for her stretched out long with his legs astride. She feels she owes him a debt of gratitude. The very least she can do. Kneels down between them and unzips his fly. Pulls out the mother of all trouser snakes and prepares to give him a Frontline Special.

Lynda getting well into her rhythm and Caleb responding by holding her head. Getting the timing right. In his dream he's living in teacher heaven. Nothing on earth can beat this feeling. But suddenly there's a knocking on Heaven's door. Knock, knock, knocking. Gentle at first, a polite and friendly warning. Lynda and Caleb take no notice. Too bound up with what they're doing. Then louder. Just to make sure you know

he's there. Lynda the first to turn and see him. A turbaned Indian in the doorway! Oh my God! He'd been watching them! She screams out in embarrassment and flees the room. Arms held across her to cover her breasts. Bouncing up and down. Caleb left in flagrante delicto. Trousers down around his ankles and todger on the bone. Has to talk his way out of this. Smiles to break the ice.

"Sorry about that. She gets these sudden urges. Nothing I can do to stop her I'm afraid. You know what girls are like these days. I blame the Spice Girls and girl power."

He doesn't seem to care. More important things on his mind. A burly chap with strong laser eyes that seek to burn a hole right through you. A bushy beard and crooked hooked nose that's struck many a bargain over the years. Smart in his Bristol Omnibus uniform. Caleb tucks his tool back in and zips up his fly.

"Commander Duck at your service sir! What can I do for you?"

Hand outstretched for him to shake. The oily fingers don't put him off.

"Yes pleese. I'm Mr Singh. Looking for my son Baldev. He's a very very naughty boy. He hasn't come home since last Friday."

Jesus fucking Christ! Caleb can't believe the dramatic fluctuation in his fortunes. One second he's having a Frontline Special the next he's crashing headlong to the floor. Knees giving out from under him. A victim of the stress of it all. He didn't expect to see Mr Singh quite so soon. Asks the question anxiously.

"Have you contacted the police yet Mr Singh?"

The last thing Caleb wants is their involvement. A search of the building would reveal the tunnel. He scrambles to his feet and repeats the question.

"Have you?"

An uneasiness about Mr Singh at the mention of the police. He shuffles about uncomfortably. Looks behind to see if anyone's there. Enters Caleb's room.

"O Mr Duck. Mr Duck sahib. Pleese do not tell the

poleece. I offer precious gifts in exchange for your silence. My lovely daughter Kishan's hand in marriage. She is sixteen year's old and trained in all the ways of a woman. She will make you a very happy man sahib. I swear to you."

Caleb astonished by the bribe on offer. There's more to this than meets the eye.

"Tell me what the problem is then Mr Singh. If I can help I will."

Mr Singh gives out a heavy sigh. Resigned to spilling the beans. Seems he has no other option. Shuts the door behind him.

"I came to England many years ago Mr Duck. Smuggled in without any papers or passport. I still have to pay the Wicked Indian Man every week money or else he go to the police and grass me! He bloody blackmailer Mr Duck. Fucking bastard!"

Caleb thought belonging to a persecuted minority group was bad enough but to be mercilessly exploited on top of that by one of his own was outrageous. Mr Singh continues in full flow.

"It's not a nice place where I live Mr Duck. Blasted blacks play very loud music. Does my fucking head in. I wish to return to the Punjab and buy some land but the Wicked Indian Man not let me return. He make me stay and pay him money. He will kill me Mr Duck and feed me to his dogs if I try go home. Help me sahib. I am in deep trouble."

Caleb takes time to digest this knowledge. Paces up and down Napoleon style. The drugs in his system disturbing his thinking. A magnificent plan forming in his head. One to bring triumph and acclaim. Rees had always advocated developing community links. Turning Walliscote Road School into a Community College. Here was Caleb's opportunity to develop the idea and send his stock rising even higher. Ensure he won the Teacher of the Year Award by involving outside agencies. The voices tell Caleb to act at once. Arrange a deal with the Wicked Indian Man. A C.T.L.A./Indian Alliance would strengthen the bond between two great cultures. He'll knock the tunnel idea on the head. Kick it into touch. Establish a citadel of learning right here in Bristol. The place where

he'll make his final stand. To get his ideas across. With the King of Fractions Caleb Duck riding at the head of a million men. Huge banners of the Council Taxpayers Liberation Army flowing proudly in the wind. A crusade to turn the divisor upside down and then multiply across. Cancel top and bottom. It was a simple, yet ingenious plan.*

"Mr Singh I will help you. I won't go to the police on one condition."

Mr Singh awaits with an eagerness he can barely suppress.

"Speak O Master speak."

"Go back and tell the Wicked Indian Man he must agree to be my business partner. Tell him that he can have this building to hide any Indians he's brought across the seas without a licence. Tell him Kim-o-sammy there's plenty of room here for his people to live in peace. They be heap-big safe here because no white man comes into my castle. Devil land. Much-um shit scared of what goes on inside its walls. Tell him we have many blankets and much coal for heating and cooking. We have fire water for his braves and beautiful girls for fickey-fick. Tell the Wicked Indian Man we have got-um plenty rice and sheep to eat. Plenty land with much-um water. No box canyons for soldiers to hide in. Him come live here with his people and they will be safe from white man with stick that talks and iron horse that breathes fire. You go Mr Singh and tell him all this. All I want from him is to smoke the pipe of peace and the rent for this building. He can have-um ice cream concession and the buffalo burger stand. From you I want your daughter Kishan's hand in marriage as a token of your good faith. Then I not go to Big White Chief who lives across the water."

Mr Singh's face lights up with delight. Overwhelmed by Caleb's generosity. He steps forward to embrace his saviour. Tears of joy streaming down his face.

"It shall be done Mr Duck sahib! Allah be praised! I will go

* Dr Benefield told the Enquiry it was an extreme case of megalomania brought about by the rich cocktail of drugs Caleb Duck had consumed. Establishing a new Educational Order and appointing himself The King of Fractions without even drawing up a shortlist represented the nadir of Caleb's illness.

and meet the Wicked Indian Man. Tell him your words of wisdom!"

A final posture in the open doorway to mutter a prayer of thanks. Then he's gone. Away to spread the word among his people that a new Spiritual Ruler has arisen to lead them out of bondage.

Caleb glows with an inner beauty that only the great give off. He feels a goodness and kindness towards all men. Only too pleased to help. Smiles as the phone sounds off again. It's Tosser laughing his head off.

"Sorry to bug you Caleb. I got a funny story man. I know you'd want to hear it."

"What is it Tosser? I've work to do!"

"Get ready for this one Caleb. You know that yokel you met in the country this morning? The one who pointed the shooter at you?"

"Yeah. What about him?"

"Well his brother's just been nicked for fucking a pig! On the motorway. In the back of a car! What a fucking laugh eh Caleb? . . . Caleb? Are you there?"

Even before Caleb topples to the floor the contents of his stomach have risen. Taken it upon themselves to exit their normal habitat as a six foot stream of projectile vomit. Splash against the window. Smashing a pane of glass! As he lies white and rigid on the ground the Founding Father of Modern Education clenches the cheeks of his buttocks together. Steam tight so nothing can enter. Screams out loud with all the force that's in him.

"Bastard! Bastard! Fucking bastard!"

CHAPTER 32

Rees tried to put it out of his mind. He couldn't understand why there were so many. More to the point why they were here. A queue that snaked its way through the Main School gates and made its way into the I.S. Department. All ages, male and female. Lots of yelling babies and loaded handcarts. Plenty of dogs on string. What his maverick Head of I.S. was up to now he didn't have the nerve to ask. The last time he'd gone across to enquire he'd been shown up to be a fool. Doubting the talent of a brilliant teacher blessed with a special gift. Why only that morning he'd signed the form nominating Caleb Duck as Special Needs Teacher of the Year. An honour he richly deserved. Countersigned by the Chairman of Governors. No, whatever was going on over there was surely in the best interests of the school. And that being the case he'd leave well alone. Besides his blasted phone was ringing again as it had been all morning.

The parents of some of the inner city children at Walliscote Road Comprehensive School are amazed at the growing maturity of their young. Can't believe the change in them. Only weeks ago they were brainless adolescents. Typical products of their age. No aim in life and a 'couldn't care less' attitude towards their work. All that has suddenly changed. Their willingness now to go to school is nothing short of remarkable. Sometimes they even stay all night to catch up on their homework. Weekends too. The new dynamic Head of the Integrated Studies Department has given them renewed confidence in their own abilities. Revitalised their urge to succeed. Now he wants to take them on a day trip to America to broaden their horizons.

Maria's mother definitely wants her daughter to go. Get away from her evil father who practises voodoo in the kitchen. She studies the letter in front of her keenly.

Walliscote Road Comprehensive School
7.6.98

Dear Parent/Guardian

On Saturday, July 1st, as part of their GCSE course in Geography, the I.S. Department are going on a field trip to America. As the coach journey is quite a long one it is advisable for the children to bring a packed lunch and waterproof clothing just in case it rains. We should get back some time later in the week. Depends on the driver. The cost of the trip will be £814. 45p return and any parent wishing their child to go should sign the slip at the bottom of this letter and return it to me as soon as possible together with a deposit of £200. Places on the coach have been strictly limited to thirty-five so it is inevitable that some children are going to be disappointed. Because of this I am going to adopt a strict first come – first served policy. I am sure you will appreciate the educational value of such an enterprise and have no hesitation in allowing your child to participate.

I look forward to receiving your £200.

Yours sincerely
Commander Caleb Duck
Head of Field Studies

Maria's mother is so keen for her daughter to go she immediately reaches for the phone. Can't get through to Mr Duck because of that unfortunate Greenwood business. Speaks instead to the Acting Headmaster. Mrs Stewart says Maria is dying to go to Americal, but she can't get the two hundred quid until next weekend when she gets her money off her bloke. Could you save her a place love? I'd be ever so grateful. She says how thrilled she is at the progress Maria is making at school. Nobody in her family had ever taken fifteen GCSEs before. And what a wonderful idea my lover to sell coal off cheaply to the old dears in the district and get the kids to work for empty packets of crisps to teach them basic comics. She thought the idea of digging an underpass under the sportsfield was bleedin' fantastic. Save all 'em kids coming

out the Main Gate all at once wouldn't it? Bound to be an accident if that went on. Init marvellous the way Mr Duck has opened up one of the classrooms as a city farm. Never did things like that in my day. By the way love, if you've got any topsoil going spare I'll have some for me mother's garden. She can't get nuttin' to grow at all.

Mrs Stewart stays on the phone for over an hour. Crossing all the eyes and supping the teas. When she finally finishes and puts the phone down Mr Nasty W.C. is taken quite ill. Starts to shake uncontrollably. Glances out of the office window, just as his predecessor had done before him, but this time instead of seeing a flock of sheep he witnesses the arrival of the Ofsted team. Trying to make their way through the huge crowd that's gathered. Same difference really. Horror to end all horrors! Collapses into the swivel chair still clutching the telephone to his ear. Spinning round and round and going higher and higher. An air of helplessness about him. Loses the use of his arms and legs.

Meanwhile, blissfully unaware that Rees had been tipped off about his secret plans Commander Duck jacks up on smack. He's taken a real fancy to Yellowhead's horse and can't get enough of the stuff. Wanders about the building in a glassy eyed state of euphoria. Delighted at the progress being made by his latest batch of students. Ever since he did the deal with the Wicked Indian Man events had sped swiftly along. In return for showing them how to fill in forms that can then be exchanged for empty packets of crisps which in turn will entitle them to full board and lodge, Mr Duck sahib collects their Housing Benefit. A small percentage to the Wicked Indian Man. The money raised from this profitable source to fund the courses on offer at the recently renamed Golden Temple Community College. As well as pay for his drugs. Baldev's father Mr Singh is convinced Caleb is their great redeemer. A man chosen by the gods to harbour them from exploitation. It was Mr. Singh's idea to call Mr Duck Guru Ram Das after the Great One himself. It will be an honour to give his daughter Kishan's hand in marriage to a man of such renown.

Hubcap and Junior make their way upstairs. Begin to assimilate into mainstream society. Without the driving force of Errol behind them the Boiler Room Boys have begun to take things easy. Even signing on for some of the courses on offer now that the curriculum has been dramatically expanded. As well as the old stalwarts of colouring in, ping-pong and elusive word searches, the College Principal has added Electronic Engineering and Bike Technology to the syllabus. Run by Boom-Boom and Back-Wheel respectively. Both on Senior Lecturer salary and paid for out of the rent.

To give the Community College accreditation with the local education authority Guru Ram Das has written a charter. On a flip chart with a Magic Marker and put on display in the hall. That everyone is to be held of equal value. Entitled to full access to opportunities offered regardless of age, ethnic origin, gender, sexual orientation, religion, disability, academic ability or social class. This he reasoned in one of his more lucid moments would scupper any plans those Ofsted bastards had of closing him down. And just to prove he was a man of his word he gave full reign to the ideas produced by his students at a brain storming session held in the Dug-Out Club. In Yellowhead's absence of course.

A challenging and exciting new curriculum grew up almost overnight. Ethnic Cooking on open coal fires, Basket-making, Exotic Pet Care, Archery, Knife Throwing, Sitar Instruction and even Circus Skills. These seemed to the Principal to be first-class suggestions with something for everyone. All these he considered enrichment activities and when placed alongside the already up and running Language Support, Literacy Awareness, Bookcheck, Summer School, P. S. E. and the Integrated Cross-Curricular Curriculum gave a balanced view of what his objectives were. Which if the truth be told he hadn't a fucking clue about.

Caleb suddenly felt quite different. Wiser and more mature. Like a giant moon shadow had passed over him and blessed him with secret knowledge. It was then the penny dropped. He'd achieved the target he'd been searching for these last few days and more! The Sixth Level of Awareness! That bullshit

baffles brains! Only one thing took the gloss off it. That Rees the Cunt had got there first. Was ahead of him in the game. The dreadful realisation of this caused him to vomit into a wastepaper bin. Forced him to seek solace in a bit of nose candy.

The building once known as the I.S. Department becomes a bustling hive of activity. Flames from open coal cooking fires lick their way towards the roof. The Indian grandmothers are busy around them preparing the evening meal. Ably assisted by New Age Travellers. Keen to get involved. The staple diet seems to be sheep provided by Shitty Shearn. He's taken his place with the other traders and yells out his wares with the best. Pooing his pants in a display of enjoyment.

Caleb notes to his intense satisfaction the way General Kowalski has grown in stature. The lad's appointed himself i/c Internal Security and surrounded himself with a considerable force. Sikh warriors dressed in yellow turbans who'll never take a backward step. Each one chosen by him personally for their prowess with a knife and capacity to acquire wealth fast. And the bravest of these he's made Caleb's personal bodyguard. Sworn to protect him with his life. Rajvir Singh elder brother of Baldev leads Guru Ram Das on a tour of duty around the Community College. Fiery eyes that run in the family peering into the crowds that line the route seeking out assassins.

Moving along the bottom corridor that once housed Butlinland Guru Ram Das watches as a gang of eager young sudras, members of the lowest caste, lift the chest freezer from its resting place and carry it up to Tunnel H.Q. The faithful Gelert in command to make sure nobody peeps inside and wakes the sleeping Sweet. Can't have the old boy thawing out and causing a bit of a stink.

More of Mr Singh the builder's carpenters and electricians work on the frontage of Lynda's new business. An enticing entrance into the massage parlour. Purple lighting and flashing neon signs spell out what's on offer. Lynda as Caleb thought she would be taking full charge of the operation. He leaves her to get on with the job and continues with his

inspection. Spots a couple of girls with bored expressions. Amazing. No matter how interesting and varied he makes his lessons there'll always be pupils he will never reach. Big Sharon and 'Foreskin' Sandra for example. Lie back in their armchairs listening to Radio One. Foreskin earned her handle from boys with coins. They allowed her to keep all she used. Now lost in a phoney world of plastic and glitter. Chewing and having a fag. As spiritual leader of all these people and not just the ones who wish to learn Guru Ram Das feels it's his bounden duty to encourage them to socially interact with their peer group. As advocated in the Lancashire syllabus for P.S.E. He asks them to sell the raffle tickets. Go out and raise funds for the C.T.L.A. Give them a job to do so they feel valued. Works wonders for their self esteem.

Sir John has taken a temporary break from conducting Mozart's Symphonia Concertante in E Flat for violin and viola. Ambles up to Caleb to offer secret information. The voice thick and slow with a naïve honesty that only a Bristol simpleton can produce.

"Yer sir. That fat cunt Rees and some other geezers are on their way over yer. I've just spied 'em with me telescope."

Guru Ram Das goes momentarily blind. Swoons. Watches an army of worms wriggle across the floor. Some of them start to copulate. Clitellums bulging with thick secretions. The whole floor becoming a slimy ooze with a whirlpool of stress at its centre. A hand out to the wall to prevent himself from falling. At last the moment has arrived. The moment he's been waiting for. To demonstrate to the Ofsted inspectors what wonderful skills his pupils are capable of. The nutters, the crazies, the disaffected, the loonies gone in the head. Give him the tools and he'll finish the job where others lie and pretend. Caleb doesn't hide behind exclusions, headmasters suspensions and quiet rooms. He goes in hard where the action is. Reverses the role of the thug. Nobody's a bigger headbanger than him and the kids respect him for it. Now is his chance to prove to the world that if you let these kids do exactly as they want you'll be amazed at what they can accomplish.

Guru Ram Das springs into action. He wants to welcome Rees and the Ofsted inspectors with a reception they'll never forget. He sends a message via one of the sudras for Maria and her friends to start marinating the trout. Up the old beef curtains for a full thirty minutes. Turning it over every now and again to ensure the juices are evenly distributed. A rare treat reserved for special guests. Nothing but the best.

Caleb ignores the waves of warm spring water that cascade down between his thighs. Fills his Aladdin shoes to overflowing. Instead he orders Gelert the Faithful to blow his bugle to signal a public announcement. Everything in the Golden Temple Community College comes to an immediate halt. Noises dwindle as they await his commands. When all is silent he addresses the throng.

"Listen to me my people! Great news I bring! Two great Brahmins from across the water are to pay us an honoured visit. They are the ones who provided this place of learning. They are Friends of Golden Temple P.T.A!"

The crowd rise up and cheer. Huge applause and shouts of 'Hail Guru Ram Das!' Caleb acknowledges their praise and beckons the man selling cheap bedroom carpets.

"Carpet maker! Bring out your best Axminster stair carpet and lay it at the South entrance to the College. Cooks prepare the food! Let the musicians play!"

Guru Ram Das strides across the Community College like a colossus with a cracked brain. Recounting the heroes of his youth. He sees himself as a hybrid amalgam of such champions of the underdog as El Cid, Spartacus and Braveheart Wallace. Of course others played their part as well. People like Wilson of the Wizard, Desperate Dan and Bernard Briggs who only lost one goal. Dan Dare, Bilko, John Wayne, Alan Ladd, Audie Murphy in the Red Badge of Courage. Elvis and Mohammed Ali. Marlon Brando in On the Waterfront. Cagney, Bogart and Edward G., Kirk Douglas, Burt Lancaster and Aldo Ray. Women like Ava Gardner and Doris Day. Whip crack away and Bridget Bardot. He remembers wanking away over a full-size cutout. Marilyn and Audrey Hepburn.

Elizabeth Taylor in Cleopatra. Kathy Kirby with the shiny lips and Alma Cogan with the laugh in her voice.

All these helped mould Caleb into what he is today. Spirited leader of his people. The Lord of Lords. King of Fractions. Designate Teacher of the Year! Ever since he found out from Mr Singh the chemist that man was made of earth, wind, fire and water everything else just slotted into place. All quite straightforward and simple really.

"Take me back to H.Q. Rajvir! I need a snort or two!"

Caleb went into overload. Tried the full range of drugs on offer and felt much better for it. Now Errol's no longer here to advise him he doesn't know when to stop.

There's a hammering on the door of Tunnel H.Q. Jan Scott standing there in a distressed condition. Tears running down her face.

"Caleb have you seen Baldev anywhere? Some of the boys are saying he's dead!"

Caleb brusque. No reason why he should be gentle with her. She's been no help at all.

"Don't worry Jan. He died for what he believed in. A very brave lad indeed. You can be proud of what he achieved."

She breaks down in very am. dram. fashion. Grabs Caleb's arm for support. He feels the strength ebb from his body.

"Caleb, I'm going to have his baby! What will my husband say when I give birth to an Indian child?"

The Father of Modern Education puts two hands on her head to console her. The power of righteousness surges through.

"Return to your classroom and rest my child. The gods have chosen you to bear the son of Stoker Baldev. He will grow up to be a mighty leader whose shoes I'm not worthy to undo."

Jan stares at Caleb in wide-eyed wonder. Adoration even. Least that's what he thinks she does. Angelic music in her ears. He hopes. She takes a backward step to get away. Runs screaming from the hall. Not quite sure how to take the news.

CHAPTER 33

Mr Rees the not quite so nasty W.C. after his last visit to the
I.S. Department with Mr Harris. When he apologised and
praised Caleb's work. Recommended him for a Plato. Makes
his way nervously across to the I.S. Department completely
unaware of the change of name and function of the building.
Trailing in his wake are Messrs Vile and Dagger feared leaders
of the Ofsted team looking very trendy in their light grey
suits. Mr Men ties to match. Two extremely fine examples of
the Woodentop Raiders.

On his previous visit to the school Mr Dagger had been
appalled by what he'd seen. No discipline, no enthusiasm
from staff or pupils, no syllabus, no Records of Achievement.
Not even a desire to improve. He's made a vow to himself.
This time there'll be no messing around. Unless he sees a
dramatic improvement, or by the heck he'll close the school!

As the Ofsted inspectors step inside the building they're
given a tumultuous reception. Garlands of flowers placed
around their necks by beautiful scantily dressed maidens.
Huge crowds line the route along the bottom corridor tossing
petals and rice in their path. Vile and Dagger are thrilled to
bits. They've never been welcomed like this before. Usually
get a frosty reception. Rees experiences a huge sense of relief.
A deep inner glow of satisfaction. Just about to give himself a
pat on the back for reappointing Caleb as Head of Depart-
ment when his eyes suddenly rest on a flashing neon sign.
Wank and Spank Sauna and Massage. Open 24 hrs. Welcomes
clients to Lynda's parlour. Satisfaction guaranteed. Coach
parties catered for and videos provided.

Rees fights a losing battle with his stomach. Huge rasping
coughs into a hanky to disguise his gut wrenching heaves.
Manages to recover sufficient composure to lead Messrs Vile
and Dagger away from the tasty temptations on offer.

More flowers and rice are showered upon them as they
make their way up the carpeted stairs. Enter the oak-studded

swing doors of the South Gate of the College where again they're met by thunderous applause. The sitars and drums of the B. Tech orchestra stir up a dreadful noise. Discordant in the extreme. Sir John believing the musical bias has strayed too far to the East starts up with Land of Hope and Glory. Full volume on the tape recorder. His arms working frantically up and down striving to achieve more patriotic fervour. But alas he is outclassed. He cannot compete with a fifty strong orchestra. Has to accept defeat.

Mr Rees W.C. and the Ofsted team make their way nervously along the Axminster. Completely stunned by their reception. The acting Deputy Head looks strained. White faced, thin and withdrawn. A developing twitch over his left eye which some in the crowd interpret as a friendly wink. They wink back in return and smile. His mouth hangs open and he begins to stumble forcing Dagger to offer a hand of support. Together they stagger along the carpet towards the magnificent presence of Guru Ram Das. Head of Fractions. Light of the World. High as a kite on smack. The Turban of Wisdom on his head giving him added status.

Dagger and Vile look towards Rees to open proceedings but alas he poor chap has lost the capacity of speech. It's left to Dagger to do the honours. Like Stanley greeting Dr Livingstone.

"Mr Duck I presume. Allow me to introduce myself. My name is Dagger and this is my fellow Ofsted inspector Mr Vile. I must say how appreciative we are of the welcome. It augurs well for the future."

An arm outstretched in welcome. Guru Ram Das looks him firmly in the eye. Grips the hand with tremendous power. The word 'HATE' on his knuckles showing angry and red. Displaying early symptoms of septicaemia.

"Greetings squire! I'm sure you're going to like it here!"

"I'm sure we will Mr Duck."

"Let's agree something right from the start? Yeah? Don't fuck with me and I won't fuck with you. A deal yeah?"

A look of incredulity crosses Dagger's face. Stares at Caleb with mouth agape. Can't believe his ears. Vile and W.C. Rees

as well. Shocking! Outrageous! Must have misheard. Benefit of the doubt.

Caleb clicks his fingers for drinks to be brought. Carried out by Geeta a beautiful sundra given to him by the Wicked Indian Man as part of the deal involving B and B. Tremendous cheering erupts again as they drink a toast together.

"Hail Guru Ram Das! Hail Guru Ram Das!"

Huge sighs of relief all round. Messrs Dagger and Vile have been accepted as friends. Let the feasting and dancing commence. Caleb leads his dumbstruck guests towards the throne-like chairs erected on a stage. Bodyguards on duty to the fore and rear. Rajvir at Caleb's side. Swords flashing in the light given off by the fire-eaters who now perform in front of them as part of their City and Guilds. Caleb had instructed the Performing Arts class to put on a special show. Cane baskets arrive laden with fruit. Savoury dishes on silver platters. Huge mounds of Tandoori chicken and chapattis. Enough to feed a regiment.

The founder of the Community College glances across to the Ofsted inspectors to see how his hospitality is being received. Eyes rest upon Vile's Mr Perfect socks and he gives a little chortle. Apart from Dagger's opening speech neither has said a word. Completely overwhelmed. He makes an attempt at conversation.

"Well gentlemen, what do you think of the changes I've made?"

Rees turns his head slowly to look at his Head of Department. Dull grey eyes perplexed and still. Set inside a parchment face. Just like Williams before him. The job has taken its toll. Gone the hyperefficient and belligerent manner. Voice faint and cracked. Barely audible.

"You should have told me about all this Caleb. Should have mentioned it to me y'know!"

Caleb can't believe his ears. After all the trouble he'd gone to in order to make the inspectors feel welcome Rees has to introduce a negative vibe. The woolly clouds inside his head manifest themselves into anger.

"Listen Rees you dumb-fuck! I don't have to ask or

mention it to anyone. I'm the fucking Principal! It's my syllabus we follow!"

Caleb's words have such an immediate and dramatic effect that it surprises even him. Rees slumps sideways in his chair. Spilling his ice-cold orange over the snake charmer's cobra. An ominous stirring below.

Dagger the Ofsted Minister of Propaganda decides to speak at last. Has chosen to ignore Caleb's plea for peace. Adopts a much more hostile tone with a hint of piss-take in the voice.

"I take it Mr Duck this feasting is all part of the National Curriculum?"

"Of course it fucking is! We operate a negotiated timetable. I scratch their backs they scratch mine."

Dagger stares at Caleb as if he's crazy. Either that or he's digesting the thrust of his words. After a long deliberate pause he seeks a second opinion. Heavy-duty sarcasm implied.

"What d'you think Mr Vile? About Mr Duck's somewhat unusual aims and objectives and his rather forceful language?"

But Mr Vile can't think. The rather large head of a swaying cobra moves within inches of his face. The Ofsted inspector begins to dribble. Breath comes loud in deep petrified gasps. Fortunately the snake charmers tutor proves he's up to the job. Returns the reptile to the basket. Grins his toothless grin at Vile.

The Government inspectors decide to stay. Want to witness all this for themselves. They want to be in an impregnable position when they recommend the closure of the school. They pretend to smile and go along with the show but write copious notes in their heads. The talking comes later when they've had their fill.

Maria's marinated trout goes down a bomb. Dagger even has the cheek to ask for more. She keeps the recipe to herself despite continual questioning from the two inspectors. However, she does pay tribute to her team of helpers and has the grace to mention them all by name. 'Foreskin' Sandra would have been included but she has the curse so couldn't help. Instead she put the ganja into the cakes which Dagger and Vile are whoofing back now. As if there were no tomorrow.

Rees wants to distance himself from this crackpot Duck. Prove to Vile and Dagger he's played no part in this outrage. Rises from his chair and points a trembling finger.

"Who gave you permission to light these fires Duck? Eh? Who? And who the hell are all these people? Where did they all come from?"

Caleb annoyed at this boorish behaviour. Not the time nor the place for such a thing.

"Lighten up Rees you uptight fucker! I'm developing links with the local community!"

His valley Welsh vowels even more heavily pronounced. High and shrill with hysteria.

"For God's sake Duck man! Tell Mr Vile and Mr Dagger this is nothing to do with me! Tell them damn you! My career's at stake!"

He turns to Dagger pleading his innocence.

"I swear to God I know nothing of this! He's conned us all! He's a raving lunatic!"

Again the finger points at Caleb. Rees screaming at the top of his voice. Wants to get it off his chest once and for all.

"The police want to question one of his cretinous thugs in connection with Greenwood's murder! And he has two boys out on the sports field at night guarding sheep for their GCSE in Agricultural Studies for Christ's sake! I ask you!"

But Dagger and Vile aren't paying attention. They giggle a lot and eat more cake. Begin stroking the beautiful serving girls who lie adoringly at their feet tempting them with wide open eyes. Suddenly the mighty speakers boom into action. Yellowhead's decided to turn up early for work. With so many new customers on his doorstep he'd be foolish to keep the club shut. The 4/4 beat sets the pulse racing in a latest mix of speedgarageacidhousetechno! Snapping spines at fifty paces. Wow man! Pass the doves!

Rees the Nasty W.C. can't stand it any longer. Seen and heard enough already to qualify for a breakdown pension. Post-traumatic stress disorder. Rises slowly from his chair and moves across to the Ofsted team. Tapping their feet to the sound of the music. Sneaking a glimpse of tit.

"Excuse me gentlemen. We ought to be leaving. I apologise profusely for these unfortunate events. I'll bring the police in to clear the building."

Vile and Dagger allow themselves to be led away smiling. Arm in arm with the servant girls. However, the South Entrance to the College is blocked by Internal Security. Drawn swords hold them back to allow Delroy, Shitty Shearn and Grabber Newell to pass through with another railway line. Rees recoils in horror. His very worst fears confirmed. He gives Caleb a look of the utmost despair. Voice choked with pain and recriminations.

"Was it you who took the other lines Duck? Caused the train to crash?"

Guru Ram Das has great difficulty in disguising the pride he feels. Although digging the tunnel had come to a stop the coal production continues.

"We need the rails to get the coal out of the tunnel Rees. My own idea. Jolly good eh?"

Caleb steps forward to shake the hands of his men. Award them all with medals. Norman Hunter, Colin Bell and Peter Osgood.

"Well done boys! I'm very proud of you. I'll hear your report when I've shown my guests to the door."

The Acting Headmaster splutters and stammers. Brain spinning with the nightmare experience. Desperate to leave this madhouse behind him and let the boys in blue deal with the problem. In the meantime he has a more pressing task. How to get the Ofsted inspectors out of the Wank and Spank. A Frontline Special lined up for them both! Trust Lynda not to miss the chance!

When the heavy-duty stress had ended Guru Ram Das went to spend some time alone. Another line of snow to stay in the mood. He dismisses Rajvir and enters his old classroom. The gobby leading the way. He looks out of the window to survey his kingdom. Soon his name will be on all their lips as the man who brought standards and sanity back into teaching. Gone all notions of escaping by tunnel. Out of his head completely. As he's just proved to the Ofsted team he doesn't need

to go anywhere. With the force he's mustered under his command he can stay right here where he is!

Perks the groundsman and Prince his dog are cutting the grass on the sportsfield below. With Prince beside him in the tractor Perks happily works his way up and down. Casting the occasional glance over his shoulder to make sure he's spelt it correctly. 'Coons go home' on the outfield. Caleb studies him closely for a moment. Here is the contented racist at work. Toiling in the afternoon sun, preparing the cricket square for the coming season. No stress attached to his job. It's simplicity itself. He follows the seasons. Wind, rain, sun, snow. All part of the magical scheme of things. A part of life's rich tapestry.

The look of peaceful satisfaction on Caleb's face does not diminish as he watches the tractor plunge into a huge gaping hole that's suddenly appeared on the cricket square. Little pieces of Perks are hurled into the air accompanied by the high pitched whine of an over-revving engine. Caleb remains both calm and serene as the green of the cricket square slowly turns red. Comes to the joyous but simple conclusion it's the way nature intended it to be. Back to the earth from whence we all came. Perks would have wanted it no other way.

Under any other set of circumstances the Principal would have said this was the ultimate level. Ashes to ashes. Dust to dust. But not this time. He quickly dismisses the idea from his head. No way could the Sixth and Seventh fall in such rapid succession. It can't be as easy as that. An apprenticeship if you like. No. The Seventh level has to be something special. Momentous in the extreme.

CHAPTER 34

Guru Ram Das cuts a splendid figure as he sits high up on the pyramid throne Mr Singh the builder has erected for him out of scaffold planks and pipes. Replacing the pile of desks. He lounges back in his favourite armchair enjoying the delights of an earlier hit. Pondering the state of the nation. The fearless Rajvir stands beside him guarding him with his life. He makes formidable opposition in his battle gear. A pair of cricket pads strapped to his legs and another on his sword arm. A grotesque protective device on his head. Enough to strike fear into any heart. A metal wastepaper basket turned upside down with a horizontal slot cut out for vision. Janet's feather duster through a hole in the top.

Together they ponder the students below. Eagerly taking up the many worthwhile challenges the new timetable offers. The sheep hunting class for example. The Master i/c Internal Security is teaching them how to hit a moving target with bows and arrows on the run. Chasing a solitary sheep around the College unleashing their poisoned arrows. The poor creature is wounded beyond repair as it desperately tries to escape. Kowalski demonstrates how to end its misery with an arrow through the head. A smile on his face as he does it.

Caleb takes it all in. A great sense of pride in what he's achieved. Kowalski a typical example. Written off by society as an unteachable thug. A psycho waiting for prison. Caleb has turned him around since he's been in charge. Instilled in Kowalski and all the others a greater sense of responsibility. An iron discipline and will to succeed. A burning desire to win.

Caleb's thoughts on the subject are suddenly interrupted by a frantic yell from above. Little Kushwant Singh, grandson of Mr Singh, father of Baldev, nephew of Mr Singh the builder shouts through the trap door above his head.

"Master! Master! Come quickly! I fear we are under attack!"

His job was to man the lookout tower above the Community College. Let Guru Ram Das know if the enemy approached. Obviously they have.

The roof of the building is being converted. Instead of a traditional sloping roof with double Roman tiles it was decided at a Curriculum Development meeting to have a dome-like structure. Gold like the Taj Mahal. Already the scaffolding is in position to enable the builders to walk about. Ram Das does it now. The air is cool upon his face. Fresh, pure and silent. He sucks in deep to charge his batteries. Ready for the reckoning. He looks resplendent in his Principal's outfit. Pantaloon trousers and flowing robes. Turban of Wisdom on his head. He gazes down at the scene below. Heart blood racing wildly. The tiny figures of the boys in blue have formed themselves into two separate squads. Dispersing swelling queues of prospective students who wish to develop their minds. Guru Ram Das senses this is it. A defining moment in educational history. He orders little Kushwant to tell Kowalski to get his men prepared. There's a sudden churning in his gut that only Charlie can cure.

Caleb retreats to the calm of Battle H.Q. Snorts it up with relish. Offers some across to the faithful Gelert who still stands guard over Roger Sweet. Following sound advice Stockhausen had offered Gelert has taken to standing on one leg. Just like a pretty flamingo. Even put pink feathers in his headdress to make him look the part. A one-legged stance condenses his blood/IQ system and uses parts of his brain not normally required.* It certainly works with Gelert. He's taken to reading the Times Educational Supplement and developed some thoughts of his own. Unbelievably in this moment of crisis he starts to expound on the virtues of private education. Points to the freezer as he says it.

* Stockhausen claimed that by standing on one leg and having the other bound up tight behind you the blood/IQ is forced into the half of the brain we never use. Thus stimulating grey matter. By alternating legs a person can remain on the alert for twenty-four hours a day, increasing in intelligence all the time. It's the same principle that applies to amputees but has the added advantage of retaining all limbs. See Chapter 21. Page 158.

"I venture to suggest Father Catalyst none of these quite shocking events would have occurred in a Public School!"

Guru Ram Das can't believe his ears. After all he'd done for the lad! Dragged him into the twentieth century and given him a first-class education. Suddenly he's become a Tory!

"Listen Gelert if I had my way I'd plough all the fucking Public Schools into the ground. Turn them into fucking car parks!"

But Gelert the Faithful won't have it. Gets rather emotional in his defence. Obviously too much time on his hands.

"It's no good spouting that Old Labour dogma at me! Comprehensives reduce their intake to the lowest common denominator! The end results speak for themselves!"

The argument would have rattled on for a good deal longer probably ending in blows but halfway through the telephone rings.

"Caleb it's me Sergeant Torrington. I need to come in and talk to you."

"You can't! You need official authorisation!"

"What authorisation? What are you talking about?"

"You need the code word and your passport."

Sounds of whispered rozzer conversations at the other end of the line. Words like 'fucking', 'loony' and 'gone in the head', sneak through to reach his ears. Then.

"Listen Caleb. They've found the body of Baldev Singh. Least what was left after the rats finished with it."

Buzz! Buzz! A stirring in the hive. One or two clamber over the anvil and hammer causing Caleb to shudder a little.

"I need to come in and talk to you Caleb before things get out of hand. I've got Dr Benefield here with me. She'd like to have a word."

The voices tell Caleb to put the phone down quick before they trace the call. He hasn't much time. He must prepare. Tell Gelert to sound the alarm.

Another line of coke and five notes later everyone's assembled in the hall. All eyes upon him live on stage. On top of the pyramid throne. Guru Ram Das with his arms aloft addresses the gathered throng. A full array of society's misfits.

Dossers, crusties and new age travellers. Illegal immigrants the lot!

"Brothers and sisters! Pray harken to my words! The enemies of learning are at the gate! They don't want you to succeed! You have the right to take your GCSEs in as many subjects as you like! Don't let those cunts tell you otherwise! You lot have just one chance to get out of the gutter! This is it! Take it! Seize it with both hands!"

A huge response to Caleb's stirring words. An ear splitting chorus of 'Aieeeeeh! Aieeeeeh!' that causes the walls of the College to shake. The Turban on a roll. Delivers the message they all want to hear.

"It is our duty to demand an integrated pattern of learning! A cross-curricular curriculum! Join with me now and sing the College hymn! Let our voices strike fear into the infidel hearts!"

Guru Ram Das shouts across to the B. Tech orchestra massed on the bandstand erected by Mr Singh outside the city farm.

"After three! One! Two! Three!"

> Three gypsies stood at the castle gate.
> They sang so high, they sang so low.

The words are familiar to the I.S. children. They sing along with gusto. Following the dot on the overhead projectors.

"Come on! Let's hear it! All of you! Let's take the roof off this time!"

> What care I for a goose feather bed?
> With the sheet turned down so bravely-o!
> For tonight I shall sleep in a cold open field,
> Along with the raggle-taggle gypsies-o!

Just at the start of the second verse there's a furious commotion at the South Gate of the hall. The riot squad have arrived and taken them by surprise. The singing comes to a sudden end as College security leaps in to defend. Wave after wave of drug crazed fanatics hurl themselves at the intruders. General

Kowalski at their head. Emitting bloodcurdling screams that fire them up and urge them on to kill. A second group of coppers burst through the North Gate heading towards Guru Ram Das. Rajvir spies the danger. Sworn to protect his master with his life. Charges down the steps of the pyramid throne and throws himself upon them. The swishing blade of his deadly scimitar levelling three at a time.

A scene of utter carnage unfolds but one which sets his heart blood racing. Guru Ram Das wallows in the glory of it all. His passion drug enhanced. The thrill that he was the cause of all this. Fighting for what was right. He yells at the band to keep on playing. Screams at Sir John to spur them on. Encourage his warriors in every way.

But only minutes into battle an angry frown creases the Principal's brow. He's suddenly twigged the enemy tactics. The pupils of the former I.S. Department are being singled out. Being whisked away secretly one by one. Lured out of the building by Tosser Torrington who's offering them a hundred empty packets of crisps to go for a ride in his car. Denying them the right of choice! The bastard!

Caleb's eyes search out the battleground to see how many men he has left. Precious few by the look of it. Even the mighty Delroy has fallen. All ten foot twelve of him! Sir John too has been carted off. The band in shambles and leaderless play out of tune and give up the challenge. Lay their instruments down and skulk out of the hall. Surrendering without a fight! Fucking typical of musicians. Gutless bunch of cunts! It's down to Yellowhead in the Dug-Out Club to stir up the passions with some rabid Techno. Full blast on his giant speaker. The noise fantastic. Brilliant. Freestyle jams over room-smashing beats. The message is simple. Cut to the bone. Don't fuck with me pig or I'll kill ya!

One naive young copper whose musical tastes don't embrace street culture is out to make a name for himself. Volunteers to enter the Dug-Out Club and pull the plug on Yellowhead's system. Nobody fucks with Yellowhead. Not on his own patch anyway. The shooter comes out of the inside pocket and blows a hole in Mr Plod's leg.

"Turn that fuckin' thing back on man! Less I'll splatter your fuckin' brains against the fuckin' wall!"

The copper obliges at once. Hand over his wound to halt the bleeding. Crawls away as fast as he can. Tricky comes on much louder than ever. A Bristol boy made good. More coppers at the Dug-Out entrance politely ask him to leave. Yellowhead scatters them with his Magnum. A volley of wildly aimed shots at the door.

Three sharp blasts of a whistle trill out and the police beat a hasty retreat. They didn't expect a response like that. From real live guns and ammunition. An enormous cheer rises up from the Educational Crusaders. As one they turn and praise their leader. Rajvir a brave but wounded survivor standing proudly at his side.

"Hail Guru Ram Das! Hail Guru Ram Das!"

Caleb climbs down from his scaffold throne to walk amongst his surviving troops. In and out of the dwindling campfires. The cries of the wounded and hungry reach out to him. Causing great sorrow to fill his heart. He offers them soft words of comfort. Tells them they stood proud with their neighbours in defence of their rights. The standards The Elders strove so hard to achieve. Their fame would be trumpeted throughout the land. A front page story everywhere. And they can say that they were there.

It depresses Caleb to think of all his missing pupils. Tempted away by Tosser's crisps. Bogey, Shitty and Hub-Cap Kelly. Backwheel, Car-Keys and Grabber Newell. After all he's done for them. Ungrateful bunch of bastards! His thoughts switch immediately to Errol Perkins. The boy he made his Second i/c. Even put a roof over his head and promised him fifty-four GCSEs at Grade A*. All to no avail. Errol fucked off when the going got tough. The word on the street says he's hiding in London.

It's with a heavy heart the penny drops and Caleb learns a bitter lesson. No matter what you do for kids, how much emotional energy you put into the job. In caring for them, loving them, putting them back on the straight and narrow. No matter how many of their problems you help them solve

they take it all for granted. Turn against you in the end. All that is except the mighty Kowalski. He's made of stronger stuff. Why even now he's rallying his men. Lighting the fires up on the roof ready for the next attack.

As if he didn't have enough problems already the Wicked Indian Man comes across to complain. Snapping Caleb out of his moribund mood. He says the deal didn't include a full scale battle. All he negotiated was full board and lodging paid for out of income support, housing benefit and council tax relief. Reports the food supply is running out. All the sheep have been eaten or run away. Shitty Shearn not there to defend them.

"Unless I have your firm assurance these people will be fed Mr Duck sahib, I'm afraid I'll have to seek alternative accommodation."

These are desperate hours for Guru Ram Das. Retreats to the relative calm of Tunnel H.Q. He thanks the Lord that Gelert survives. Overlooked by the boys in blue. Still guarding the freezer with his life. Displaying the fine sense of duty of the public school.

Caleb prepares four lines of Charlie and invites Gelert to join him which the boy willingly does. Wants to share the delights of his master's habit. Done it before on many occasions. Both settle back in easy chairs and languish in the reward. Fantastic! Brilliant buzz! All previous differences forgotten.

Voices from the past creep up on Caleb to whisper warnings in his ear. Offer advice and other intelligence with The Master euphoric and absorbing it all. There's Jayne and James and the face in the mirror, Rosie the cow B. Ed. Kaye materialises as a ghoulish apparition but only to call him sad and pathetic. The Pigman too with his gangrenous prick. Caleb refuses to believe the Pigman did it. Rammed the festering knob up his arse. Convinced it was all a horrible dream. Nevertheless he makes a daily inspection using the angled shaving mirror. Maria and Angela and Deaf Head Doris contrive to put in a fleeting appearance. Joining the others in the queue. Each and every one of them expounding the

expert knowledge they purport to have. Their collective advice to Caleb is to surrender. He yells out bollocks to that! He hasn't come all this way to give up so meekly.

After all is said and done there's only one way the battle's won. An army marches on its stomach. It's Guru Ram Das himself who makes the decision. It's food he wants and plenty of it. Quick.

The voices guide Caleb towards the crucial solution. How to restore order to all this chaos. Guru Ram Das smiles a secret smile and allows his eyes to fall upon the freezer. Manic laughter fills the air. Gelert giggling along with him.

It didn't take Gelert and Caleb long to saw the body into steaks. It was made much easier because it was frozen. Then dice it into little pieces. The head left intact inside the freezer. Wrapped up tight in a Tesco bag.

The campfires crackle back into life as Rajvir distributes the precious protein. He tells how two sheep were found in The Master's study. Surely a sign from Heaven above. Proof if further proof were needed that Guru Ram Das should stay in command.

The tandoor ovens are fired up again. The fragrant smells of Indian cooking waft gorgeously around the Temple grounds. Adrak, dhaniya and jeera. Kesar, lal mirach and soomph. Rajvir amongst them like a TV chef recommending they use plenty of ginger. Fresh green chillies if they can. Because the meat might taste a little sweet! Caleb and Gelert on the floor laughing. Clutching their sides at the joke.

CHAPTER 35

They came out of the sun with the wind behind them. The crack armed response unit of the riot police. Two thousand strong. They'd surrounded the building and entered the tunnel as far as the boiler room. When the signal was given to mount their attack they poured into the College grounds. Through every downstairs door and window. Stun grenades and C.S. gas hurled around with fearsome intent.

Caleb's men were still asleep and taken by surprise! All except Yellowhead, who because of the chemicals he is taking is able to stay awake. Continues raving into the night. Entertaining the Yardies and Columbian drug barons. Into the following day. Nonstop speed garage, acid, techno, chip shop gangsta crap. Thumping away. Incessant. Loud.

Ram Das stands tall and ready for action. The Spartan war helmet has replaced the turban. A hint of a smile on his face. Two lines of Charlie up his nose and a tab of acid in his gut. From his lofty position on the pyramid stage he watches the action unfold. The faithful Gelert at his feet rises to be by his side. Tightly clutching the Tesco bag now slowly defrosting and seeping the blood of the one who started all this.

The police make Caleb their numero uno target. Cut off the head and the body will fall. They gather together in Roman Square formation and club their way towards him. The bleeding Rajvir holds them back. Battles like a man possessed. The fierce red eyes that run in the family flash through the slot in the wastepaper basket and singe the moustaches of the boys in blue. But alas even he poor fellow is soon struck down. Felled by a well-aimed boot in the bollocks. Arms quickly handcuffed behind his back. Another kick for luck. Caleb lines up a posthumous medal. Alan Oakes with bar.

Guru Ram Das is in a desperate position. He watches his men take a terrible beating. Paying the price of the nine times table. Unless he makes an attempt to escape he can see himself

being captured alive. Years spent in a dark and dingy cell on the Isle of Wight like Napoleon did.

The precious few who remain of the crack Smackhead Light Brigade fight like rabid dogs. Leap bravely to the defence of Yellowhead's club. Columbians and Yardies side by side. Not going down without a real fight. You'll never take me copper!

The crackle of gunfire from the Dug-Out helps concentrate Caleb's mind. The armed response unit emerge elated and give the thumbs up sign. Intent on revenge after their comrade was shot they've just evened up the score. Caleb sheds a tear. Yellowhead wasn't such a bad lad really. Considering his background he'd done really well.

Guru Ram Das is cornered. Trapped with no way out. Enemy forces are climbing the steps of the pyramid clubbing their way to the top. Gelert's javelin accounts for one of them but forty or more remain. This indeed is Caleb's darkest hour. Where can he go from here? Just when he was about to hand in his notice a voice rings out from above.

"SIR! On the fuckin' roof SIR! NOW!"

The Union Jack tattoo on the shaven skull. The spider tattoo on his neck. Kowalski has come to the rescue. Caleb had forgotten all about him. Just thinking of himself. Ignoring his duty of care for his pupils. In loco parentis. How could he forget about General Kowalski who represents all that's good in the young generation? The flowering bud of youth! Fearless, loyal and fucking hard! The antithesis of popular thought.

The Principal of the Community College starts climbing the ladder to safety. Gelert follows close behind with the Tesco bag dangling from his waist. Dripping on those below. Hand over hand and into the brightly lit loft space now converted into luxury penthouse suites by the Wicked Indian Man. Pulling the ladder up behind they batten down the trapdoor quick. Any attempt to take them now must come from outside the building. Kowalski leads them onto the roof where a stirring sight awaits. A lump appears at the back of Guru Ram Das's throat as he spies the rooftop guards. The mighty Temple archers forged from the crème de la crème of

Kowalski's evening class. No sweat – no gain. No pain – no glory. Men who'd eat their own guts then ask for more. Kowalski has drilled them into a killing unit. A credit to their commander. All wearing black turbans and carrying dustbin lid shields. Painted blue and white quarters like Bristol Rovers with the word 'PREFECT' emblazoned across it. All wear the obligatory protective clothing. Cricket pads and batting gloves. In their fists their bows and arrows polished ready for action.

Ram Das strides along the battlements. Inspecting the men and offering encouraging words. He tells how Air Vice-Marshal Singh had fallen bravely in battle. Giving his life for the C.T.L.A. cause. If they're to achieve an integrated pattern of learning they must be prepared to do the same. General Kowalski answers on behalf of his men. A devotion to duty that does him credit.

"SIR! Any cunt who does not shed blood for you SIR! I'll throw off the fucking roof SIR!"

Not a blink when he says it. Total control.

Gelert has climbed to the top of the lookout tower. He yells an urgent warning. Finger points across.

"Father Catalyst! Here they come!"

Caleb looks below. Dozens of fire engines are being man-oeuvred into position. Ladders shooting skywards. Three well armed policemen to each platform seeking to land on the roof.

"Ready with the oil General Kowalski!"

"When you're ready SIR!"

Eight boiling cauldrons of Chinese frying oil courtesy of Corporal Wong are pushed to the edge of the college roof. Hissing and bubbling at a thousand degrees.

"Right then men! Let 'em have it!"

Kowalski drops his arm. One after another in quick succession the scalding contents are tipped over the side. On to the unsuspecting raiders beneath. Their screams and agonies rent the air. Sending a shudder down Caleb's spine. The ladders are immediately swung away from the building. The engines driven off at speed. But General Kowalski is merciless. The twisted mind of a psycho at work. Enjoying every second.

"Archers in position!"

He checks to see the rising sun is in the sky behind his sheep hunting class. In the eyes of the enemy below. Gives the order to fire. From every conceivable vantage point arrows shoot high into the air. The sky goes black as they shut out the sun. Form a gigantic sheet of sharp destruction that slowly approaches its zenith. A graceful parabolic curve to drop almost vertically on to the enemy below. Some already dying of horrific burns. Volley after volley let loose. Ruthless and unrelenting. A continual whining as a rushing wind whizzing on its deadly way. Reaping a bloody harvest.

Guru Ram Das is awestruck. Never before had he witnessed such carnage. A horrific display of military might. Using Sir John's brass telescope he homes in on the crowd. Thousands have gathered to watch the affray. Heeding the clarion calls of the local media. All stand still in a deathly hush. Held back by police at the road closed barriers. Shocked at the slaughter they've witnessed.

Suddenly Caleb's heart misses a beat. He's picked out some faces he's recognised. Members of his erstwhile family. Kaye, Jayne and James. What brings them here he wonders? Perhaps to bask in this second-hand glory. Proud to be related to the man on a mission. In his finest hour. And further around another huge surprise! Owen Harris the Chair of Governors standing next to Andy Powell. Looking very suntanned and fit! The one who's never here!*

The screams of the wounded in the playground a sickening sound to the ear. Ambulance men going about their duties under the protection of a Red Cross flag. Emergency sirens fill the air as police reinforcements speed into school. More

* Andy Powell told the Enquiry he was appalled by what was going on in the I.S. Dept. He claimed he repeatedly complained to Williams and Rees about the outrageous behaviour of Caleb Duck but neither of them took the slightest notice of him. It was because of this that he was forced to absent himself from school. He could see the way things were heading and wanted no part in it.

The Judge praised him for his honesty and integrity. Recommended that when the school reopened he should apply for the job of H.O.D.!†

† Author's note.

He did and got it. Cunt.

troops alight in a hurry. Rifles and safety nets at the ready. Another shout from Gelert.

"Father Catalyst! Look over yonder!"

Caleb spies a solitary fire engine slowly approaching the building. Just one man on top of the ladder waving the white flag of truce. Wrapped in all kinds of protective clothing. A fireman's helmet and bulletproof shield. Motorcycle goggles over his eyes and an axe tucked into his belt. Caleb instantly recognises who it is. The fat rotund figure gives him away.

"Listen Duck man! This has gone beyond a joke! Christ knows how many you've killed already!"

"They started it Rees, I didn't! All I wanted was to implement my syllabus!"

"There's doctors down here boy who can help you. Kaye's down there. She wants to talk!"

"Tell her she's spent the last six weeks in the service of Satan! If she has any true beauty left she'll come and join my ranks!"

"For Christ's sake Duck! See reason man! Think of the shame and disgrace you're bringing onto the school!"

Guru Ram Das is amazed. Shakes his head in disbelief. It's not shame and disgrace but glory in the highest. These deeds will reverberate around the world. From Timbuktu to Severn Beach. From Alice Springs to Ur.

"Listen Rees do us all a favour and fuck off home! Let me get on with the work I was chosen to do!"

"You're mad Duck! You're sick! Don't say I didn't warn you!"

Poor Rees still hasn't learnt how to be polite and well-mannered. Show some degree of respect. You just can't speak to the Principal like that. Especially within earshot of a fanatic. On a hairspring trigger temperament. Kowalski takes aim with his bow and fires an arrow. It thuds into his protective shield. Mr Nasty W.C. gives a shriek of terror. Yelps instructions at those below. Requests to be brought down at once. Now knows for certain he's dealing with madness. Turns to abuse them even further.

"Kowalski you're suspended for that! I hold you responsible for this Duck! He's out of control man! All of them! Worse than animals in a zoo!"

Caleb scoffs in reply at the Nasty W.C.

"You've got it all wrong Rees. Stupid cunt! You no longer control their lives! They're masters of their own destiny now! This is their only chance!"

Foolishly Rees wants to debate the matter. Hurls vile abuse from the ladder.

"You're fucking mad Duck! D'you know that? You're embracing the scum of the earth! Morons, pimps, bullies, tarts! Drug-crazed thugs like that thick fucker Kowalski there! The police want to question him about the attempted murder of the two Singh brothers! When I've got him in my office I'll"

Kowalski never allowed him to finish the sentence. The arrow flies straight and true. Brings a great hissing noise from out of his Tweedle Dum trousers. Rees emits a strangled cry as he slumps against the support rail. The second arrow goes clean through his brain. Only the safety harness prevents him from toppling off. Immediately a volley of shots ring out and General Kowalski is hit. Bullets ripping his body apart. The flowering Adolf has been nipped in the bud. Never to fulfil his potential.

Caleb oblivious to the huge significance. The serious repercussions. The crack in his head growing wider and wider with each alarming development. Not even the ladders up against the College wall and the hovering helicopters overhead can instil in him a sense of reality. Only one thing spurs him on. Acts as a sop to the drugs he's consumed. The standards of the Elders. Forget about good manners and literacy or even straight lines when the whistle blows. In his current state of impaired mental function his raison d'etre for all this trouble has been finely distilled into one basic skill. The chanting of the nine times table within an integrated pattern of learning. Not much to ask in this modern age of education, education, education. It doesn't concern Caleb he's lowered his sights he's more pressing problems to contend with.

The enemy troops are highly efficient. Pour over the

ramparts in their droves and zigzag their way forward. Shooting from the hip. The gallant Temple Archers begin to fall. Cut down in the very prime of life. The remainder engulfed in bitter hand to hand fighting. Cricket stump versus bayonet. The rooftop a scrum of orgiastic violence as the horror of war unfolds. The mother of all battles.

Instinct tells Gelert this is the crucial moment for him to claim the glory. One final gesture of self-sacrifice to help rally the troops to his master's cause. He puts the bugle to his lips and plays with a magical touch. Triple tonguing with the best. Hours and hours of public school practice enable him to perform. The sweet music serves to swell the breast and galvanise the men. He climbs a ladder so more can see him. Hear his mellifluous tones. Just like Gunga Din. Cruelly a bullet takes him through both lungs and he crashes to the floor. Precious lifeblood oozing out.

Guru Ram Das rushes to hold him in his arms. A faint flicker of a smile. Hands Caleb the Tesco carrier bag and with his final breath he speaks.

"Kiss me Father Catalyst! Kiss me!"

Guru Ram Das is moved to tears. Kisses him sweetly on the forehead then with a final sigh he dies. A highly charged emotional moment deserving of the highest honour. Bobby Moore with bar. Over and above the call of duty. The most decorated man of the war.

Guru Ram Das is trapped once more. Bullets begin to splatter around him. Shadowy figures move in for the kill. Time is running out. One last gesture of defiance to prove he's not afraid. He unravels the Tesco carrier bag and takes out the gruesome extremity of Roger Sweet. Looks into his dull and lifeless eyes and dares him to make a sound. Spits his words out with a controlled manic fury.

"All your fault goatee man! See what you've made me do!"

Grasping the head by its blood matted locks Gura Ram Das climbs the scaffolding tower to the very top of the college dome. Holds it high so all can see then rams it on a golden spike. Screams at the world watching from below. Bullets raking the air.

"Look Kaye! Special Needs Teacher of the Year!"

Instead of being blown up like Jimmy Cagney Caleb manages to scuttle away. Chanting aloud the nine times table. Follows his natural survival instincts and escapes the heat of battle. Hides behind a chimney stack and snorts another line. Waits for the drug to kick in. And when it does the wondrous surge of mental wellbeing enables him to travel along secret passages he'd dug out in more peaceful times. When he and Kaye were young. He tiptoes along a hidden goat path. Dons underwater breathing gear and swims through flooded mines. All the time whispering the nine times table. Softly so no one would hear.

Finally after many an odyssey of cultural delight that carried him across the Aegean Sea. Confronting sea serpents on a daily basis and establishing myth and legend. Amongst them Hydra, Jason and Apollo. An immortal winged horse called Pegasus which sprang from the blood of the slain Medusa. Enabled Bellerophon and Caleb to become fabled Tesco Trolley Men with double point bargains to collect. Three for the price of two. He emerges from a shaft in an open space just behind the school kitchens. The sound of cannon-fire comes from his left. Huge palls of thick black smoke unfurl their way skyward and flames leap high in the air. Wailing police sirens and clanging ambulance bells is further evidence the battle's still raging. The Temple Archers will die at their posts rather than be taken alive by the foe. Death will guarantee them a place in Heaven.

Guru Ram Das crouches down low behind a wheelie bin. Making sure the coast is clear. There in front of him is his target. His only means of escape. The dustbin lorry itself. Parked in a small courtyard at the back of the kitchens. Unguarded. He's in luck. He rises to his feet and strolls nonchalantly towards it. As if he were just passing by. Just twelve more paces and he's safe.

"Yer sir! Bin looking all over for you!"

Caleb jumps at least a foot off the ground. Spins round fast. Knife at the ready. Expecting to hear the click of a trigger.

"We've got the money for the raffle tickets sir! Sold 'em all. Got any more?"

Caught by Big Sharon and 'Foreskin' Sandra the two I.S. slackers. Guru Ram Das has to think fast. He never expected this to happen. Whatever doubts he may have harboured about P.S.E. have vanished now for good. A brilliant concept. Top hole!

"Foreskin! You scared the shit out of me! I thought you were working for Lynda!"

"I was but they closed us down! Bastards!"

"Where is she now then? What happened?"

"Bin arrested. Dragged 'er off screaming. Should 'ave seen it sir. She went berserk!"

Caleb's heart goes out to his secretary. Yet another victim. It's tough out there in the commercial world. A message he always preached.

"Look Foreskin, there's more tickets in my office. In one of the drawers. Give me the money tomorrow."

He tries his best to hurry them along. Get rid of them before the dustmen come back.

"You'd better be quick girls because the building's on fire! Buy yourselves some fags out of the money you get. Go on, hurry up!"

That does the trick.

"Cor thanks sir!"

They leave at once. Laughing and giggling. Nudging each other as they go. Looking behind at a human scarecrow. A madman on the loose. Spartan war helmet on his head. Aladdin shoes on his feet.

The leader of the Great Education Revolt creeps warily towards the lorry. Many famous men have travelled this route. Mao, Fidel and Wat Tyler. The leader of the Peasants. Furtive scurrying about to avoid detection. Caleb clambers into the back. Burrows a way through all the stinking garbage towards the end near the driver's cab. The sickly smell of rotting food sends his senses reeling. Makes him want to puke.

After what seems to be an age he hears footsteps approach the lorry. The sound of a man climbing into the driver's

cab. A key is turned and the engine roars into life. Slowly pulls away. Past the sounds of bitter fighting. Gunfire and loudhailers.

Guru Ram Das is strangely quiet as he sits astride some rotting sprouts. Watching maggots and worms squirming over his feet. Contemplating. Ignoring the warm sticky mess building up in his pants. Trickling down his inside leg. Just like Shitty Shearn. Other things on his mind. He thinks he'll head southwards to Yugoslavia. A hundred and fifty miles away across the mountains of the Austrian Tyrol. He hopes to make it within a week. Make contact with Stalin and M.C.C. Get them to join the C.T.L.A. and fight for a cross-curricular curriculum. Now his Nemesis Rees is out of the equation it should be an easy target. He's already proved to the locals he can do it. Get lowlife scumbags to raise their game and reach the highest echelons of the social strata. Make a worthwhile contribution. Vile and Dagger witnessed that for themselves. As soon as they publish their report the whole world will learn of his great achievement and provide the necessary funding. He starts chanting aloud the mantra of the nine times table to help concentrate his mind. Six nines are fifty-four!

Suddenly the lorry comes to a juddering halt. Angry exchanges outside. Guru Ram Das wonders what the hell's going on? Soon to be made apparent. The roof of the lorry crashes back. Exposing his hiding place. A triumphant cry of, "There he is!", as Caleb raises his head. Putrid helpings of ancient school dinners slowly evolve into human form. Stare and look around. Cries out loud so all can hear.

"Seven nines are sixty-three!"

The lorry has been stopped near the city centre. On its way to the tip. Men in white coats and police outriders take up strategic positions. Police dogs straining at the leash. Strangled gasps of shock and horror from the throats of law and order. Never in all their days in the line of duty had they witnessed such a sight. A Guy Fawkes made of kitchen waste leaps screaming from the lorry. Charges through their ranks.

All their attempts to bring him down are easily repelled. Their prey has take the cunning precaution of smearing

himself with a foul smelling ooze. Similar to human faeces. Impossible to get a grip. Nine nines are eighty-one!

Caleb laughs at their feeble attempts to catch him. Goes tearing across the City Centre leaving a trail that's easy to follow. Foetid cheese and scrambled eggs. Ten nines are ninety! High knee lift and pointed toes. Tremendous acceleration. Takes him away from the chasing throng. Towards a glorious future. All the hours he spent in training with Rosie beginning to pay off handsomely. His head is clear. His breathing controlled. Eleven nines are ninety-nine! Starts planning the months ahead. Preparing his acceptance speech for Teacher of the Year. He'll announce at the ceremony it was a team effort. He couldn't have done it on his own. He'll praise all those who helped him achieve it. Credit where credit's due. But only two he'll mention by name. Gelert and Kowalski. If he gets enough funding they won't be forgotten. Caleb's intention now is to start his own school with himself as a teaching headmaster. He'll name two of the houses Kowalski and Gelert. The others he hasn't decided.

A vigorous pumping arm action. Tops of the thighs parallel to the ground. Head held steady and eyes to the front. Thrusting legs off the ground. The police-dog handlers let go their Alsatians. Hurtle after Caleb. Mouths frothy white in brutal rage. Intent on ripping asunder. But for some strange mystical, unearthly reason they don't go into attack. Keep their distance and follow him as he hares off down the road. Their yelping and barking attracts more canine attention. All the stray dogs in the city. Mongrels and pampered Pekinese. Soon the pack numbers over a thousand. Baying and yelping their support of him. Recognising a leader. They follow in the wake of Caleb the Good blazing a trail to freedom. Seeking the Seventh Level of Awareness. Somewhere up ahead. Wherever it is he's sure to find it. Discover where he goes from here. Twelve nines are one hundred and eight! Come on! Up the Gas!

THE BRADLEY REPORT

In his report after the Enquiry into the Walliscote Incident, Judge William Bradley recommended that no teacher of inner-city, multiracial, comprehensive school pupils should be allowed to teach for more than three consecutive years unless the following procedures had first taken place.

1. Regular psychological assessments.
2. Wives, husbands, partners, children interviewed by Educational psychologists for signs of emotional distress.
3. Regular counselling of teachers by independent professionals (i.e. every three months)

NB. WITH E.B.D. TEACHERS THE FOLLOWING SHOULD ALSO APPLY:

TEACHERS SHOULD:

4. Be entitled to one year's sabbatical (fully paid) after each three year period.
5. Be regularly tested for drug and alcohol abuse.
6. Be regularly tested for S.T.Ds.
7. Be fingerprinted and photographed for security reasons.
8. Have their passport confiscated during teaching term.
9. Report regularly to local police stations to show current state of (a) appearance and (b) bank balance.
10. Put in compulsory appearances at identification parades as and when requested.
11. Any teacher requesting a second three year contract teaching pupils with Educational and/or Behavioural Difficulties to be automatically detained under Section 11 of the Mental Health Act.